LIVING THE PRACTICE
VOLUME I:

THE WAY OF LOVE

bancroft
press

Rohini Ralby

Interior Design: tracycopescreative.com

978-1-61088-575-1 HC

978-1-61088-576-8 PB

978-1-61088-577-5 Ebook

978-1-610880-578-2 PDF

978-1-61088-579-9 Audiobook

Published by Bancroft Press

"Books that Enlighten"

410-358-0658

P.O. Box 65360,

Baltimore, MD 21209

www.bancroftpress.com

Printed in the United States of America

To my Guru, Swami Muktananda,
who is with me always

And to my husband David and my sons, Ian and Aaron,
who love and play with me on this journey

TABLE OF CONTENTS

CHAPTER THREE:
GURU AND DISCIPLE: BABA

CHAPTER FOUR:
GURU AND DISCIPLE:
DISCIPLESHIP

INTRODUCTION

This book, like everything else of value in my life, I owe to my Guru, Swami Muktananda Paramahamsa. Baba generously shared with the world what he knew and lived. He spent many long hours with me, often alone, instructing me, often wordlessly, in the internal practice that allows us to re-cognize our true nature.

I went to Baba because I wanted the bottom line of life. In 1975, at a retreat in Arcata, California, he gave me the experience of that bottom line. I knew I needed to remain with him, so I dismantled my entire worldly life in order to do that. From then until he left his body in 1982, I worked to be as close to him in his physical form as possible. Since 1982, Baba has remained with me wherever I have gone.

While with Baba, I served in different capacities, but always remained close to him. Most days my job was to spend hours standing near him, often alone, providing whatever he requested. It was during those hours and days that he taught me all I needed to learn. There were times when I asked him about mundane issues, but mostly I just did what he told me to do to the best of my ability at any moment and hung onto his feet.

Baba met with many people and often gave talks in which he spoke of scriptures, saints, and poets. But throughout my time with Baba, though he and I physically and personally interacted, our communication and connection unfolded at a level underneath what anyone watching our relationship would have seen. He gave me what I wanted most in my life: the Truth.

In 1981, after Baba's second world tour, we returned to his ashram in Ganeshpuri, India. Baba put me in charge of the library, which no one else could enter; only then did I read much scripture. I believe I took in what

was in the books through osmosis more than anything else, because my love in that library was to sit on the desk and watch Baba through the window. Through the practice of focusing on Baba's image, which I did during all my *seva* (service), whether at the back stairs or in the courtyard or in the library, I would be pulled inward and then rest deep inside.

Since Baba's passing, I have continued to practice what Baba taught me personally in order to get beyond the personal. I have also found myself studying the scriptures Baba valued, the poets he quoted, and, as Baba specifically had me read other traditions and share them with him, texts from many faiths. All these studies have only reinforced what Baba himself taught me.

Baba especially loved what many people call Kashmir Shaivism—the nondualist tantric traditions of the region of Kashmir—and he would chant its scriptures and poetry. So it is important to understand some of what tantra as Baba taught it is and isn't. The word *tantra* is connected with the Sanskrit root *tan*, which means to extend, as in thread or weaving—and therefore anything set forth or spread out. There are many beliefs, practices, and texts that can be called tantric, but there is no tidy definition of the term. Some texts called tantras are not religious at all; some texts that clearly set forth doctrines or practices that we might call "tantric" are not called tantras. Some of these traditions were dualist, some nondualist. Many focused on the Goddess, but most worshipped the Absolute as Shiva.

Kashmir Shaivism, the greatest of the nondualist traditions, was most completely expressed by a series of Guru-scholars writing in Sanskrit around the 9th to 11th centuries. The greatest of these, Abhinavagupta, emphatically says that outward ritual is for beginners, and that more elite practitioners should dispense with exoteric ritual and make their practice wholly internal. Like every living spiritual tradition, this "higher" tantra is about lineage. Central to it are the principles that true initiation takes the form of a spiritual awakening, and that the Guru is the means. It is this

tradition that was embodied by Bhagavan Nityananda and passed through him to Muktananda, and it is this tradition of interior practice that Muktananda taught me, and that I pass on.

The awakening of the spiritual energy, *kundalini,* is spoken of in all faith traditions; though the language is different, the substance is the same. *Kundalini* awakening is like turning on the ignition in a car. It ignites the engine that can make the car move. The Guru turns the ignition key, and is also the one who adds fuel as needed and guides you—the student driver— in what direction to go and what hazards to avoid. Baba continues to do this for me. This book and its sequel will convey much of what Baba taught me, and continues to teach me, about breaking the mirror of delusion and re-cognizing the true Self.

These two books have been ripening over many years. They come out of ruminating on and articulating the journey, the map, and the terrain that I traverse. I am compelled to share what Baba has taught me, so that others traveling might be able to see at least some of the signposts along the way. Though the book can be read cover to cover, it is perfectly fine to read it out of sequence; feel free to follow your curiosity, your questions, and your evolving understanding. As you read, you will find that lessons, stories, and key passages return again and again, to be contemplated and understood in deeper ways with each encounter. You will also come to appreciate the crucial differences signified through letter case, such as between Love and love, or Real and real.

This first volume highlights the importance of lineage and the Guru-disciple relationship. Without this relationship, without both Guru and disciple being in right relation and aligned appropriately, nothing can unfold. Just as only those who know how to follow can truly lead, a Guru has to have been a disciple in order to be capable of moving a disciple forward. The Guru rests at the feet of his or her Guru. It is this unbroken lineage that promotes the qualities of the Guru and maps out the

characteristics required of the disciple.

Surrender is one of the most important practices to advance us on our journey. Without surrender, we will not be able to undertake the core of any spiritual practice: simultaneously to be with our experience, let whatever comes up from that experience come up, and function appropriately on the physical plane. Unless we can surrender what is unreal, our vehicles will remain out of alignment with God, and we will function only as separate, shrunken selves, always choosing to protect and preserve what we really need to give up. The Guru never asks us to surrender the Self. He will always ask us to surrender our wrong identification, our attachment to what is temporary and non-Self.

With this surrender and the Guru's guidance, Love is able to arise within us. The blockages caused by wrong knowledge are dissolved, and who we truly are emerges—because our true nature is Love. This Love is not the love which is the opposite of hate, for that would be merely a kind of pleasure. This is the Love that is the bottom line of existence, what Dante called the love that moves the sun and other stars. From this Love, which is *sat-cit-ananda* (Truth, Consciousness, and Bliss), all vibrations emerge and the world manifests. This Love is the Real, the underlying unity of All.

The prose reflections, poems, and paintings in this book were produced over many years. There is much in them to contemplate beyond the letters and words and colors and strokes of which they were composed. Take time with them. Revisit them. Let yourself be drawn to particular ones. Through them, Baba's teaching, and therefore something of Baba himself, will be transmitted; you need only be willing to receive it.

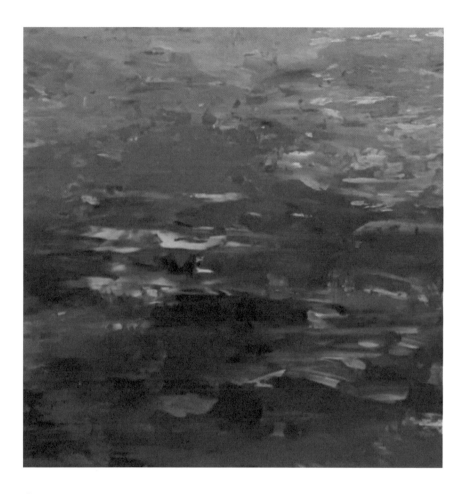

Oceanic (2017)

inscription....

 document

the infinite

 listen

 express that

 share through

 vehicles

 unique

 each soul

 sole manifest

 with

each us

 dictated

 to

 to

 document

Shiva's game....

Shiva
 gives birth
 to
Shakti
 gives birth
 to
 world

so Shiva
 can
 play
 we are
 part of
the play
 the make believe
 we believe
 is real
 and make
 Shiva
 laugh
as we are
 so serious
missing
 the divine comedy
 for tragedy

punctuation....

what time is it

 now

 this moment

past present
 and

 future

right now

relative
 reality
 is
 limited reality
 shrunken into
 time
we live
 truly
 in
Absolute

where time
 is
 All
 the time
 we think is
 now
 and then and
 soon
there
 we never
 miss
 an appointment

because
 we are
 always
 on time
 in the
 m o m e n t
we never forget
 punctual
 pastpresentfuture
 is

 now

the duelists....

prakasha creates vimarsha
 out of Self
 non dual

 God creates adam
 then eve out
 of adam

 non dual

 till we all fall
 in to
 different pieces

 duelistically
 we duel each
 other
who is our self

 make one just
 wrong
 one
 wrong duel
 fighting
non duel your self
non duel dueling
 delusion
 right duel is
 non dual

emergence....

a
r
i
s
letters
o difficult
r
o
m

vibration
sound
meaning
a
n
i
f
e
s
to

form
world
as You
all ways

seekers....

algorithm for

God

is

not

that is

correct

no algorithm

creator of algorithm

is not

experiencer

not the experience

creator of

 experience

steady blue pearl

witness who is also

 dancer

not the vehicles

 who dances

 through
 vehicles

seekers dance the seeking

 dancer laughs

shhh....

still vibrations
 of all
 vibrations
be with vibration
 face does not
 let go
 quiets
 stills dissolves
 evaporates
 to find next one

crossing....

so much to handle

 four bodies
 four states
 three so
 obvious
 only
 when
 in fourth

 can't cope
 can't play
 can't see
 until we
 land
 in
 fourth

 by Guru's grace
 anchored in fourth
 pulling us
 in across
 the

 span

 of
 waking
 tundra dream
 deep sleep

 to
 meet our Self
 in

turiya

Sad (2017)

Sad	Erratic
Depressed	Alive

CHAPTER ONE
FOUNDATIONAL CONCEPTS

Beginners....

I like seeing myself as a beginner. I have always been a beginner. This way I can always learn. If I "know," then there is nothing more to learn. For all of us in relative reality, thinking we "know" is dangerous. If we lived in Absolute Reality, then I could say "fine, I know." But then, if I were in Absolute Reality, I would not be saying "I know." So for God's sake and your own, just be a beginner and grow from where you are.

After each new level reveals itself from the most recent ego death, the experience is that now we are in new territory. We are now playing in a subtler landscape and the rules are slightly different, as something has fallen away. We are not sure "who we are," which is a good thing, and our job is not to find a new "me." We are to continue boring in toward the Truth, the Absolute, Heart, Home. We are to let go of what we are now looking at and move toward God, the Self of All.

Though there are times we will lose, our job is to persevere, not to let our limited shrunken self inform our lives. As beginners, we can keep working. The danger for experts is to become complacent. Then we can find ourselves so far off we are no longer in the game at all. Beginners tend to pay attention though they do not see clearly; experts see more, but they can lose concentration. Until we have reached Union, none of us sees completely clearly.

Develop discrimination and non-attachment. Know you are neither your good nor your bad shrunken self.

Beginner	Expert
Learner	Know-it-all

As we own them all, we begin to be who we really are.

St. Symeon's Discussion....

St. Symeon's discussion of contemplative prayer in the *Philokalia* might serve as a good reference point for the practice I teach. He establishes three levels of attention and prayer. The first level relates to the five senses, with God as Other; the practice makes use of outward props such as icons, statues, and formal ritual. The second level relates to the mind, and is described by Symeon as "thought fighting thought"; the problem with that is that it takes place in the head. The third level is the mind resting in the Heart, the Heart being not the seat of emotionality but the place within us where God resides.

Only with third-level practice do we actually have the opportunity to be truly still, beyond thought. This practice can be found in nearly every spiritual tradition, including Sufism, Christianity, Judaism, and the many Indic and East Asian traditions.

By working toward the third level of attention and prayer, people from all backgrounds can begin moving toward a dialogue in which they are not so attached to their own individual and collective narratives. We can then get past much of what separates us and find the unity in the diversity. My goal is to get people to experience that unity for themselves, not just think it. With that in mind, I try to avoid using jargon of any kind, so that people can approach the experience from their own traditions.

Human Security....

Human security starts within. The single greatest source of human insecurity is ignorance. Human security is the removal of ignorance;

ignorance of who we and everyone truly are. You, the actor, are okay. The character, the lower self, is in fear for its life. To be truly secure, you must let go of the character. That means not being identified with the role you are playing. We play our part, but we are not the part. So we can witness and see the choices we actually have.

The dialectic of "freedom from fear" vs. "freedom from want" fails to take into account the internal experience of security. If someone in a strife-torn region has internalized insecurity and has become identified with it, then improving their external circumstances will not remove their experience of insecurity, and they will then work, perhaps unconsciously, to recreate familiar insecurities, thereby perpetuating external as well as internal strife.

Internal insecurity is passed on from generation to generation within a community. As we grow, we can give up the legacy, the tradition. This can be very difficult because it can be seen as disloyal. Do you want to move on or just remain stuck in the same narrative?

Systems....

Everyone uses a system, whether consciously or not. Our family culture is a system of sorts, with jargon, rules, behaviors, judgments, and mannerisms both overt and covert. This being the case, when we meet someone new, we unwittingly compare our system to theirs. We may not even be aware of it, but we are in fact assessing others based on our system. Many times, we hit it off or not based on unconscious decisions.

There have been times when I will start to tell someone about my tools, such as the fourchotomy, and get the response, "I don't like systems." I reply, "Oh, then what would you like to talk about?" We will then meander down a path that demonstrates that person's system.

There is nothing wrong with systems; they give our lives order and continuity. What is important is to be consciously aware of what systems

we use. Don't believe you are the only person in the world who doesn't use a system. We all use them. Rather, don't be attached to your systems or identified with them. If you are not attached to your system, you can adjust and be fluid and appropriate. We need to be able to let go and not require everyone to relate with our systems. This will give everyone a chance to relate with you and with each other.

Clarity of Goals and Definitions....

When we start a conversation, we tend to look for common ground. This might be language, activities, or anything that we feel will bridge us to the other person. In our desire to connect, we may miss what is actually going on.

If what we share is a common language, then we need to check our definitions. Assuming shared definitions can be quite dangerous. Savvy politicians equivocate; they use vague, overarching language to rope in as many people as they can. They work to let people believe they are on the same wavelength. We need to pin ourselves and others down.

When we assume, we are probably projecting, and relating according to an idea. If we are in fact not on the same page but are using similar language, communication can get frustrating. Though the words are the same, the definitions are quite different, so we are in fact speaking different languages. Depth is an important factor here. Many times people will think they are in a deeper place with a greater understanding than they actually have. There is nothing wrong with being beginners unless we believe we are at the highest level of understanding. The truth is, we all have to face where we really are as opposed to where we think we are. Once we understand where we are, we can begin to discern. If we know our definitions and are not vague but clear, we can actually communicate better and hear someone else's position.

Years ago, I was in a conversation with a Christian chaplain. My error was that I assumed we wanted the same thing: union with God. He, however, did not believe that was an option. By union, he meant heaven, which for him was remaining a separate self and being with God, not transcending separateness and being absorbed in God. My mistake was that I had not asked up front for each of us to define terms. We were not even close.

So the first question has to be, what do you want? Heaven is different from union with God. Pleasure is different from happiness.

If you are clear about your goal, then your life will express your goal. Ask yourself what your goal is. Ask others what their goal is. Check it out. If your answer is going to God, and others do not want that, then you are not on the same page. Their page is just fine. Do not ram your position down their throats. And remember, we cannot assume all really want God as we do; their definition of God may be completely different. Relax and know where you are.

What Does It Really Mean to Own Something?....

Are you thinking and reasoning or allowing yourself to be with your experience? Dissociating does not mean you are neutral. It is not rational. Do not intellectualize your experience. The *Vijnanabhairava* tells us we have to go back to the source. When we go toward the source, we will experience Love and then realize that our twisted Love was its manifestation. Do you learn from your experience? What do you learn? We can learn to dissociate or we can take things to Heart.

Choices when something arises:
1. Learn not to face anything. Denial.
 You're miserable and don't know it.
2. See where your attachments are and do nothing.
 Therapy. You know you are miserable.

3. Face your attachments and free yourself from them.

 You free yourself from misery.

In order to burn up karma, we have to face reality and feel it. Remorse and repentance are required.

Remember: Love enlivens and informs everything, even delusion.

Grace….

There's so much talk about Grace. Born again, Pentecost, Yoga, New Age, from every corner we hear this word used. What is Grace? For me, Grace is knowing who I really am. Knowing through Being is what Grace gives us.

Many people believe that Grace is having the bells and whistles; the lights, sounds, feelings, smells, and even tastes that comprise supernatural experiences. The Desert Fathers spoke of the dangers of seeing lights or hearing voices. They knew that these supersensuous experiences could delude a monk into thinking he was somewhere he wasn't. Today we face the same concern. If I have extravagant experiences, then I can delude myself into thinking I am superior to others. I should be on the long path heading to God, but I fall to the side of the road, believing that if I see subtler colors or hear subtler sounds than you, then I am further along the path than you. Considered this way, it looks rather silly.

In the ashram of Swami Muktananda, many people had incredible experiences. These experiences were amazing, but for many people, everything went back to normal after they returned to their homes. Around Baba, people would have extravagant experiences and even feel that they saw and knew the Truth. And some did. And what was the Truth? Knowing and Being who they were. Baba used to say, "I give you what you want so that someday you will want what I have to give you." Those people who went beyond the experiences to know themselves had Grace. This is what Baba wanted to give each of us.

Sometimes people who had very powerful experiences but had not done the work of stilling their own individuality ended up having humongous egos. They were enlightened shrunken selves, sure they had achieved something great. These people ended up deluding themselves, and often others. Because they believed everything that came from them was from God, they believed they could never do anything wrong. Their orientation brought them to this: "If my intentions are always good, then I am always good. When I commit a wrong, since doing so was not my intention, I am not wrong or bad. I am above judgment, because I am sure that I have nothing but good intentions." How sad.

Powerful experiences can show us that we may be on the right track, but these experiences are not the goal. If that were the case, then on the physical plane people who have wealth and beauty would be Realized despite the fact many of these people are not even interested in knowing Reality.

Without reflection, we are just senses with feet. And then when we have supersensuous experiences, we think we are super. Only when we reflect and see that these experiences are nothing but subtle matter, subtle vibrations, can we then move on toward our true destination. Let us say we want to go to Boston from Baltimore. We reach Philadelphia, which is filled with many distractions, so we do not leave. We never get to Boston, our goal. Supernatural powers are like that image of Philadelphia: we have to go through them, but we need to leave our attachment to them behind. We need to move on to the goal. If we have not received Grace, then we may just stay in Philly fascinated and deluded by signs, thinking we have reached our destination.

Receiving Grace is receiving the Reality of who we are and knowing it.

Risk....

Risk is no risk when you are an expert. How many times have we watched someone with great skill and believed they were doing the impossible, when in fact they themselves feel it is no big deal? Yet when we are ignorant and act without skill, we are the ones risking. It is really dangerous, and it is out of our wrong vision that we believe we are sure of what we are doing. Because of our lack of knowledge, we are not even aware of the possible stakes. This usually ends in a mess, and the question is, why me? The answer should be, because I choose it.

When we are experts, we see the whole picture and know things that people with less skill do not. So the expert is sure of all possible risk because he has more and better data and knows how to interpret it. The non-expert will probably devise a solution fraught with risk because he lacks the information that would have guided him directly to the resolution. Then many will say the expert is lucky, but he will say no, the direction is clear.

So how do we become an expert? *Yoga Sutras* 1.14 states that through practice done for a long time, with no interruption and with great devotion, we can reach our goal. We need persistent, correct hard work to bring us to the knowledge we seek. How many times have we seen people putting in effort that does not bear fruit because it is not the right effort? They are inefficient, and may be repeating the same shallow process and not wanting to face the challenge that is in front of them. They continue to perform this same activity thinking it will bring them success. At some point, these shallow workers decide that the knowledge is flawed or that it is impossible to attain. They abandon the work. If they had looked at how they had approached the work, they could have seen that their own effort was flawed. From these conclusions, they decide that the expert was just talented; it was easy for him. They ascribe words like "lucky" to the expert, and this removes any sense of responsibility for their own failure. No, every true expert has worked extraordinarily hard and pushed through obstacles that

most people have never met.

At some point, the effort is so internal no one can see it, so observers think real effort does not exist. The path to becoming an expert follows the three levels of attention and prayer expressed by all spiritual traditions. St. Symeon in the tenth century and the *Shiva Sutras* speak of these three levels in regard to spiritual practice. They can, however, be applied to the acquiring of any expertise. First, we see the person doing the same activity as we do. This is the first level. We are all struggling with the external processes. We learn the tools and techniques of the trade. We are using our five senses. We are learning external structure and skill. For most, that is all there is. And that is the problem. Some, however, begin to question and look to understand intellectually what they are learning. They will study and will wrestle; they will even try other techniques to the same goal. These people know there is more to know and are moving in the direction of acquiring that knowledge. For them, expertise is having the most knowledge and skill. They are heading in the right direction, but they are not done; there is more after this.

When I was a dancer, we used to work hard to have full control over our instrument so that it could say and do whatever we wanted it to. But we were never going to be dancers until we could go beyond technique. To be an expert, we have to follow the steps, the first and second level of knowledge. We have to practice the skills and techniques and become proficient in the processes in which we are working. We have to learn the ins and outs so that our skill is at the highest level—and then we have to let go of all control.

The shrunken self cannot be a part of this. It cannot take credit for any of the work or the outcome of our work. Once we have acquired the knowledge, we have to surrender to God, to the Self, to really be an expert. We may let go in the early stages by sheer accident, but that does not make us an expert. First, we have not yet acquired the skill at a high enough level,

and second, it was an accident that we let go; we were not conscious. The shrunken self will come back and say I don't know what happened, I don't know who that was. No, to be a true expert, we have to have worked to a level where we have full control of our subject both physically and intellectually; then we let go of the control and God is the doer. At that point, we are at the third level.

There are no shortcuts. The three levels have to be practiced in order to reach mastery. We own, master, and then transcend. And we are now no longer risk takers.

Leaving the Fall....

Every spiritual tradition values what is known in Sanskrit as *sahaj samadhi*, or walking bliss: being in the Heart and being with the world simultaneously. The problem is that we make this state of being into a lovely ideal or a distant place that we could never attain. In fact, walking bliss is available to each of us. The real questions are: do we want it, and are we willing to work for this state? Once there is a "yes," then we have to actually learn the truth of how to work.

We must first define the Heart, something often spoken of but seldom understood. By Heart, I mean the innermost center: beyond the physical center of the waking state, beyond the subtle center of the dream state, beyond the center of the deep sleep state to the place where We, the pure Subject, reside. In Sanskrit, this state is called *turiya* or the fourth state, but it is categorically different from the other three. This is the state where We are the Witness of the other three states. We are the Perceiver, not the perceived. This is the Heart.

We literally get there by going through all the other centers of each of the states. This is not imagining, this is actual. We start by withdrawing all our attention from everything except the center of the physical body, the center of our chest; from there we bore in, letting go of each previous

center and continue until by will alone, quietly, we rest in the Heart. Remaining there will take years of practice, which includes the continued removal of whatever distracts us. This is the ultimate work for each of us: to return home to being our Self.

Most cultures talk about a Fall of some kind. What is the purpose of God's sending us out of the Garden of Eden? God did that so we can become conscious and return to the Garden in a state of pure consciousness. We have to work to purify in order to return to our Home. Before, we were bliss with no awareness, with no understanding of our state or even of God. Not until we are thrown out and then have to work through our wrong understanding can we see what we lost and what we choose. We have to give up who we think we are in order to be who we truly are. This work is what we call spiritual practice, *sadhana*. And without a good teacher, we can think we are becoming conscious when all we have done has only added a layer of concepts to our shrunken self. We change our idea of who we are instead of surrendering to being the Self. Not until we do the hard work of surrendering our wrong understanding, of giving up the ignorance that takes what is impermanent to be permanent, what is impure to be pure, what is misery to be happiness, what is not the self to be the Self, does our true Self emerge. Who we are is always here; we just don't know it because the shrunken self is veiled into believing it is Real.

Spiritual practice should lay out clearly and definitively how to remove our ignorance. If it does not, then it encourages the very activity we are working to get rid of.

Walking Home with Baba: The Heart of Spiritual Practice shares a path that has been walked for thousands of years; it also demonstrates the actual practice as taught by my Guru, Swami Muktananda. The teaching chapters explain where to go, why we are heading in this direction, and what tools to use on the journey. I provide some valuable tools I have developed in my years as a spiritual director, such as the Foursquare (now Fourchotomy)

Personality Game, which reveals our attachments and allows us to transcend them. The anecdotes are teaching stories from my life with Muktananda. Those stories are not fables about sweet concepts. They are accounts that share the heat of one who lived in the fire of a realized being. They recount daily interactions always designed to remove my veils—not to tear me down but to shine a light on the false self, so I could let it go and the true Self could shine forth. Baba never wanted to build my shrunken self back up; he wanted me to be as he was—pure Love—and I could not be that until I was willing to see and relinquish my own wrong understanding. This process had to be done consciously, not merely by the touch of grace but through hard work joined with the grace of the Guru. Ultimately, we have to surrender our shrunken self; no one else, no matter how powerful and loving, can do that for us. The Guru will guide us, God will guide us, but in the end we have to remove the final veil by conscious, active surrender to God, the Self of All. We must break the cup and merge back into the ocean. Our individuality that was formed with the Fall has to be consciously let go.

Then we are living in *sahaj samadhi*, walking bliss. We are resting in the Heart and being with the world simultaneously; we are both immanent and transcendent. And though we may relate in the diversity of it all, we live in the universality, the Oneness, the Love, at the same time. *Sat Chit Ananda*: Absolute Truth, Absolute Consciousness, and Absolute Bliss.

How Spiritual Practice Unfolds....

All is misery. This is because of the *kleshas*, the afflictions spoken of in the *Yoga Sutras*. Our ignorance of who we are is what causes our misery. There is always a sense of missing something, of not being true, of not feeling fulfilled or experiencing Love. We can have moments and then say we are fulfilled in our work or have great relationships, but always sitting around the corner is the pain, whether we admit it or not, that we are just

not ourselves. When we have had enough of this nagging feeling in the background of our lives, we may start our search. This will be the search for deeper meaning, more fulfillment, authentic voice, true happiness. In the world today, there are many circus barkers selling solutions. And for them, their solution is *the* solution. They have come up with an easy new way that will get you there in a heartbeat with no work. Magic.

Sorry, I do not hawk magic. This is not an easy path. It is very steep. So if you are not up to the task, that is okay; you can tune out now. If you want the Truth, however, the path that has been traveled for thousands of years and that brings you to the goal, then listen up.

Ignorance, according to Patanjali, is taking what is not real to be real, what is impermanent to be permanent, what is impure to be pure, what is not-Self to be Self. Once we do this, we lose our subject in the object with which we have mistakenly identified. After this, we are then attracted to certain things because of our wrong identification; we are also repulsed by certain things because of this identification. Finally, we cling to this identity because we fear death. All the writings of all traditions and schools of thought say we can be freed from this wrong knowledge.

The first step is for us to be able to listen to and hear our honest answer. Our honest answer is not the true Self; it is just our honest answer. But it is our honest answer that runs us, that controls us, that keeps everything going. So if we do not hear our honest answer, we do not know what we are actually doing. We may intellectually have really good ideas, but it is the honest answer sitting underneath that runs us. So what we need to do first is be able to hear our honest answer. We may think there should be no reason why we would not listen to ourselves. But our honest answer is not always the answer we want to hear. And if it isn't what we want to hear, we may deny it. Therefore, step one is to hear and then accept our honest answer. The fourchotomy game is a way of developing this hearing and acceptance. The seed exercise, explained in *Walking Home with Baba*, will

help with seeing and acceptance. Until we get to and accept our honest answer, we cannot move. If we are tormented by our answer, then obviously we have not accepted it. We have somehow run away. Our job is not to judge but to accept. Once we have continuously listened to our honest answer and accepted it, we can then move. We can actually start working.

Second, we need to be with our experience, let whatever comes up come up, and function efficiently and appropriately on the physical plane. It is better to be with whatever our experience is than to deny what we do not like. Being with our experience is, again, not wallowing or tormenting. We have to accept. Everything in the world comes from us. If we do not accept this, we unwittingly end up perpetuating pain when we believe we are acting out of love and compassion. We have to own the truth of our motives, and we cannot until we are willing to live, being with our true experience of the moment and not denying it. We have to be strong enough to look squarely at what comes up and accept all qualities. Not functioning appropriately is one way of not accepting our honest answer. By the way, if we do not allow ourselves to be with our honest experience of the moment, we may believe we are only avoiding negative experiences that we call bad. In fact, we are also avoiding true positive feeling, like actual joy or love. We will only be allowing the shadow or the distant iteration of the true experience. For instance, if we are committed to positive sentiments, we will just manifest as sappy, which will then annoy many people. So we have to be willing to be as true as we can be in the moment and function appropriately.

This third step is where we are no longer in the territory of the therapeutic model. Most of the work in the early stages of *sadhana*, which can take years, is about cleaning our vehicles, so good therapy can be very helpful. During these early stages, people may think that therapy and spiritual practice are the same thing. It is in step three that the two schools separate very clearly. Therapy wants me to be the best "Rohini" I can

possibly be. Spiritual practice knows that I am not Rohini, because Rohini is knowable. The goal of spiritual practice is to disentangle from Rohini. So step three is letting go of perceivables. Our task is to keep withdrawing the line of demarcation between who we think we are and what we perceive. We are disentangling what we perceive from "I." Eventually, we will get to pure Subject, with no object.

When we get to pure Subject with no object, we will Know who we are. We are the Perceiver, not the perceived. We are the Seer, not the seen. If we can know it, perceive it, see it—then it cannot be who we are.

What are the means to get to pure Subject? According to all the schools and traditions: discriminative knowledge. How do we acquire this knowledge? If we return to step one, we will see that from the very beginning, we have been practicing and developing these means. Being able to hear our honest answer rather than the "right" or "good" of the shrunken self is an early form of discriminative knowledge. If we can accept this answer, then we are not running away from ourselves, even in our shrunken form. Then, as we proceed, we can discern who we are not from who we really are. Discriminative knowledge is being able to tell the difference between the Real and the not real.

Who are we? We are the Self of All, Pure Love. Practice, and then be your Self. And remember: this takes many years.

You Are Perfect Just the Way You Are....

You are perfect just the way you are. So, be where you are and accept it. That is the practice. Boring in toward the Heart does not mean you will feel good. It means you are heading in the right direction toward Home, where all vibration is stilled, and Love is.

In order to get there, we have to stop the fight. We have to know where we are at any given moment. We have to know we are in the swamp. If we are looking over toward the light, we are not accepting where we are. If we

actually accept that we are perfect just the way we are, then we are moving toward no longer being identified with a particular experience. We then know the experience is a knowable and is not us. We are no longer looking for pleasure or pain. All is the same. We are perfect just the way we are— miserable, happy, sad, angry, whatever.

None of these attributes is who we are. "I am in truth not my fourchotomy. I am wherever I am and okay. Perfect the way I am. So stop telling me to be nice or something else you want me to be, because I am perfect the way I am, and so are you." We can then not like the way someone does something and we can leave. We do not have to like the way someone is. However, we need to accept the way someone is.

You are perfect the way you are. I now can choose not to play with you, as you can choose not to play with me. That is okay. You are perfect just the way you are. You resist learning in my class. That is okay. Then you will no longer have to be in my class. Your choice. You are perfect the way you are. I am giving you what you want.

Let whatever comes up come up. This means we are not running from our experience. We are letting what comes up be where and what it is. That is what being with our experience is. And then we are able to function appropriately on the physical plane. We hear all that comes up. "I hate that person. I am angry with that person." Let whatever comes up come up. Be with it. You are perfect just the way you are. But then we need to be appropriate. Do not share it all; do not dump it. We can open our mouths and say whatever there is, but if it is inappropriate, the next thing out of our mouths had better be "I am so sorry. Look what just came out of my mouth. It is hurtful. Sorry."

Functioning appropriately on the physical plane is the hard part of this process. If you say whatever comes up, then do not expect everyone to put up with you and take it. They can say you are perfect just the way you are. I am also perfect the way I am. So I now choose not to participate in your

play. I withdraw happily. If you do this, someone might say to you, "It is not nice to withdraw." You can respond, "I am okay with it. I am not nice; you already said that. Now I confirm it. No excuses. I am willing to be where I am." Don't just say, "That is my shrunken self." No, it is you. It is where you are, and it is okay. Let yourself be where you are. Just accept it. You might say, "But I do not like that experience." No, stop the fight. Be with it. Accept it. You are perfect just the way you are. Do not run.

Do not pretend to be somewhere other than where you are. That is what others are saying when they use the phrase "perfect the way you are." They do not mean it on the level of living; they mean it only on the level of the abstract. So we cannot really be ourselves and go through what we need to. We are not personal, we are abstracts, so we never really can connect in the best sense of the word. We have to remain superficial because we cannot accept that where we are is okay, is perfect. If we remain as an intellectual idea, we are then "all perfect just the way we are." Reality will never touch us or our relations with others.

We then end up being the only people with problems, because we cannot empathize with anyone. If I can be where I am truly and accept it, then I can understand where you are and accept where you are. If I am all about me, then I am not accepting. I am wallowing and complaining. I am then not perfect the way I am because I am not happy with where I am. But if I can accept it as no big deal, that this is what I have today, then I am perfect the way I am.

I am perfect just the way I am and so are you. Accept it. So wherever I am, I am going to feel it. I am perfect feeling misery, sadness, anger, happiness, hurt, agitation. I am going to bore in. I am going to be with it. I am perfect. The perfection does not change; the experience changes. The experience is not us; experience is a vibration. When we accept ourselves for where we are in the moment—no excuses, no complaints—the experience changes and the vibrations still. I have not changed; my

experience has. We then have distance from something that is not us. This distance comes from accepting all the knowables. Vibrations are knowables. Experiences are knowables, not who we are, just possibly how we are. I am okay with what I have. I am perfect just the way I am. And so are you.

Stop Repackaging the Practice....

Be with your experience. This does not mean "in it." This means "let it happen." Always did. When I first wrote down the practice Baba taught me in *A Spiritual Survival Kit*, it was 1992. The truth is the truth and it has not changed. Be with your experience, whatever it is. This is so important. We are not to pretend something else; we are not to deny our experience. There is no need to judge your vibration. It is what it is and the only way to freedom is to accept that experience.

Let whatever comes up come up. Emotions come up as vibrations from the Heart. They are not who we are; emotions are enlivened by us. We should be with them—not attach to them—and let them subside into stillness. Instead, we tend to attach letters to them, identify with them, judge them, and let them make the rest of our vehicles vibrate. We value them. Then we are lost in them. Because we enliven a vehicle, if we have not transcended it, we are attached to it and then consciousness thinks we are it. We are then deluded, and we believe we are what we enliven. Emotions are enlivened by us; that is the truth.

Wrong understanding is that the emotions come up within us as us. The belief is that if they come up within us, they are part of us. They are us. We then decide which emotions are acceptable and which are not. We decide whether we are good or not. We are then lost. Another wrong understanding is that emotions are caused by outside forces. First, emotions are outside who we are in truth. Second, the most the outside does is serve as a trigger for our emotions. If we are clear, then when the trigger occurs, we will not vibrate the emotion.

Function appropriately on the physical plane. This means for us to act with integrity, without causing trouble inappropriately. We are serving the situation and truth in a manner that creates harmony rather than disruption. Don't splatter on anyone. Don't scream at people inappropriately, verbally or non-verbally. Don't vibe. If we are vibing, we are not practicing. Don't stifle it, bury it, or package it. Hold on to nothing. Accept and let pass. None of it is us. So relax and let go.

There is not a fourth step! Yet most people automatically add and repackage the practice with a fourth step. This step, which should not be there, is packaging, abstracting, figuring out, rationalizing, processing, finding causes, and mitigating.

Please stop defending your shrunken self. We go nowhere when we pursue this fourth step. A decision is not the solution. We cannot decide our way to God. The shrunken self as the decider will make sure it is the center of attention so we do not ever resolve anything. We leave practice completely when we move to this action of the shrunken self. The decider will decide the wrong action. If we package or figure out, we are vibing. Here, the decider is the Absolute in our minds. It is definitive, loud, solid, direct, sure, and WRONG.

The shrunken self needs to be receptive in order to surrender—to merge with God. The shrunken self has to become fluid, and that happens when we are willing to be with our experience, let whatever comes up come up, and function efficiently on the physical plane. When you honestly just be and do not repackage the practice into something your shrunken self wants you to do in order to keep it alive, then you are actually practicing, and there is no place or corner for the individual to mislead you from our goal of returning home to God.

Practicing for the Right Reasons....

Are you practicing? No one has to know except you. Practice is done inside of you. What does it mean to practice? Being in the Heart. Staying in the Heart. Not straying. What do you do when going into the Heart is painful? You face the pain and burn it up. How do you burn up the pain? You burn up pain by being with your experience no matter what it is, letting whatever comes up come up no matter what the thought, and functioning appropriately on the physical plane. The pain will eventually dissolve. If you do not do this, you get to keep the pain forever. How do you get to the sweet bliss in the Heart? You get to the Heart by burning up all obstacles that prevent you from being you.

Why are you practicing? Okay, really: why are you practicing? Do you want Love or power? If you want to be really powerful, then you have to give up yourself. If you want Love, then you have to give up yourself. Our shrunken self cannot meet God. We have to leave in order for God to come.

If you think you can maintain yourself and be powerful, then you have no understanding. The only power you can have this way is petty and will disappear with one move. In order to have this shrunken power without Love, you have to have no core. Without a core, you will merely resonate with everyone else's emotions and think you know both other people and yourself. If the goal of your practice is anything other than God and Love, then hopefully somewhere down the road you will see the error and make the proper correction.

How are you practicing? Good question. Are you surrendering to God in the truest sense, or are you surrendering to a nice idea you have manufactured and cultivated? As you practice, do you react and resonate to the world around you? If you do, then the outside is definitely in control and the world dictates your actions.

When are you practicing? Where are you practicing? Do you only practice in a prescribed place and time? Or do you practice all the time, in all places? When we are working intently, we need a place where the environment is conducive to turning inward. We need this especially at the beginning, because distractions take us off our purpose very easily. Gradually, we venture out into the world and practice no matter where we are or what we are doing. No one has to know we are practicing. If they are astute and also inwardly conscious, they may be aware, but because the practice is internal, unless you know, you will not know. So practice is to be done at all times and in all places.

Practicing all the time in all places, constantly redirecting our attention from the head into the Heart to draw nearer to God, will change our relationship with the world. We will have the distance to assess and then respond appropriately rather than reacting and resonating. Resonating with and reacting to the world cause misery for us and those around us. When we resonate, we delude ourselves that we see clearly, but we are drowning in whatever feeling we are sharing with others. We may believe we are loving and sensitive when in fact we are unctuous or sentimental.

Do you want Love? Then practice.

I'm All for Nondualism....

We have to die. Who has to die? The one that never existed. This seems unclear, but from the standpoint of the Self, it totally makes sense. As long as the shrunken self believes it exists, we are living a dualistic life, separate from God. Nondualism does not occur except in philosophy and theology class until we actually remove our ignorance of attachment from the shrunken self. Then and only then can we express one voice, *the* one voice. We play at being connected to God, but real connection does not and will not happen until we give up our wrong understanding.

According to Henry Suso, "When the soul, forgetting itself, dwells in
that radiant darkness, it loses all its faculties and all its qualities, as St.
Bernard has said. And this, more or less completely, according to whether
the soul—whether in the body or out of the body—is more or less united
to God. This forgetfulness of self is, in a measure, a transformation in
God; who then becomes, in a certain manner, all things for the soul, as
Scripture saith. In the rapture the soul disappears, but not yet entirely. It
acquires, it is true, certain qualities of divinity, but does not naturally
become divine. ... To speak in the common language, the soul is rapt, by
the divine power of resplendent Being, above its natural faculties, into the
nakedness of Nothing" (Underhill, *Mysticism*).

All of us have to begin our walk home as dualists, but, like Plotinus,
we eventually arrive at the place of Unity: "[H]e is become the Unity,
nothing within him or without inducing any diversity; no movement now,
no passion, no outlooking desire, once this ascent is achieved; reasoning is
in abeyance and all Intellection and even, to dare the word, the very self:
caught away, filled with God, he has in perfect stillness attained isolation;
all the being calmed, he turns neither to this side nor to that, not even
inwards to himself; utterly resting he has become very rest" (*Enneads* 9.11,
transl. Stephen MacKenna).

As we move toward Unity, we become purer expressions of Love.
When people who have not practiced at all say that going within is selfish
and neglectful of others, they reveal their ignorance. When we go into the
Heart, we can finally care about others and love in a way that is not
self-centered. As we can see with Suso and Plotinus and Swami
Muktananda, being in the Heart brought them out of themselves and into
God. The individual no longer was in the way. There was no chance of
selfishness because All was All.

So in dualist *sadhana*, one voice has to die. Which one? We practice by
disentangling from *prakrti*, only to find that the one who has been

practicing is also *prakrti* and must in the end be let go of. The Heart is the cave—that still, luminously dark cave where All is. We are there, and we meet each other and ourselves as one there. There is no other purpose but this. Let go of all that is temporary and we put everything in order; all becomes clear. We are none of our vehicles, our instruments. We have an individual manifestation so that we can participate and act in the world. The only thing wrong is that we think this individual is us.

Only when we let go of all our vehicles can we be in the place of Love.

Talking, Doing, Being….

Idealists are idealized, and there is little people will say against them. We tend not to argue with them; most of the time they are right. Other names for idealists are visionaries, idea people, intellectuals, and talkers. Many of these people believe talking and sharing ideas is at a higher level than doing, and think their job is done when they have expressed their ideas. When this is the case, idealists need others to put their ideas into action.

Doers: these are the people who are vital and yet in many ways invisible. These people of action are seen as lesser than the idealists; yet without them ideas do not manifest. Doers tend to rely on visionaries to guide their activity. But without discernment, they may follow the wrong ideas and the wrong idealist. The discerning doer will see clearly and bring into action the ideas of a clear and appropriate thinker. The inert actor will act blindly, motivated by ignorance. The passionate actor will just act, and his actions will be dark or clear according to his internal state at the moment.

Some people have within them the ability to use both the power to think and the power to act. If they know their own capacities, they can function well on the physical plane. But there is another level of action, and it is only available to people who have mastered and are no longer attached to any of their abilities. These people appreciate and know their own

capacity for both word and deed, but they are not identified with those skills. These people live in the center of Being, where all else is a vehicle enlivened by Being. So whether they are thinking, talking, or acting, they are first being, and everything evolves consciously from being.

This is not an idea; this is a reality. This is actual living in the Center of Being. We can go there, live there, and act and function from there. In order to do this, we have to examine all our ideas and discern which are valid and which are just nice ideas. We have to face where we are—not as a concept, but as a reality. There can be no mixing Absolute Truth with relative reality. If we all lived in Absolute Reality and imbibed that Truth, then there would be no need to journey home. There would be no need for this book. There would be no need to practice.

The reality is that we inhabit relative reality to learn what we each need to learn. Each of us has a different path in life because we have different lessons to learn. Once we face this truth within ourselves and accept it, along with all the pain of having been out of alignment, we can then actually do the work of going Home to who we truly are. Again, only if this is more than a great idea will it lead us into action to go Home. The action is not easy. It is not fun much of the time. It forces us to see the horror of what we have done and what we do. This action also brings us to love and joy. There is so much relief when we surrender to reality and Reality.

What do you then think and do in order to be? Right now, redirect your attention into the center of your chest; doing this will lead you inward to the Heart. Then keep your attention there and dig in, going deeper and mining what you find there. Mining means actually facing, and owning, mastering, and transcending what comes up from the Heart. You actually have to burn and dissolve all that has cloaked your Love and covered who you are. You will then be centered in who you are, not who you thought you were. These are not concepts; they are actually practices, real actions. We do them in order to BE.

Internal Only….

"Exoteric" and "esoteric" are two words I rarely if ever use. They basically split everything into external and internal. While in the UK recently, I met with a dear friend from the ashram. He said that Baba taught both exoteric and esoteric practice, and that most people went to the ashram for exoteric practice, thinking and believing it was esoteric. My friend knew I had not gone to Baba for anything exoteric because I had already been immersed in the external and knew its limitations.

As I have been focusing on making sure everyone who studies with me understands the internal practice that Baba taught, I have been wondering why more people do not practice it.

At the ashram, many people believed that *shaktipat* was the esoteric, internal practice; they thought that once they got *shaktipat*, then as long as they did the outside dharma of chanting and meditating and selfless service, everything would move along internally. I knew this was not the case from my practice of Tai Chi Chuan. No matter how much I practiced the form, even after my *kundalini* was awakened, when I stopped and did something else as simple as eating, walking, or anything in ordinary life, all was lost.

Baba appeared in my life because I was looking for someone who could teach me how to have that inner experience all the time, not just when I was doing an external ritual or practice. Baba was and is a realized being who gave people the experience of Witness Consciousness. I knew in my heart of hearts that he could teach me the practice that would allow me to be who I truly am all the time, not just in glimpses. So I gave up everything that did not matter to follow him.

Baba knew what I wanted, and I was emphatic that I was going to learn from him, that he was going to teach me. From the outside, I must have appeared arrogant and pushy, but I never cared. I was on a mission. I knew Baba had what I wanted, and I was going to make him give it to me. Aggressive, persistent, and one-pointed. Friends and lifestyle were not my

goals; the practice, devoid of anything external, of trappings of any kind, was what I longed for.

Baba was full of Love and gave each of us what we wanted. His kindness to me through all the years as I had to strip away the trappings of emotion, personality, and ideas showed me the level of compassion he had for each of us.

Now, so many years since that day my Guru, who gave me what I wanted, left his body, I wonder why so many are so focused on the exoteric. Baba used to call me naïve, and he was so right. I thought everyone wanted what I wanted, that everyone knew the esoteric practice he so willingly taught. I realize now that people got distracted by the outside practices.

My manner of teaching is not popular. I am extremely boring in that I keep pointing to the Heart. I drive into all my students the practice of attention, of the will directed into the Heart. Boring into the Heart and resting there: the gift Baba gave us. So many people think they are in the Heart—but thinking they are in the Heart doesn't make it so. I realize now that most people practice being in the Heart in their heads. In other words, practice for most is just a really nice idea.

No—the internal practice uses the will, not the head, not ideas. The esoteric practice is literal. The Heart is actual. God is Real. God is. In order to know that, then rather than just believe it, we have to practice the internal practice that every tradition has at its core: the practice that Muktananda offered to all of us.

Reaching the Third Level....

The third level of practice, which is called *shambhavopaya* (path of Shiva) in the tradition of Kashmir Shaivism, uses the will. All traditions teach this practice, in which we rest in the Heart by a well-directed will. Obviously, this is not easy; it requires discipline and complete surrender to God, Self, the Absolute.

Yoga Sutras 3.17 says that through intense concentration, meditation, and absorption, we can and will separate the name of an object, the idea of the object, and the object itself, which are normally merged in our consciousness, and be able to understand what lies beneath all utterances. Many people do not realize that there are distinctions between these three. When they say the word "Heart" and imagine Heart, they believe they have gotten to or are in the actual Heart. This is a major problem for most people pursuing spiritual practice; they believe that if they think it, then it is real.

This is idealism at its most negative. Idealism should be a signpost that leads us first to the belief that what we want exists and then to the conviction that what we want is real and attainable. If we have separated these three different understandings, we will be able to go from the word to the idea to the actuality.

Scripture says if we call something or someone's name, we will get what we call. So people of all sorts, from the traditionally religious to the New Age, call on God and anything else, downwards to the most superficial. They use mantra with emotional earnestness and probably wonder why nothing manifests for them. Such manifestation happens only after we experience the distinction of name, form, and idea, and have surrendered all that is not God.

We have to be free from identification with all that is not God, with all that is temporary. Then, when we call the name, we get both the idea and the object. Sages were said to have fought battles by calling weapons into manifestation.

If we want to go to the Heart and rest in the Heart, then we may start with the name and then go to an idea in our minds, but we have to give those two up and actually go to where the Heart is. Where is the Heart? Beyond the waking state, dream state, and deep sleep state. The Heart is where we "know" we are the witness of the three states.

What then should we do when we are unable to practice at this level?

When obstacles and past impressions show themselves to us in ways that distract us, we have to go back to practices and tools that are more obvious and can aid us to reestablish and maintain our foothold in the third level.

What are these practices and tools? Below is a list of some of these.

First Level tools and practices:

Rituals

Chanting

Breath

Environment—incense, cleanliness, listening to *sattvic* music and chanting

Healthy lifestyle—eating moderately and healthily, sleeping appropriately, exercising

Good company and community

Attending a place of group worship

Second Level tools and practices:

Study

Mantra and prayer

Remembering

Seeds

Fourchotomies

Reflection

When we use these tools and then get back on track, we can again redirect our will toward the Heart. We again actually practice, because we have returned to the path that takes us Home. We are able to distinguish our mental machinery from us and disentangle out of those vehicles with which we have been so identified.

Then we are no longer deluded by words or images in our minds; we are able to discern that we are redirecting our attention literally out of the head and into the Heart.

It's Not about the Packaging....

When I was growing up, in my house, gift-wrapping paper was not emphasized. The present was what mattered; how it was packaged was of little import. Though presents were wrapped, the paper was quickly torn and thrown away.

As I grew older, I learned to appreciate beautifully presented gifts. The packaging provided a certain excitement about what was to be uncovered. But what was under the paper was still more important. No matter how perfect the wrapping, if the inside did not fulfill something, there was disappointment.

As a cheerleader for the St. Louis Cardinals, I would wear bell-bottom jeans, and while demonstrating against the Vietnam War, I would wear a dress. Someone once said to me, "You cannot wear a dress to the demonstration." My response was that I did not know there was a dress code. I was testing the packaging, what was important and what really did not matter.

This was true for me as a dancer. I knew that, no matter how perfect my leotard and leg warmers were, if I could not live up to them as I danced, I looked ridiculous. When I had my school for Tai Chi Chuan in Cambridge, Massachusetts, I was interested in the form, Taoist texts, acupuncture, the *I Ching*, and the Chinese language. Only when I was publicly demonstrating the form did I wear the "uniform" of a martial artist; street clothes were my norm. My aesthetic was austere, with an appreciation of Zen, Shaker, and Bauhaus combined: nothing too much.

Meeting Baba was a shock to my sensibility. Bright colors, patterns, shapes, and designs; none of the packaging I appreciated. And yet Baba

gave me everything I was looking for inside. The packaging seemed all wrong. I have a terrible voice, so chanting was an important part of the daily activity. Movement mattered to me, so we sat a lot. The clothes were not at all conducive to being a martial artist. The outside was really hard to adjust to, but I knew Baba was my Guru.

My packaging was all wrong for the ashram, or so I thought. As a guard, I was outside much of the time. One day, a longtime ashramite told me Baba did not like girls with suntans. Nor did Baba like girls with short hair. I had both. There was clearly a conflict between what was going on outside and what was internal as I saw it.

Once, I did the form in a field where I thought no one could see me. The President of SYDA saw me and said it was beautiful. I said that I thought Baba would not like it because it was not part of the program there; he replied that Baba would never be against something so beautiful. I felt great relief and saw how much I was attached to my idea of the outer packaging. Maybe the ashramites wouldn't have approved, but the one who mattered, Baba, would have.

Baba tested me over and over again on this. The packaging does not matter if there is nothing underneath. When everyone was wearing saris, Baba had me wear suits. When everyone was wearing their fanciest saris, Baba gave me a white cotton one to wear. He kept stripping away all my ideas of the way things should look, even when I was sure I did not have these ideas. Baba was never about his packaging; he was not the package. This gave Baba immense spontaneity, a freedom to be appropriate to every situation because there were no rigid ideas about how things had to be. The package always served Baba, not the other way around.

There is nothing wrong with packaging. We all have some form of it. Mine tends to be minimal, which is still packaging of a sort. Still, I love Evensong at King's College Chapel, Cambridge. It may not be my style, but I can appreciate it and it is beautiful. There is something underneath.

So if you take away the packaging, there had better be something of real value underneath. If it is only really nice packaging with no real gift, we will be really disappointed when we tear away the paper.

Knowing the Road....

The reason I started down this path was that I had to. I knew that what I wanted to know was there, wherever "there" was. What did I want? Happiness and peace. Knowing the Truth, the bottom line of life, I knew would give me lasting peace and joy.

Thus began my treasure hunt. From science back to my first love of dance. From dance to Tai Chi Chuan. From Tai Chi Chuan to the five excellences. From the five excellences to Swami Muktananda. The truth is, the search was more about the teacher than the activity. The outer activity was only the occasion for the teacher to drive me further toward my goal.

Annelise Mertz used dance to bring me to the freedom of *vitarka samadhi*. For her we were not dancing unless we had discipline and were in the zone—conscious, clear, and without thought of any kind.

T. R. Chung demanded that we surrender to what was beyond the form of Tai Chi. In Tai Chi, "internal practice" did not mean being inside the body; it meant letting go of the body and moving the *chi*. The body was required to be disciplined, but this was not the goal. It was not the body that provided the force, but the energy within and beyond that moved everything.

Though I loved both of these expressions, neither Mertz nor Chung could give me what I was looking for. Frank Pierce Jones further supported my direction, as did Dr. James Tin Yau So, my acupuncture teacher. They all willingly gave what they had to offer, but I was not satisfied.

I was having powerful experiences but did not understand them; nor did I have a good context to put my mind at ease. It was then that I

encountered Swami Muktananda. He was the Teacher. He knew the answer to my question, and he could show me how to get there.

It is now forty-six years since I started consciously walking this path. Muktananda left his body in 1982. Since that time I have been working to embody what he taught me.

What did he teach me?

He did not teach me that the goal of *sadhana* is a happy shrunken self that has supernormal experiences.

He did not teach me to remain limited and to be okay with that.

He did not teach me to then limit God so I could contain and understand Him in my shrunken idea of myself.

He did not teach that the Witness is the rudimentary awareness of my emotional and thought constructs. I did not take nearly fifty years to achieve an ordinary sense of objectivity.

Baba spoke of the Witness in the *turiya* state.

He spoke of the Self in the Heart beyond the waking, dream, and deep sleep states.

He taught that the Witness is the witness of the three states because It resides in the fourth state, outside the other three.

He taught that God is in fact everywhere at all times.

He awakened people's spiritual energy, known as *kundalini*. Once someone is awakened, divine Grace will assist them if they put forth the right effort with determination and devotion.

If you have a *kundalini* awakening but no experience of the Witness, then you will believe your experiences belong to the shrunken self. Every experience then only feeds and expands the shrunken self, which thinks it owns everything.

The goal is not to have supernormal experiences and an expanded idea of who I think I am. If that were the goal, then I could just take hallucinogens.

The goal is not to think of myself as a good person. It is not to like myself as I construct myself to be.

The goal is not to feel powerful. People want to prove that they are more powerful than anyone else. They want to be beyond anyone else's control, including God's. This is just idolatry.

The goal is to experience that God is within you as you, wherever you go. To experience at every moment that you are not the doer, that God is the doer, that God is All—not as a concept, but as Reality.

To arrive here, you must give up your identification with who you think you are, with all the thought constructs that make up "you."

This *sadhana* is active, not passive. If you want misery, just remain passive. If you want bliss, give up your pain, along with your pride in your pain. The spiritual warrior kills his own misery and comes out triumphant by surrendering and going to God.

All my prior teachers paved the way for Baba. He then taught me this. And this is what I teach.

Perfect....

All my years with Baba taught me to be true to my Self. The way to get there is to accept where we are now. And now. And now. That means giving up judgment, now. So many people say, "I am perfect just the way I am." Yes, you are correct. You are perfect as a mean, kind, honest, insincere person.

We are perfect, and our shrunken selves are also "perfect." But we need to assess them as they really are. "I am a good person" is a belief, and granted, I sometimes or many times do good actions; but I am not good all the time. Also, not everyone will assess my "good" actions as good. So who

I am is not "good." Then I must be "bad." But I do not always do "bad" deeds. So who I am cannot be "bad" either. So who is perfect, and what does perfect mean?

Here we need to be careful. My idea of myself is perfect for the part I am playing in the cosmic play, but I do not like the story and its actions all the time. I have to accept that perfect is perfect because life simply is.

Om poornamadah poornamidam

Poornaat poorna-mudachyate

Poornasya poorna-maadaaya

Poorna-mevaa-va-shishyate

Om. That is perfect. This is perfect. From the perfect springs the perfect. If from the perfect the perfect is taken, the perfect remains.

Absolute Reality and relative reality are both perfect, but when we live in relative reality, it does not appear perfect because of our limited understanding. From the standpoint of Absolute Reality, everything actually is all perfect. All.

We live in relative reality as long as we have temporal vehicles. We are perfect; we just don't know it consciously. We may know it intellectually. We may think this perfection with various phrases and sayings. We may even believe that everything is perfect. But until we have given up our attachment to our ideas of ourselves, no matter what those ideas are, and have surrendered our individuality to the Absolute, we will not have a chance of consciously knowing our perfection.

Perfect	Imperfect
Static	Dynamic

In order to uncover our perfection as Reality, we have to start where we are. If I believe I am perfect and you are not, then I am not where I say I am. To get to "everything is perfect," I have to know how I am. I have to assess all my qualities and actions and call them what they are. Hence the fourchotomy. It is a great way to uncover all the aspects of my perfection. I am perfect and okay. I am static and okay. I am imperfect and okay. I am dynamic and okay. As we accept our placement moment to moment, we will see that what we thought was us is always changing. What we are identified with is not the Self but the ever-changing story we have created.

So, as we start practicing, we begin to see that we are not happy, but we are perfect. How can I get to perfection as Love? To Absolute perfection even while living in this body and functioning in relative reality? By accepting the box I have created and called "me" and accepting that it makes choices based on its survival and not God's will. Until we reach this acceptance, we are out of alignment with the Truth.

Sadhana begins with acceptance. Be with your experience, whatever it is. Let whatever comes up come up. And function appropriately.

What Unity Means….

We are all the philosophies and all the religions.

We are all Muslim. We are all Sunni. We are all Shia.

We are all Christian. We are all Orthodox Christian. We are all Roman Catholic. Baptist. Methodist. Episcopalian. Presbyterian. Lutheran. Congregationalist. Unitarian. Mormon. Adventist.

We are all Jews. Reformed. Conservative. Reconstructionist. Orthodox. Hasidic.

We are all Taoist. We are all Buddhist and all the sects of Buddhism. We are all Shinto.

We are all the traditions that fall under the name of Hinduism. We are all Jain. We are all Sikh. We are all Zoroastrian. We are all Santería. We are all animist. To name a few of the many.

We are all nationalities and geographic origins. American. European. African. Asian. Australian. Islander. Israeli. Palestinian. Serbian. Croatian. Bosnian. Cuban. Irish. Canadian. To name a few of the many.

We are all ethnic groups. We are all races. Unfortunately, we race for superiority. And that is the joke.

What truly makes us special is the Heart, where we are all the same. We are all equal in Absolute Reality. In our ignorance, we cling to relative reality in order to be special.

Baba used to tell us the story of the Lords' Club. He would tell us this story over and over.

The only people who could be in this club were lords. And yet, in order to run the club, people had to do different jobs. So someone had to be the doorman, someone had to be the president, someone had to be the cook, someone had to be the janitor. But all the members were lords. So what they would do is draw lots by week for positions. So each week somebody else was the cook, somebody else was the president, somebody else was the janitor, somebody else performed whatever role.

And nobody treated anybody differently; everyone was treated with respect, because everybody was a lord, and everybody knew that everybody was a lord.

And in Truth, that's what we are. We are the Lords' Club. Everyone is a lord. Everyone: no matter who they are, no matter where they live, no matter what the color of their skin, no matter what nationality, no matter what socioeconomic status, is a lord.

And yet we do not treat each other with that respect. And we're all determined to climb up some ridiculous ladder of power and control. None

of us gets to Love as long as we do that. Only by surrendering to God and resting in the Heart, where we're all equal, do we know Love.

I want us to work to let go of all that keeps us different and special. This doesn't mean we then change the color of our skin or adopt different nationalities so we can all be the same. No: we don't pretend we're all the same. We all know we're all different. But our job is not to be attached and identified with difference of any kind.

So we all play our various parts. That's important. But we're not to be attached to our part, not be identified with any aspect of it and say, "This is what makes me, me." It doesn't.

I want us all to work to still, and to liberate ourselves from the false identities that keep us from contributing Love, living in Bliss, and knowing the Real.

Walking Bliss....

Lokananda samadhi sukkam. The Bliss of the world is the Bliss of *samadhi. Sahaj samadhi:* walking Bliss. This is why I went to Swami Muktananda. Baba had imbibed and lived this understanding, and I wanted to learn and imbibe it from him. Prior to meeting Baba, I had known very powerful energy experiences. I had seen lights and colors, heard sounds, felt the power of the *chi* charging through my body and out of my hands. So when I met Baba, the powerful experiences people had from being around him didn't impress me. Powerful experiences were not what I was looking for. I wanted to be the Truth and live it 24/7.

I knew *nirvikalpa samadhi*; it was being in "the zone." That is not what I was looking for. I knew *nirvichara samadhi*, where my mind grasped higher abstractions without thought. That is not what I was looking for. I knew *ananda samadhi*, when I was completely absorbed in Bliss. I was not looking for that, either. I wanted *asmita samadhi*, where I would be pure I-awareness, and then *nirbija samadhi*, where "Rohini" would dissolve and only the Self of

All would remain. In that state, "Rohini" would be enlivened as needed. Baba knew and lived there. Baba taught me the practice of returning Home, and what I teach now is what Baba showed me. He was constantly directing me away from identification with the individual.

Spiritual experiences, like any other experiences, are not who we are, and we should not identify with them.

Baba always said,

Meditate on your Self,

Worship your Self,

Kneel to your Self,

Honor your Self,

God dwells within you as you.

Baba was not speaking about the shrunken self as the Self. That distinction was obvious. What has to happen is that the shrunken self must be surrendered, so that we can re-cognize the Self that, as Baba made clear, is our true nature.

There is a Sufi story in which the Sufi laments that whenever he is present, God is not, and when God is present, the Sufi is not. The Sufi says, "No matter how much I beg and plead, God always says, 'It is either you or Me'." This understanding is so vital. The individual will never become enlightened; the individual is not who we truly are.

The practice Baba taught me is *sahaj samadhi*: looking into the Heart and out at the world simultaneously. It is purely internal. We bore into our center, always moving toward the Heart. This is to be practiced all the time, not just when sitting. This is a practice that removes our attachments, grinds down our wrong understanding, and moves us to truly knowing who we are. As I always say, be with your experience, let whatever comes up come up, and function appropriately on the physical plane. This is how we dig

down through the shrunken self and let it go. This is how we keep learning we are the Knower and not the knowing or the known. We let go and redirect our attention into the Heart. Eventually, we rest in the Heart and look out at the world. In Kashmir Shaivism, this resting in the Heart is termed *shambhavopaya*. In the Christian tradition, it has been called the third level of attention and prayer.

By Heart, I do not mean the physical heart, or the subtle heart of thoughts and emotions, or the heart of the causal body where we experience deep sleep. This Heart is beyond the waking state, the dream state, and the deep sleep state. This Heart is the Witness of those three states. The Heart is in the fourth body, the supracausal body. It is the *turiya* state, the fourth state, the state beyond all mutability. The Heart is far beyond where the individual resides. Here, there are no emotions, thoughts, or any of the vehicles needed in the waking, dream, or deep sleep state. Here, there is only the Self, only God.

My writing has been pushing us in our practice, emphasizing what must be given up if we are to continue to work deeper and deeper toward the Heart. I have written about self-hate; remember that the root of that self-loathing, whatever other forms it may adopt, is our inescapable memory of our Real nature. We remember our True Self in spite of the fact that we now wrongly believe we are its vehicles, especially its faculty of knowing. This is our first wrong understanding: we misidentify the Knower as the mechanism of knowing.

The faculty of knowing takes ownership of all our experiences, including our spiritual ones. It is enlivened by the Knower, but because the Knower's subjectivity is now infused into it, the faculty of knowing believes it is alive and conscious. Metaphorically speaking, the moon thinks it is self-illuminative, when it is in truth only illumined by the Sun. The Self illumines the faculty of knowing. The faculty of knowing is the habitat of the shrunken self.

In that light, ordinary human existence is a kind of slumber. When the scriptures say "wake up" and "Great Beings never sleep," it is not that they do not rest their bodies and go to sleep. It means that they are awake in the waking state, awake in the dream state, and awake in the deep sleep state. These Great Beings dwell in the Heart, where they are always awake, and witness the life of the individual. These beings are all-knowing because they know who they are in Reality, and are no longer attached and identified with their individuality. This is what Baba taught, as have all the great teachers and scriptures of the world.

The final freedom from the merely individual happens when we surrender our faculty of knowing to the Self of All. We have then disentangled from all our vehicles and rest in our true nature. Until now, the faculty of knowing has been doing the spiritual practice. *Sadhana* is always done by the shrunken self: by purifying and stilling itself, it reaches a place where it is purely an object, and the Knower of all objects is the only subject. Then we no longer think we are the image in the mirror, taking the non-Self to be the Self. We are the Self, in the Garden of the Heart—as, in Truth, we have always been.

Recent Questions….

People have all kinds of ideas about what spiritual practice is and isn't, and even when they get an explanation, they interpret what they hear or read in all sorts of ways, most of which are off the mark. Here, I will be answering some questions that have recently arisen. If you read carefully, you might find your own questions cleared up.

Did Baba make clear in his teachings that liberation is not for the individual?

I can't recall any time when Baba taught otherwise. He always stressed that the individual cannot be liberated, and that the only way to liberation is

to give up our attachment to, and wrong identification with, any separate identity. In the end, the shrunken self must go: the one doing *sadhana* is not the One who endures. This was always very clear. If someone did not see it in Baba's teaching, that does not mean it wasn't there—it was everywhere. I specifically went to Baba because that was what he taught.

For me, the truth that all individuality, all separateness, must be let go—the reality that there is no such thing as a liberated individual—was always evident in Baba's teaching. Below are a few examples from his writings:

When the Shakti of the Self contracts, She is known as a limited individual, subject to innumerable births and deaths. She remains a transmigratory soul as long as She is contracted, but once She expands, She becomes Paramashiva. (Secret of the Siddhas)

Bondage and liberation exist only when there is division. The ideas of bondage, liberation, and so on, apply only to a person who, because of māyā, does not understand his true nature and is afraid. (Secret of the Siddhas)

"I can do nothing;

it is the universal Self who does all."

This is sublime teaching.

"I will accomplish this work;

I have already done it."

This is total ignorance and pride. (Reflections of the Self)

He regards this world not as matter

but as the embodiment of Consciousness.

For him there is no Maya, no body;

whatever exists is Shiva. (Reflections of the Self)

Many people around Baba never grasped this teaching. Most of them were not prepared for what Baba had to offer; that's why Baba used to say, "I give you what you want, so that someday you might want what I have to give." It has been an eye-opener for me that so few people got anywhere near the real teaching. I think it's true that many of the people who congregated around Baba were simply experience junkies. That's why all they have now is memories of experiences.

Perhaps I should stress that an intellectual grasp of non-duality is all very well, but to know and inhabit that Reality requires a long and arduous grinding down of the individual identity. This begins with knowing how that individual identity operates. There are plenty of spiritual seekers who believe they can advance toward liberation without doing that painstaking work. They get nowhere, except in their heads. The techniques that I present—other than the fourchotomy, which I created—are all time-honored internal practices that Baba taught. Whether you call it *shambhavopaya* or St. Symeon's third level of attention and prayer, constantly boring inward toward the Heart until consciousness rests there is the one crucial practice. It makes no difference where you are on the path; until you reach liberation, that is the practice that matters. It uses the will. If you are not doing this, nothing else you do is likely to get you anywhere.

How did Baba teach you the practice, and what do you mean by "boring in"?

It's important to realize that when I was alone with Baba by the back stair, he taught me wordlessly, through the Great Silence. It was never an intellectual exercise. From the moment I encountered Baba, I was determined to get what he had, and was going to study only with him. I wasn't interested in what anyone else in the ashram wanted to teach. Why sit in classes with "teachers" when I could learn from the Guru? How many people never understood that the only teaching worth knowing came from

Baba himself, and it was imbued in all its fullness? It was never, for me, intellectual learning. If a teacher's clarifications are intellectual, they will only give people an intellectual understanding of what Baba taught me silently and experientially.

"Boring in" is what Baba taught me by the back stair. It is the core of the practice, and it rests at the heart of all mystical traditions. You should take it almost literally—the only difference being that you're not using a drill; you're using the will to redirect consciousness back into the Heart, through all the bodies that serve as vehicles of the Self. As you practice, your understanding and experience will grow clearer and subtler. I describe this practice in *Walking Home with Baba*. It is simple, and very difficult. But it is the practice. Anything that doesn't center on this right effort of the will is off the point. Anyone who tells you that this isn't the highest practice has no real awareness of thousands of years of teaching and lineage and scripture, in all mystical traditions.

Can only tantric Gurus give shaktipat?

The notion that only tantric adepts can give *shaktipat* is misguided. They may be the only ones who call it *shaktipat*, but even a cursory reading of the Gospels and the saints' lives reveals that there have been living lineages of spiritual awakening in the Christian tradition, and the same histories can be found in almost any tradition. Sufis speak specifically of masters passing on awakening experiences, and what do you think is really going on in those Zen stories of masters hitting their students, who promptly become awakened? I give *shaktipat*, and I don't think of it as tantric; it is simply part of what Baba taught me.

Hopefully, these questions and answers will clarify the practice for you. As you continue on the path, the practice will unfold as it should.

From the Many to the One....

A few years ago in a coffee shop in Cambridge, England, I had a discussion on the nature of Reality with an Anglican priest. He had earned his doctorate from Oxford and appeared open to thinking outside Christianity. However, he believed that the individual always remains separate from God. For him, union with God was not an option; believing in it would be human presumption. The best we could hope for was moving from the image to the likeness of God but remaining distinct. As for me, I am aligned with some of the Christian and Indian mystics: if we surrender our individual identity, we return to our true identity in God. What the priest believed we maintain—our individuality—is exactly what I believe we have to give up. The priest and I ended up having to agree to disagree about where we were all heading. He was committed to dualism and I to non-dualism. The duel was a draw.

Recently, I had a similar discussion with someone who thought dualism in any form was delusive. This time I found myself on the other side, arguing for dualism having its place as a stage of *sadhana*.

Dualism and non-dualism are maps that express the path from God to manifestation. Depending on a person's temperament and capacity, one map will serve better at first than the other. Baba always said to first teach *shambavopaya*, and if the student was not ready, then step the practice back to where they are. We will all eventually reach non-dualism; when is another story.

People may even ask why I teach the *Yoga Sutras* of Patanjali, because it is a dualistic path. The map is actually very helpful in seeing our afflictions and the way beyond them. Where we end up is *kaivalya*, which is aloneness, or at-onement—for all intents and purposes, non-dualism.

The truth is, we live in relative reality, which is based on dualism. If we artificially superimpose Absolute Reality on the relative, we will be inappropriate at every turn. Even the *Shiva Sutras*, a great tantric text, speaks

of the nature of bondage, which is ignorance. There are three impurities (*malas*) in Kashmir Shaivism: I am imperfect (*anava mala*), I am separate (*mayiya mala*), and I am the doer (*karma mala*). These three *malas* cause us to believe we exist as limited individuals, when in Truth we are not shrunken but the Self of All, Perfect, One, the real doer.

Our ignorance causes us to believe everyone sees the world as we do. According to Kashmir Shaivism, each of us lives in a separate manifested reality (*prakṛti*). This *prakṛti* is designed specifically based on our past actions and what we need in order to reach liberation. In relative reality, we are limited and shrunken, obscured from the truth.

From the standpoint of Absolute Reality, there is only Subject with no object. There is only "sciousness"—not even consciousness, which implies duality—and we are Perfect, the Self, God.

In Absolute Reality, there is no dialogue. All is perfection; there is no conflict, because conflict requires an "other."

This brings me to another component of Kashmir Shaivism: the understanding of *bheda* to *bhedabheda* to *abheda*. Depending on where we are internally, we will see the world differently. At the start of the path, we see the world as *bheda*, the many. Everything is other, different. As we grow, we will be seeing the world as *bhedabheda*, One in the many. Finally, we know *abheda*, that there is only the One.

Nondual and dual. One and many. Universal and separate. God is nondual; we as individuals (*jiva*) are dual. Give up *jiva* and attachment to *jiva*, which is bondage, and we go from *bheda* to *abheda*. *Abheda* has to be our bottom line; we just do not know it. If we were not That, then we could not realize That. We are already there, and we are not.

In 1975, I was living in Cambridge, Massachusetts. I had received a letter from Baba's organization the day before. It included a quote from Baba: "God forgets his own true nature and looks for God. God worships

God. God meditates on God, and God is trying to find God. It is God who questions and God who answers." When I read this, it detonated something in me. I was struck. The quote stayed with me for the rest of that day. The next day, I walked down by the Charles River, near where I lived. Looking out at the water, I felt the Reality of Baba's words become clear. I experienced the Joke of it all, and laughed nonstop for several hours. It all made sense. There is only God. *Abheda*. Non-dualism. Pure Bliss.

I did come back to normal consciousness, to the world of *bheda* (difference). But the imprint of *abheda* was always underneath *bhedabedha*. I knew that my direction, and all of our direction, is to *abheda* (non-difference). We live in relative reality and must function appropriately in this arena. All our vehicles are a part of this reality. There is a big difference between knowing in the Heart who we are because we reside in and are Being, and intellectually knowing the truth as an idea that we strongly believe. In Truth, we are Absolute Reality, but until we know this at all times and in all places and we are truly *abheda*, let us not pretend. We are in this world of relative reality, and we are accountable to it.

Living Sadhana....

You can't think your *sadhana*. And yet that is exactly what so many people do. They think good thoughts and believe that is *sadhana*. They wear "pure" clothes and eat "pure" food and act "purely." They "believe" they are doing everything to succeed in *sadhana*. They are in fact going about it all wrong because they are approaching practice as if the goal is a worldly one. They are following the path of worldly success to reach God.

In Vedanta, the longing for God is a requirement. We cannot truly pursue *sadhana* without that longing; it has to have been earned at some point. So it is both a requirement and an earned trait. Longing for God has nothing to do with what we call worldly success. The approach to God is not like anything in the world. Longing for God and the journey to God

require the aspirant to surrender his attachment to the world even as he is in the world. The shrunken self has to be let go of. We must give up our identification with the individual and individual success. God is the doer.

Even people who want to help others have to practice this nonattachment. As the theologian Jürgen Moltmann says in his essay "The Theology of Mystical Experience," "Anyone who wants to fill up his own hollowness by helping other people will only spread that very same hollowness. Why? Because people are far less influenced by what another person says and does than the activist would like to believe; they are influenced by the other person's own being, by what he is. Only the person who has found his own self can give of his own self." And the only way to find the Self is to be willing to surrender the self.

In *sadhana*, there is no private or public; there is only authenticity. And authenticity is about being, not merely thinking. If we oscillate between private and public in the way we act without remaining inwardly centered and discerning what is appropriate, then we are just moving around in the room of our mind, and thinking where we are rather than being where we are. Our individuality then works to separate us; we struggle within ourselves over being good or bad. We decide what we are and what we do. Until we get off this playing field, we are just thinking our *sadhana*.

In the same essay, Moltmann describes the consequences of thinking spiritual practice without living it. "In societies which force men and women into active life, and only reward achievement and success, meditation…counts as being superseded, useless and superfluous. That is understandable enough. What is not understandable is when meditation exercises are recommended to nervy activists and worn-out managers, on the grounds that they provide a useful kind of counterbalancing sport, which will help them to recover their mental equilibrium; or when yoga techniques are sold as a means of increasing performance. Pragmatic and utilitarian marketing means the final destruction of meditation. It does not

let people find peace, and even if they find peace they do not find themselves in the process." When we think our *sadhana* without living it, we turn it into a kind of accessory to the mental life of the shrunken self, which isn't really internal at all.

Since anyone reading this probably has a physical body, chances are we all live in relative reality. Anyone reading this will also have a subtle body, because that is where the mind resides. We can delude ourselves all we want, but the more we pretend, the further we are away from *sadhana* and the purpose for which we say we pursue *sadhana*. If we really are longing for God, then we should be doing everything to let go of anything that is in the way. The doing is not about attaining God; God already is. The doing is the shrunken self, the individual, working to "know" itself. Once it truly faces and knows itself, it unwittingly has dismantled itself. It dissolves in the brilliant light of honesty.

So, as we move from *tamas*—delusion and hiding the truth—through *rajas*—pain and agitation—to *sattva*—serenity and the Truth—we accept what the individual actually is: a vehicle for the true Self. We then are no longer thinking *sadhana* but living it, being it. We then move from intellectually knowing the truth to experientially Knowing the Truth. We move from delusion, to the pain of what is, to accepting the light of it all.

Emotional pain is a good thing, in that it tells us we are not accepting reality or Reality. Pain is a way to distinguish between when we *think* acceptance and when we actually accept. If we have fully accepted something, we will no longer be pained by it. When we actually accept, the pain dissolves. If instead of truly accepting something, we only think we are accepting it, we will feel pain, because we are still attached. If we feel pain, we are *rajasic*, and are not reconciled to the truth even if we "know" the truth. Or we may not believe or want to see the truth, in which case we are *tamasic*. Not until we own, master, and transcend—not until we move from *tamas* to *rajas* to *sattva*—do we move from thinking *sadhana* to living *sadhana*.

Remember: thinking *sadhana* keeps everything pristine and nice. Living *sadhana* is not either. *Sadhana* can have those qualities, but that means it also encompasses the impure and unkind. Not until we embrace and know the individual self we are working with can we get rid of it. In the world, we put our best foot forward in heading for success. In *sadhana*, there is no best foot or worst foot. We have to just BE.

Ultimately, truly living our *sadhana* means going within and beyond all that keeps us from God. Hugh of St. Victor expresses it beautifully: "To ascend to God, that means to enter into the self, and not to enter into the self solely, but to go beyond it in one's innermost being in a way that is inexpressible. He therefore who enters with supreme inwardness into himself, who passes through himself in his innermost being and who rises above himself—he in very truth ascends to God."

Shakti and Wisdom....

Everybody loves energy. It is everywhere, and manifests in countless ways. Without energy, there is no life. In my tradition, the term for energy is *shakti*; the *shakti* is God's power of manifestation. Spiritual energy is latent, asleep, in each of us. And the term for that spiritual energy is *kundalini-shakti*. In order to return home to who we really are, we must have our *kundalini* awakened and then fully unfolded; this cannot be done without real understanding and committed practice. Baba used to say that the bird to paradise flies with two wings: self-effort and divine grace. It can also be said that the bird to paradise has the two wings of *shakti* and wisdom. You can't fly with just one wing.

The *shakti* is consciousness manifesting as energy. It is all-knowing. But we aren't. The *shakti* is wise; we are stupid. One of the most common and damaging mistakes a spiritual aspirant can make is to believe that the *shakti* will take care of everything, and it isn't necessary to cultivate wisdom. That way, we believe we are freed of responsibility for our own spiritual

condition. From all my years with Baba, I can say with certainty that such a belief couldn't be further from the truth.

Shaktipat—the "descent of power" that constitutes awakening—can be an overwhelming and ecstatic experience. Still, it is only a glimpse of where we are heading; it is an invitation to undertake the journey. It is like receiving a picture postcard of a destination we must now set out to reach. Baba used to say, "Even a dog can give *shaktipat*." His point was that spiritual awakening can happen spontaneously and does not necessarily require a Guru. But discerning what to do after *shaktipat* requires wisdom, and this is where the Guru is essential. If you do not have wisdom, then you are going to misinterpret the *shakti*. A great teacher has wisdom and *shakti*. Better the teacher who has wisdom and no *shakti* than the teacher with great *shakti* and no wisdom.

Wisdom arises from nonattachment, acceptance, and surrender: nonattachment to all that is not the Self, acceptance of who and what we really are, and surrender to what God has in store for us.

The *shakti* enlivens. Where there is no wisdom, it will enliven ignorance and delusion. It will enliven the shrunken self, and its desires for power and control, money, sex, food, or intoxicating substances. Without the guidance of a wise teacher, the *shakti* will delude the shrunken self into thinking it is powerful and enlightened. Wisdom, on the other hand, will teach the shrunken self what it actually is, and then the *shakti* will enhance and enliven that wisdom. All too often around Baba, I saw people go for the *shakti* and forsake the wisdom—there was no need for wisdom in their minds, because the *shakti* would do all the work.

Baba had me look after many people who came to the ashram. Some of them were false Gurus. Often, they had tremendous *shakti*, without a jot of wisdom—but their followers were hooked on the intoxication of *shakti*. Many people were intoxicated by Baba's *shakti*, which was overwhelming. But when Baba used to say, "I give you what you want, so that one day

you'll want what I have to give you," part of what he meant was that he was giving people *shakti* so they would someday want to receive his wisdom.

Shakti can give you an experience of true witness consciousness, but without wisdom, everything will be again cloaked by shrunken consciousness. Until we are willing to develop the wisdom to know our shrunken self for what it is—a limiting system of thought constructs—and then dismantle it, we are destined to be bound in a prison of our own creation. But if we seek wisdom with the guidance of a teacher, the *shakti* will help us on our way. Together, Guru and *shakti* will lead us home.

Liberation....

Liberation is utterly different from what most people imagine it to be. Baba always made clear that liberation is not for the individual. He always stressed that the individual cannot be liberated, and that the only way to liberation is to give up our attachment to and wrong identification with any separate identity. I specifically went to Baba because that was what he taught. And what he taught was not ideas. An intellectual grasp of non-duality is all very well, but to know and inhabit that Reality requires a long and arduous grinding down of the individual identity that must be given up. There are plenty of spiritual seekers who believe they can advance toward liberation without doing that painstaking work; they get nowhere, except in their heads.

This process of grinding down the separate self begins with knowing how that individual identity operates. The techniques for this work that I pass on—other than the fourchotomy, which I created—are all time-honored internal practices that Baba taught. Whether we call it *shambhavopaya* or St. Symeon's third level of attention and prayer, boring continuously inward toward the Heart is the one crucial practice. It makes no difference where we are on the path; until we reach liberation, that is the practice that matters. It uses the will. If we are not doing this, nothing else

we do will get us anywhere; we will only have an "enlightened" shrunken self. The one doing *sadhana* is not the one who will endure.

As I have said before, the truth that all individuality, all separateness, must be let go, the reality that there is no such thing as a liberated individual, was always evident in Baba's teaching. But, again, here are a few passages:

When the Shakti of the Self contracts, She is known as a limited individual, subject to innumerable births and deaths. She remains a transmigratory soul as long as She is contracted, but once She expands, She becomes Paramashiva. (Secret of the Siddhas)

Bondage and liberation exist only when there is division. The ideas of bondage, liberation, and so on, apply only to a person who, because of māyā, does not understand his true nature and is afraid. (Secret of the Siddhas)

"I can do nothing;

it is the universal Self who does all."

This is sublime teaching.

"I will accomplish this work;

I have already done it."

This is total ignorance and pride. (Reflections of the Self)

He regards this world not as matter

but as the embodiment of Consciousness.

For him there is no Maya, no body;

whatever exists is Shiva. (Reflections of the Self)

I repeat: though a clear and subtle intellect is essential for practice, this Reality can't be taught intellectually; then it will only be an idea. When I used to stand alone with Baba by the back stair, he taught me wordlessly, through the Great Silence.

What Baba taught me by the back stair is the work of "boring in." It is the core of the practice, and it rests at the heart of all mystical traditions. We should take it almost literally—the only difference being that we're not using a drill, we're using the will to redirect consciousness back into the Heart, through all the bodies. As we practice, our understanding and experience will grow clearer and more subtle. This practice is simple—and very difficult. But it is the practice; anything that doesn't center on this right effort of the will is off the point. Anyone who claims that this isn't the heart of all spiritual practice has no real awareness of thousands of years of teaching and lineage and scripture, in all real traditions.

As we proceed in our practice, we will have an ever-shifting understanding of liberation. The less of our separate, shrunken selves there is to "understand" liberation, the closer we will come to the Real thing.

Journey of the Practitioner....

What is a practitioner? In many cases, academics, theologians, and intellectuals believe their expertise is the highest level—they assume they rank above practitioners. In truth, mystics are the practitioners of spirituality.

According to Evelyn Underhill, what idealists and theorists can only speak of, practitioners live:

"In Idealism we have perhaps the most sublime theory of Being which has ever been constructed by the human intellect: a theory so sublime, in fact, that it can hardly have been produced by the exercise of 'pure reason' alone, but must be looked upon as a manifestation of that natural mysticism, that instinct for the Absolute, which is latent in man. But, when we ask the idealist how we are to attain communion with the reality which he describes to us as 'certainly there,' his system suddenly breaks down; and discloses itself as a diagram of the heavens, not a ladder to the stars.... That is to say, Idealism, though just in its premises, and often daring and

honest in their application, is stultified by the exclusive intellectualism of its own methods: by its fatal trust in the squirrel-work of the industrious brain instead of the piercing vision of the desirous heart. It interests man, but does not involve him in its processes: does not catch him up to the new and more real life which it describes" (*Mysticism*).

Many years ago, I had an argument with a dear friend. He was in love with maps. I, too, love maps. For me, however, the map is a guide to take me somewhere, not just a picture to be devoted to. The map's purpose comes to fruition only if I journey across the terrain depicted. My friend remained in his head, which was filled with wonderful ideas. Our conflict was that he wanted to remain fascinated by maps while I wanted to reach a point where I could leave all maps behind. The purpose was to travel the path, reach the goal, and remain. In other words, at some point, we have to let go of the map. For my friend, the map was the end in itself; for me, it was just a tool, a means to be used for a greater purpose.

As a practitioner, I walk the territory. I perform my practice as a shrunken self choosing to practice—the wedge to get rid of the wedge. All the work is designed to make the shrunken self let go. And the more I practice letting go, the less of me is there to practice.

Ultimately, this all has to do with stilling, which is the goal of every practitioner. How do we do this? Be with your experience, let whatever comes up from that experience come up, and function appropriately on the physical plane.

Here is how to be with your experience. We have to first be willing to be with a vibration. As we continue to be with it—without getting lost in it—we will become aware of the vibration as something separate from us. In perceiving it, we will realize it to be an object of our awareness. With the vibration now an object, we can choose to disentangle from it and still be with it. Then, by keeping the light of our attention on it, we still the vibration.

Sahaj samadhi means being in the Heart and looking out at the world

simultaneously. Again: be with your experience, whatever it is. Let whatever comes up from the experience come up. And function appropriately on the physical plane. This is what Baba taught me. By practicing this, we become *Sat* (Truth), *Chit* (Consciousness), and *Ananda* (Bliss). This is the journey of the practitioner, the mystic.

Beyond Doctrine….

When I was studying dance, we always talked about being technically proficient. We all spoke about getting technically flawless, magnificently proficient, in order to let go of technique and finally dance. That was an actual verbalization every single day in the studio: become so technically proficient that you can go beyond technique. We knew that if we wanted to actually dance, we had to master technique. We understood that if we were not technically proficient and we let go, we might dance, but we probably were not going to be onstage. Nobody would want to watch us. Only if we became technically proficient and studied and put in that rigor, and afterward let go, could we become true dancers.

And what's technique? It's doctrine.

I studied several doctrines as a dancer, and always worked to express each doctrine purely, not tainting it with any other. I made myself a perfect instrument in each language. And then I let go. That's the whole thing: whether you're writing, street sweeping, banking, bagging groceries, it doesn't matter. It's the same. The technique is the doctrine. If all you're going to practice is, "Oh, I stand in first position in the middle of the studio, I raise my arms and open them to second position, I bend, I jump, I land, I glide across the floor," you're never going to get past the doctrine. "Oh, here is the toothpaste. I open the cap. I have the toothbrush. I squeeze the toothpaste onto the brush. I close the cap. I brush my teeth." If this is how you operate, you're never going to be free while dancing or brushing your teeth; you're only going to be doctrinal. There's no joy, there's

no life, there's no anything. You're at the first level forever. We should be about being conscious and letting go at every moment.

The Sutra of Vimalakirti says, "Real teaching involves no preaching, no giving orders; listening to the teaching involves no hearing and no grasping." (Hui-neng, transl. Thomas Cleary)

At the point Hui-neng mentions in that passage, is there a difference between the teacher and the student? No. When we are in the Heart—at that place, and at that moment—we are equal in Love. And I'll ask a question: who doesn't want that? Apparently, a lot of people. "I'm not going to do what you tell me to do. I'm an individual in my own right." Well, good for you. You lose. You don't get the grand prize.

So what are we doing here? We are working to still all our vibrations so that Love can arise unobscured. That is all we do here. Everything else that happens is meant to bring us each to the point where we choose to still.

You realize that myriad things are empty, and all names and words are temporary setups; constructed with an inherent emptiness, all the verbal expositions explain that all realities are signless and unfabricated, thus guiding deluded people in such a way as to get them to see their original nature and cultivate and realize unsurpassed enlightenment. (Hui-neng, transl. Thomas Cleary)

Understand that ultimately there is no doctrine. There comes a point where you let go of all the letters and go beyond doctrine, as dancers go beyond technique. Doctrine is the wedge to get rid of the wedge.

Maya and the Five Kanchukas....

Nondualism can be a dangerous practice because it can encourage people not to take responsibility for their actions. But then when we turn to a dualistic sense of *purusha* (individual self) and *prakrti* (matter), we separate ourselves from *prakrti* and see matter either as an enemy or as some horrible lesson to be learned. *Prakrti* then has nothing to do with us, and in

that sense, again, we may not take responsibility for our perceptions and actions; *prakrti* is separate from us.

When we approach a nondualistic system, we are forced to see that *prakrti* comes out of *purusha*; therefore, we are the cause of our *prakrti*, of our environment. Though both systems are true renderings of manifestation and teach us appropriately, we can delude ourselves any way we want. In truth, the individual is responsible in both systems. In nondualism, all *purushas* have their own *prakrti*, which is not different from dualism. As we evolve back to God, *prakrti* is always here for our education and liberation.

In Kashmir Shaivism, there is the understanding of *unmesha*, an upsurge of God, that arises when we are not cloaked by *maya* and the five *kanchukas*. This upsurge is Bliss itself. But for people who have not purified themselves through intense *sadhana*, an impulsive feeling or upsurge can be misinterpreted as God speaking. If everything is God, then in truth that impulse is from God, but not in the way our shrunken, deluded selves think.

Remember, Christ said, "everything comes out of the Heart":

"When he had left the crowd and entered the house, his disciples asked him about the parable. He said to them, 'Then do you also fail to understand? Do you not see that whatever goes into a person from outside cannot defile, since it enters, not the heart but the stomach, and goes out into the sewer?' (Thus he declared all foods clean.) And he said, 'It is what comes out of a person that defiles. For it is from within, from the human heart, that evil intentions come: fornication, theft, murder, adultery, envy, slander, pride, folly. All these evil things come from within, and they defile a person.'" (NRSV)

So everything is God. But until we are willing to unmask the truth of any vibration we have by practicing being with our experience whatever it is, letting whatever comes up from that vibration come up, and simultaneously

functioning appropriately on the material plane, we will delude ourselves as to what that upsurge really is. Every enthusiastic upsurge, every impulsive impulse to solve something that we think is an *unmesha*, is really an *"enmesha."* We enmesh ourselves and miss the point.

How do we do that? By thinking our view of *prakrti* is the way the world really is. By thinking, "My wants and desires are the mission that needs to be fulfilled." But when there is no core, then everything is arbitrary. Everything is "equal," and we have no discernment. According to Jaideva Singh, this is how *maya* and the five *kanchukas* cloak: "Maya draws a veil on the Self owing to which he forgets his real nature, and then Maya generates a sense of difference. The products of Maya are the five *kanchukas* or coverings." Singh goes on to list them:

Kalā: reduces universal authorship, brings about limited agency

Vidyā: reduces omniscience, brings about limitation in respect of knowledge

Rāga: reduces all-satisfaction, brings about desire for particular things

Kāla: reduces eternity, brings about limitation in respect to time

Niyati: reduces freedom and pervasiveness, brings about limitation in respect to cause, space, and form

And so we are contracted into the individual that thinks so highly of himself and yet is so small. We are deluded by the cloaking and then find ourselves perceiving a rope as a snake and conjuring a thief in a tree.

To return home, we must unveil *maya* and the five *kanchukas* for who they really are, and then unveil ourselves, so that our true nature will arise and we will not prevent Love from coming forth.

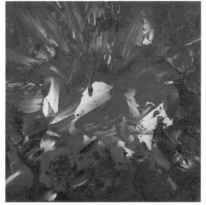 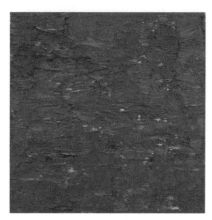

Desperate (2015)

Desperate	Secure
Tested	Complacent

awareness....

the trick
non attached
to all yet
informing all
by
resting in
Heart
manifesting
yet disentangled
enjoying
from the
source
by knowing
the source
occasions do not
fool
any more
no praise nor blame
non attached
from and
eternally resting in
Self

shunya....

been attacked

 from

 both sides

 of dichotomy

 can't win if

 please

face accept

 let go

 of matter

 then free

to

 Love

 resting in

 Heart not head

 supported with

 no supports

the magic formula....

and the recipe

 isssssssssssssssssssss

be

 with experience

 whatever it

 is

let whatever

 comes up

 come up

function

 appropriately

 on

 the physical plane

this breaks

 i down

 won't follow

 the recipe

i follow my

ideas

but

the outcome

not same

tweaking narrative

maintains shrunken self

wrong incantation

preserves their selves

recipe does not

use

preservatives

i is going to rot

wrong recipe rots

everything inside out

practice internal recipe

to uncover I

wrought iron bars....

having conversations
 using letters
having great intellectual events

thinking being in your heart
thinking understanding
thinking experiences

 all

just mental play

doesn't matter
 what the number of letters
 mixthemalltogether

nice sadhana letters
nice philosophical letters
nice spiritual words
 hip words
 boring words

 isolated
 in our words
imprisoned in our words
 still
 all words

disentangle from those letters
 be
 with the vibration

no matter how pretty the calligraphy
 wrought iron bars
 holding us
 in a box

understand un-understood mother
understand power inherent in letters
understand vibrations

 to free clear knowledge
of Reality

boredom....

boring

bore in

boring in

the kingdom
through
which

we must
bore

and bear
the agitation
of boredom

until
all dissolves
in
clarity
clearly
no refraction

Compassionate (2015)

Compassionate	Hardhearted
Bleeding heart	Dispassionate

CHAPTER TWO
TOOLS FOR
PRACTICE

Tools to Still....

No matter what the tradition, the goal of spiritual practice remains the same. It follows that every spiritual tradition draws from the same essential tools for practice. Teachers within a given lineage expand and refine its toolkit as time goes on.

Below is a list of some tools from the kit I was given by Baba. If practiced appropriately, with the right attitude, each will move us forward in our journey.

Meditation. Let go of the chatter and be still before God. If you still the vibration that comes out of the Heart, the chatter will dissolve and disappear. Do not focus on the chatter; focus on the vibrations in the Heart. Step back and you will have a greater view.

We cannot still something we are not disentangled from. We meditate to go as deep as we can within. Then we remain within and witness the meditation. When we open our eyes, we are to remain within that deepest place, so that eventually we are living *sahaj samadhi*: being in the Heart and looking out at the world simultaneously.

Fourchotomy. All qualities are made up of vibrations. Those vibrations then dictate how we label ourselves and all we encounter—how we interact with the world. The intellect sorts our experience of those vibrations into dichotomies. But our dichotomies are not rigid: each quality inhabits a semantic field with three other components, not just one alternative. For this reason, I refer to a set of four qualities as a fourchotomy.

Here is one example:

Still	Agitated
Inert	Engaged

The way to use this is to own and accept all four qualities, which will then allow us to rest in the stillness at the center of it all.

Puzzle. Writing down all that comes up, without any editing or judging, in order to create the set of puzzle pieces that make up the whole picture of a situation or relationship.

Teacher / Guru. The Guru is our lifeline. Appreciate the Guru.

Listening. When we are unconscious, what runs us is what we believe unconsciously. Real listening is hearing our honest answer of the moment, without judging, editing, or denying it.

Humor. We must stop taking our character so seriously and personally, and really see the humor of the part we are playing.

Scripture study, books, teaching stories, blogs, practice points. All these are crucial resources. It will take many readings and much reflecting to absorb and be able to use what is found here.

Seed tool. Once we realize that we repeatedly fall into certain actions or behaviors, we can trace the vibration that causes the behavior back to its source and still it.

Service. The importance of service is that we get out of seeing ourselves as the center of the world. Service is an opportunity to learn how to give.

Disentangling from vehicles. Withdrawing our energy and attention out of our various vehicles allows us to no longer identify with them.

Surrendering / Ishvara pranidhana. By letting go of all that we hold onto at any given moment and surrendering to God as completely as we can, we lose our attachment to our shrunken identity.

Mantra. We can repeat a sacred syllable, word, or phrase to override our thoughts, and eventually to hear the mantra in the Heart, repeated continuously.

Sharing and community. When we isolate ourselves, we can believe all kinds of delusions. Community and open sharing is a great reality tester. It also supports us in our practice.

Confessing / revealing. We must be willing to admit—to ourselves above all—what we've actually said, done, thought, and felt, without running from the truth.

The thing about tools is that they have no value unless you put them to good use. They are not just there to be pulled out in case of a crisis; they are there to be used in sustaining your practice. So use them. Be with your experience, whatever it is. Let whatever comes up from that experience come up. And function appropriately on the physical plane.

What Is a Fourchotomy....

The world appears to us as we choose to see it. Most of us see the world in binary terms, framing our experience in pairs of opposites. These pairs of opposites define and limit our perception by shrinking the world into a kind of template; that template in turn limits our choices and actions. Recognizing and dismantling this template is the key to seeing things as they truly are, which frees us to live fully.

Our templates are made of qualities—words for which we form our own definitions, often unconsciously. Essentially, qualities are labels that define and limit. On a pre-verbal level, qualities begin as vibrations within us. Those vibrations form words, which then dictate how we label ourselves and all we encounter—how we interact with the world. Our minds sort our experience of those vibrations into dichotomies, seeing everything in terms of two opposing choices.

THE WAY OF LOVE

But the process doesn't stop there. In reality, the mind works in what I call fourchotomies. Our dichotomies are more complex than they at first seem; each quality exists in relation with three other components, not just one alternative. In every dichotomy, the negative quality has a positive component, and the positive quality has a negative component. Depending on whether we start from a quality we consider positive or negative, a fourchotomy will take one of these two forms:

Negative Quality	Positive Opposing Quality
Positive Form of Negative Quality	Negative Form of Positive Quality

Positive Quality	Negative Opposing Quality
Negative Form of Positive Quality	Positive Form of Negative Quality

For example, the quality of impulsivity is usually seen as negative. If we look for its positive opposite, we may well choose the quality of being careful. But impulsivity has a positive element: spontaneity. And carefulness has a negative element: uptightness. So our fourchotomy might look like this:

Impulsive	is the opposite of	*Careful*
is the negative of		is the positive of
Spontaneous	is the opposite of	*Uptight*

If our starting quality is one we consider positive—say, assertiveness— the fourchotomy maps out differently:

Assertive	is the opposite of	*Passive*
is the positive of		is the negative of
Aggressive	is the opposite of	*Gracious*

The real problems arise when we fail to discern between the positive and negative components of one side of a dichotomy. We then conflate the

positive and the negative—for instance, calling ourselves spontaneous when we are really impulsive, or careful when we are really uptight. We might also call ourselves uptight when we are really just being careful. We will conflate vibrations, words, and meanings to maintain our worldview. And once we conflate the terms of a fourchotomy, we lose our discernment. In order to see clearly, we need to acknowledge all four components and arrive at a point where we are attached to none of them.

Even our notions of "positive" and "negative" can be conflated in a fourchotomy. The qualities that are positive to us are those with which we are identified; even a trait we think of as "negative" can be positive in this way. If we think of ourselves as selfish, manipulative, pathetic, and cruel, then we believe those qualities are actually who we are. We cling to these qualities precisely because we have come to believe they are essential to our being, and that giving them up would mean ceasing to exist.

If we want to tear down this prison of words, we must recognize, understand, and accept the entire grid. Only when we achieve this will we free ourselves from seeing the world through the blinders of our wrong identifications.

Accordingly, we have to accept within ourselves every quality in a fourchotomy. Transcending them requires owning them completely. "Owning" means not merely accepting the qualities in principle, but recognizing how they color every aspect of our lives. It is not enough to own three out of four qualities; the remaining term we haven't accepted is enough to, if triggered, reopen all of them.

There is no quality we can ever regard as not applying to us. If we recognize it in our world, then it is within us; if we don't recognize it, it is still within us, because we are human. The point is to be fully human. When we are fully human, Love informs all our words and actions; then we are free to manifest all qualities appropriately.

THE WAY OF LOVE

How to Use a Fourchotomy....

To work with a fourchotomy, you have to begin by being honest with yourself. This means being willing to hear your honest, unfiltered answer in the moment; if you pause to think it over, you will be answering from the wrong place entirely. It takes practice to hear your honest answer and not fall prey to your mental chatter.

Assertive	is the opposite of	_Passive_
is the positive of		is the negative of
Aggressive	is the opposite of	_Gracious_

Be aware that our tendency is to spin things, especially definitions. As a result, we conflate different terms in a fourchotomy. For instance, in the fourchotomy above, you may very well conflate the definition of "aggressive" with the word "assertive," and the definition of "passive" with the word "gracious." You may see someone who is actually assertive as aggressive, and someone who is gracious as merely passive.

Once you are clear on your definitions so that you are no longer conflating the terms of the fourchotomy, you are ready to work with it. Taking the example of Assertive, you should start by asking yourself:

"Am I assertive?"

In that moment, without hesitation, you will have an internal yes-or-no answer, but you must be willing to hear it without spinning or judging it. It may feel like a vibration arising from within you. If you allow yourself to feel the vibration, the answer will take shape from the vibration and you will "hear" it. Then you ask:

"Am I okay with that?"

Again, simply hear your honest answer as it arises from within. Continue to ask those questions for each component of the fourchotomy.

You'll find that your answers change from moment to moment; this shifting around is part of the process. Gradually, you will start to free yourself from being attached to any of those qualities. You will know that when more yeses turn up consistently in your answers. This may take some time, depending on how attached you are. Eventually, you should reach a point when your honest answer to all eight questions of a fourchotomy is "yes," ten out of ten times, on a regular basis. This means that you are no longer trapped by your attachment to any of those qualities. At least for now. This process of reaching eight yeses ten out of ten times has to be reiterated over an extended period of time. We need to check back and see if we are remaining "off the grid" of that fourchotomy.

In order to be able to use this tool fully, you will have to be able to create your own fourchotomy. A good starting point would be to think of a person you struggle to get along with. That person will display qualities that bother you. Remember that if you see a quality in others, you have it in you. If you deny it, then you unwittingly manifest it without realizing it. So to begin, choose one quality in that person that really annoys you; then you can start filling out the fourchotomy. For instance, if you find that person controlling, you can form a grid and put the word "controlling" in the top left.

Controlling	

Then, since "controlling" is clearly negative for you, find the positive opposite. It might be "relaxed."

Controlling	Relaxed

Now you must find the positive of "controlling" and the negative of "relaxed." The former might be "disciplined," the latter "careless."

Controlling	Relaxed
Disciplined	Careless

Now you start asking the questions and listening to the answers that arise from within, in the moment.

As you keep working with fourchotomies, you will find that it is just as important to free yourself from attachment to qualities you consider positive as it is to work through your attachment to negative ones. The goal is to continue working to be off the grid, so that in every situation you encounter and every relationship you have, you will see clearly and act spontaneously, freely, and appropriately.

Using the Fourchotomy Game to Get to Love....

In class, we have worked on a new fourchotomy that was a little different. This is the vibration of what we have called love. When we were very little and saw our caregivers, we "knew" they loved each other and us. We took the vibration they had to be love; that is what we all do. But the fact is, only realized beings are going to Love purely. Love is always there—ultimately, Love is all there is—but we twist Love. So our vibration, because it is not pure, is something other than Love. Each one of us then calls a different vibration love. As we grow, we may say we know our parents, as our caregivers, did not love each other. But we know this only intellectually. We have embedded the vibration we had as little ones and unwittingly call that love.

Not until we are willing to feel the vibration and call it what it is can we begin the process of moving towards real Love. What is the vibration we swim in? This vibration is all the time; we are unaware of it until the vibration becomes so loud even we can hear it.

This requires some form of trigger that we may or may not be aware of. The vibration can appear to come out of nowhere, but in fact it has been building for days or weeks with little triggers that we ignore. Finally,

we blossom into the all-too-apparent, and we express this vibration everywhere. We are now "loving" the world loudly, where before we were loving the world subtly. This vibration informs everything we do, every decision we make. We cannot avoid it.

So how do we move from this to Love? Can we? Yes. We first had Love and then we felt this vibration. So it is an object, not us, a veil that covered our Love and who we are. We lost our subject in the object of this vibration. It became our nature, this "love," and we allowed and even encouraged this vibration to dictate all.

First, we have to feel the vibration. Not just when it has blossomed forth, but when we are at rest. The vibration is always there just under the surface; we have to become aware of it. Just feel it and make it no big deal.

Next, we have to call it what it is. We have unconsciously called it "love." Now we have to discover what it actually is. Everyone has a different vibration they call "love."

For instance, the vibrations of frustrated, hateful, lonely, unwilling to rock the boat, numb, wounded, dreading, irritable, beleaguered, rageful, arrogant, know-it-all, neurotic, rejected, or suffering can be wrongly identified as "love." This may seem difficult to grasp because we all say that "love" is so different from these other vibrations. The problem is that when the vibration is in the subtle form, when we do not consciously feel the vibration, we assume we are loving but in fact we are vibing using this other vibration. Any decision and any idea is being informed by this vibration of which we are unaware. And trying to get out of it will only involve the vibration all the more. We have to accept that we are always using the vibration; it is always guiding us. We have to feel this vibration and accept it for what it is. This process is painful; it does hurt to face our own delusion. But keeping the delusion is worse. So here we are with this vibration; we thought it was love, but now we find it to be suffering. Okay, accept it. Be with it. Stop running, stop calling it some other name, stop making excuses,

stop rationalizing, and finally stop trying. Just feel the vibration and accept that this is what you have. This is your "love." You finally have what you have been avoiding all these years. Now you come to know no one else would call this vibration "love." No wonder relations and communications have not gone as you thought they should. You thought you were "loving," and you have been hating or frustrating or whatever you have.

Now that you experience the vibration, you will feel it everywhere and see how all decisions and assessments and actions come from this vibration. No wonder things turned out the way they did. No wonder people responded the way they did. Just feel and face. This is hard and will hurt. But stay with the vibration and do not run. Gradually, you will start to disentangle from it; there will be some distance. Getting to this point will take some time, so be patient. Once we separate, we have a chance now to still it, as it is beginning to lose power.

The fourchotomy game can help with calling the vibration what it is. The game can help with getting to a place of dissolution for this vibration. If we do a fourchotomy using our vibration, it can look a little different than a normal fourchotomy because the basic premise is wrong identification. I have to work with the fact that I call the vibration loving even though rationally I know it is not. There tends to be quite a bit of conflating in order to make sense of the words. For example, if being full of hate is what I have always called love, then my fourchotomy will look like this:

| Full of hate (loving) | Full of love |
| Leaving alone (loving) | Too involved / codependent |

When I leave people alone, I will believe it is the most loving thing I can do. I hate everyone because I "love" everyone. And people who actually love are called too involved and codependent.

Here are some others:

Passionate / cruel (loving)	Kind
Involved (loving)	Indifferent

Agitated (loving)	Calm
Involved / caring (loving)	Uncaring

Lonely (loving)	Connected
Independent (loving)	Smothered

So if frustration (love) is my goal, then I will unwittingly and unknowingly work to maintain frustration at all costs, and all decisions will be made to get that goal. Once we ask the questions around a fourchotomy (see the chapter in *Walking Home with Baba*) and get the eight yeses, we are beginning to get free of this vibration. We are unraveling our false idea and vibration of love. The work looks simple; it is not easy. We have to apply our attention vigilantly if we are to be successful. So be patient and persevere. It is possible to free ourselves from our wrong understanding and emerge as our Self. Then "love" is Love.

Resources....

Resources. What are they? Resources are people and materials that aid us in our lives. These resources can be within us or outside us. We should know what they are and use them wisely. Our resources should be looked on as gifts. Do not waste or disrespect your resources, because if you do they may run dry, and you are then left empty.

None of us is alone, though we may believe that to be true. When we decide to be alone and lonely, the world becomes a reflection, and sure enough no one and no thing will be there for us. The truth is, our resources are there but become hidden when we reject life. Yes, we are the ones that

reject, not the other way around. All are resources, waiting to be asked, summoned, called upon. Our resources want to help, want to assist, want to make it easier for us, want to be something we integrate into our lives.

Let us now name some resources available to us. First, we need to be able to laugh as a resource. Laughter serves a great function. Through laughter and humor, we can separate and distance ourselves from something that has bothered us, something about ourselves or others. The jester in the king's court would make people see truths through humor, so that, though things might hurt, people would be able to laugh at a situation, person, or themselves. For the ones who could not laugh, life did not go very well. Without laughter and a sense of humor, we remain attached and identified with something that is not us.

This brings us to the foursquare (now fourchotomy) personality game (see chapter seven of my book *Walking Home with Baba*). When we use this correctly and truly listen to our answers, all the qualities in our game become neutral. We then feel light and are not attached to any of the qualities no matter how "good" they may be.

If we cannot be clear enough to hear our true answers during the fourchotomy game, then we should use the Seed tool (see chapter five of my book *Walking Home with Baba*) to trace our vibrations back to finally resolve.

Meditation is a great resource when properly used. The purpose of meditation is like that which happens in a laboratory. We have eliminated the outward variables, and then work to still the inward distractions. All vibrations are to be stilled, so that who we truly are can shine forth. This practice is not easy.

We need to acquire discipline and rigor in order to use these other resources. So discipline and rigor become great resources for our use in and of themselves. As we grow, we see how important discipline is.

Many people use mantra as a way to override their thoughts. This use can aid a person but tends to cause a fight between our thought forms and the mantra we are using. Mantra is a good resource, especially when coordinated with our breath. Also, we need to grasp the meaning of the mantra, so that we put in deep feeling and understanding when we repeat it.

This brings us to the resource of study and reflection to acquire context and vocabulary. When we apply ourselves to study and reflection, we become conscious. Consciousness shines a light, and as we study and reflect, we are able to grasp things on deeper levels and express that understanding through language.

Listening to talks again through audio and video helps us to reinforce our understanding. Many times during a class, we may experience something and then not be able to remember what was said because we were listening from a deeper place and our intellect did not comprehend consciously. So reading, listening, and also watching again help us further our practice. This way we are sharing within ourselves and integrating our knowledge.

Sharing is another important tool. Community supports and helps us reflect. Community is here for each of us—teaching us lessons, educating us, and moving us toward liberation. Community shows us what we need to do; it guides us, whether we are open or not. If we relate with others by only fight-flight or appease-doormat, if we have only one function button, then we are in trouble. We are not using our resource of community to aid us.

Now, as always, is the time to stop the fight and laugh. Go ahead, use the resource: laugh at and with yourself.

Vacations….

Vacations are designed to help us. We say we need a break, we need a rest, we need to get away. Vacations can help us gain detachment. When we go away or just stop our normal work or activity, hopefully we are forced to

disentangle from that very activity. We get to see how involved we were, which may not have been for our or anyone else's good.

So vacations can be a good tool from the standpoint of spiritual practice. Perspective can arise when we have some distance from our normal life. This clarity will only come, though, when we do not take a vacation from our practice. There is never a time when we should take a vacation from our boring in and resting in the Heart.

Vacations can become a detriment when we do not practice and we just attach ourselves to our vacation environment. We are then perpetuating the practice of attachment; reinforcing attachment to what is temporary and always changing. If we practice going into and resting in the Heart, then whether we are in our normal life or on vacation, we are focused on what is Real. This way we do not lose sight of who we are, and we can approach each environment appropriately.

Nonattachment is a skill we each need to develop and then constantly practice in order to live life to its fullest. This may seem strange, that nonattachment brings richness, but nonattachment is not apathy and not caring. Nonattachment means we are disentangled from what is not real so that we do not identify inappropriately. We can see clearly and remain calm when we are nonattached. We can see clearly enough to truly know when it is time to back off from a situation and give it a rest.

So a vacation is a way to make sure we see clearly. We can see to what extent we are attached. We are not to replace one attachment with another. That is reducing life to a series of affairs. We go from repulsion to attraction. Not good. If we are not practicing, we are approaching our life from the standpoint of ignorance. We are taking our environment as Real. Once we believe that, then we identify with and lose our subject in the object of the environment. From there we are attracted to certain things based on our "identity." We are repulsed by other things based on that same wrong identity. And because we are so sure that this is Real, then we are

afraid of losing what we are, what we have. So we cling for dear life.

When we go on a vacation, those bonds can loosen. We can really work to disentangle from the life that we are clinging to and see that we are something greater than any thing or lifestyle. But if we just jump into the vacation with the same ignorance, then it really does not matter whether you are home or on vacation; it is all the same.

So wherever we are, we need to practice. We can then actually be there for our life instead of being driven into or escaping from what we are here to learn from. Our task is to participate wherever we are, and not lose ourselves in the process.

By all means go on vacation. But we have to be present to be able to go on vacation. That means we neither take the environment we have vacated with us nor do we enmesh ourselves in the new one. And if we have gotten attached even though we practice, then we have to go on vacation. Through practicing, going into and resting in the Heart, we will find our Self, really vacating who we are not and returning to who we are. Love will be who and how life is, whether in daily life or on vacation.

The Buck Stops Here….

There is a hidden joke in this title. I approach the protection of my garden in very much the way Baba taught me to handle security in the Ganeshpuri Ashram. In Ganeshpuri, there were walls with broken glass on the top. Intruders came in through the drainpipes or the front gates. After we put screens over the drainpipes, the only way in was the gates. People would come in and attempt to steal from the many fruit and nut trees. Always a great game. In the garden at my house, deer come in and devour our plants. Over the years, we have used repellents and most recently a barrier of live willows, but nothing has been successful. Until now.

We are now taking a tactic from *The Seven Samurai*; we are using bamboo. The bamboo on our property has provided amazing material to

create an eight-foot fence around the acre of landscape garden, except where evergreens have closed to form walls. There is one place where some evergreen trees have not yet grown together, and this is where the buck came in. A solitary buck came looking for female friends. He did not even eat anything. But he couldn't find his way back out. He escaped by jumping through the fence in the back, taking it down. We have now fenced off the gap in the trees where he entered. The buck was a lone, not very bright enemy. He will not be back. The buck stops here.

How does this apply to anything spiritual? Very simple. Every project, every event, is facing the enemy. Who is the enemy? We are. But in order to understand this, we need to see how those we regard as adversaries actually reflect our own inner state. The buck stops here.

In my case, who appears as my enemy? My enemy is the "proudly inert." The buck was "proudly inert." Not being the most conscious of creatures, he just wandered into the area of play. Once something is in my field of play, that means I have an attachment of some kind that I need to confront. To resolve that attachment, I can use a fourchotomy.

The opposite of "proudly inert" is "consciously growing." The positive of "proudly inert" is "grounded, down to earth." And the negative of "consciously growing" is "chameleon."

Proudly inert	Consciously growing
Grounded / down to Earth	Chameleon

My enemy arrives not only in the form of deer, but also in the form of a certain kind of student. With each of these, I am tempted to believe that "I cannot win." With the deer, I did win, by creating an environment in which the deer could not enter my playing field. I had to consciously grow and change in order to remove the deer. With people, it can be the same, but if the buck does stop here, then I am the enemy and will remove the

outside agitation only when I face myself.

First, I have to create a fourchotomy about the enemy.

Second, I must get eight yeses consistently in order to own the enemy within myself.

Third, I am then able to see what I do and the universe reflects back at me. In order to get free of the battle, I have to neither resonate nor react. I have been dancing a beautiful foxtrot for too long. It is a set dance, my dance, which I get others to join. They may even think they are in charge, just as I thought they were in charge and I could not win. But at this point, I see I was always in charge and could change the game at any time.

Fourth and finally, I can now get off the grid of the fourchotomy. I can now discern the appropriate action in any situation. The personal is removed at this point, and I can function for the greater good. The play and all the action moving forward are no longer personal.

The outside may continue to play the way it has always played, but now we no longer lose our Subject in objects. We can now stay focused on the Heart and are not distracted by the game. We can now win by acting appropriately. Many years ago, I wrote an aphorism: the only way to win is not to play at all. The only way not to play is to look in the mirror, see ourselves as the enemy, and stop the fight. Once we do that, we can act with an integrity that has no personal attachment in it. We are then acting in every way for the greater good.

The Three-dimensional Fourchotomy....

We have been working with the fourchotomy tool for many years now. It evolved from dichotomies to fourchotomies a decade ago. Now it is evolving further to aid in our uncovering and dismantling of our system.

In order to build a fourchotomy, we must start by depersonalizing and objectifying the issue. This is done by using qualities we all can relate with.

From there, we uncover the opposite of the quality. Once the dichotomy is defined, we then find the positive and negative forms of each term in the dichotomy. For example:

Crippled	Healed
Cared for	Abandoned

Crippled	Healed
Dependent	Independent

Cared for	Abandoned
Supported	Neglected

We usually start working with a fourchotomy by focusing on what we perceive as being done to us: the "outside to me." From there, we must look at what we do to others and to ourselves. So now we have a three-dimensional fourchotomy:

To me by the outside

To others by me

To me by me

From here, we can see the more outward, incidental causes and work our way back to "To me by me." Once we have owned and accepted all three versions of the fourchotomy, we can choose to irrigate the field or not. We are definitely not at the mercy of the outside; it is always our choice. We can choose to react, or to respond appropriately.

Dismantling the system this way allows us to see our power in our life. We are now free to use the qualities in the fourchotomy appropriately. Our ability to be manipulated is now diminished in regard to this fourchotomy.

Using one of these fundamental fourchotomies, we can see how we structure the questions and unfold the process. We ask ourselves the

following yes/no questions and give our honest answer of the moment. We do not give what we think or "know" is the "right" answer. This tool does not work if we are using just our intellect; we have to be willing to give our emotionally honest answer. This emotionally honest answer is the only right answer of the moment. This answer will change as we use the tool and keep asking the questions. When we honestly reach 24 yeses ten out of ten times on a regular basis, our experience will be very different as we engage with the world both within and without.

I. To me by the outside:

Am I crippled by others? Am I ok with this answer?	Am I healed by others? Am I ok with this answer?
Am I cared for by others? Am I ok with this answer?	Am I abandoned by others? Am I ok with this answer?

II. To others by me:

Do I cripple others? Am I ok with this answer?	Do I heal others? Am I ok with this answer?
Do I care for others? Am I ok with this answer?	Do I abandon others? Am I ok with this answer?

III. To me by me:

Do I cripple myself? Am I ok with this answer?	Do I heal myself? Am I ok with this answer?
Do I care for myself? Am I ok with this answer?	Do I abandon myself? Am I ok with this answer?

If we do not dismantle that fourchotomy, this is how we choose to live: our lives will be guided by beliefs that all revolve around the power we associate with crippling and abandoning. We cannot want God and power. So to get power, we will either cripple or be crippled—these are the only options. There is no room for God in our calculations.

We may choose to be powerful by crippling. If so, we will want people to be weak, fragile, injured, ill, miserable, or otherwise at risk so that we can be powerful. We will sabotage others so we can feel strong.

We may choose to believe that if we are not crippled, we will be abandoned, not "loved"—that if we are independent and healed, others will leave us. We will then use being crippled and being abandoned as powerful tools. We will use them to get others to "care for" us and "heal" us the way we want.

Regardless, we are either the cripple or the abandoner. We switch back and forth. Only one person in the relationship will be allowed to be powerful or healthy. If you are walking on eggshells, someone is trying to cripple you—and that someone may be you.

In order to be free from this or any other fourchotomy, we have to give up power. We say we want to be happy, but are we willing to give up power to be happy? That means we have to be willing to be wounded. But we have to be able to handle being wounded, and we have to develop the capacity to heal ourselves. When we are healed, we are truly independent, and truly cared for.

The Wounded Fourchotomy….

Wounded	Cared for
Educated	Indulged

Stella, a young woman who identifies herself as good, was stopped on the street by another young woman. Stella was asked for $380 to pay rent, as the young woman would be deported if she did not come up with that sum. Rather than delving deeper to verify the woman's story, rather than going with her to the rental office and then discerning what was best to do, Stella went right to the bank and gave the young woman the money she said she needed.

Now all this could be okay, but it could also mean that Stella just wounded both herself and the woman. Stella works hard for her money; what if this woman is a drug addict? The outcome turns into everyone's being indulged and wounded. Stella indulged the young woman and wounded her. Stella indulged her own sense of goodness and wounded herself. Nothing good comes of this.

If Stella had taken the time to educate and really care for herself and the woman, the results would have been different.

Now Stella, through her present woundedness, has the opportunity to shift to educated if she is willing to grow and learn from this experience. She could wake up and see how "goodness" can wound and indulge, and how reality can allow for education and caring.

Another time, another place. As I left the eyeglass store, tears were running down my cheeks. The shop owner had thought he was educating his young assistant, but he was actually wounding her terribly. He belittled rather than instructed her. She, on the other hand, did not take on woundedness and instead received his abuse as education and cared for both the owner and the customers. She did not indulge him in any way, but treated everyone with genuine kindness and respect. She served the situation beautifully. Witnessing this was such a good lesson in how we do not have to play the part someone else wants us to.

In both of these stories we can see how a fourchotomy runs us, and that there is always the option of getting off the grid. Once we own all four of these traits, then we are free to choose because we are not attached to any of the four. We can truly assess what is the most appropriate action that will support Love. We will no longer be deciding but being, and the action will not fit our system, but fit Love.

This fourchotomy plays out in the story of the great Tibetan monk and poet Milarepa and his teacher, Marpa. Knowing that Milarepa had to expiate terrible misdeeds, Marpa had him build by hand and then tear down

eight stone towers. Milarepa did not understand that Marpa was caring for him by providing the means for him to purify himself. When nearly finished the ninth tower, Milarepa lost heart and fled. Marpa was distraught, because to him Milarepa was his son and heir. Only after further wandering did Milarepa come to understand that Marpa had cared for and educated him in the most compassionate way. On Milarepa's return, Marpa took him in and finished that education. Milarepa had to accept and transcend all four qualities in the fourchotomy; only then could he stop conflating education with woundedness, and caring with indulgence.

This fourchotomy probably starts for most of us as young children, because it is so closely tied to parenting and teaching. How many times do parents wound when they think they are educating, or indulge their children and think they are caring for them? How many times, when the teacher is truly educating, does the student believe the teacher is wounding him? And how many times does the student receive care from the teacher and think not that her practice is being nurtured but that her ego is being validated? As we grow, we no longer conflate care with indulgence, and woundedness with education. We then have the discernment to receive and give both education and care appropriately.

Where We Are Today....

For many people, what's happening in our country in 2017 seems unusual. It is not so unusual in my life. I have known people who had no core, so they were always craving to be the center of attention. Though they didn't realize it, these people believed their existence depended on the gaze of others. So they put people into three categories:

1. people that adored them and were loyal

2. people that hated them, whom they desired to destroy

3. people that did not count, who did not energize them

The only solution was to bypass and ignore them. They accommodated no one, and no one could say no to them without paying for it. If someone had the temerity to say no, they came back with a vengeance.

I was deluded on so many levels. My first approach was to serve the situation—to allow them to do as they wished as long as they were not crossing any lines that caused pain to anyone. But this arrangement could not last; it became clear that serving the situation had turned into a process of enabling them. My belief that they wanted to learn and grow in the same way I did was completely wrong. Modeling behavior for them only encouraged their feeling of entitlement; they believed they were always appropriate, so they were unteachable and didn't respond to modeling.

I was foolish because I could not believe they did not want what was best for everyone. They did *believe* that what they wanted was best for everyone, but in their mind, what was right for everyone was what gratified them, so they did and decided for others on that basis.

What snookered me more than any other action were their occasional moments of sanity. I loved those moments and thought they did, too. I encouraged them and praised them, only to find they did not like them because they did not feel like they were in charge at those times.

Needless to say, I left those relationships. Once out, I knew I needed to own their traits in order to be free, and neither create another such person in my life nor become that person myself.

We all now live in an environment dominated by a similar personality. Accordingly, we should all own the fourchotomies below as a way to free ourselves, get off the grid, and function appropriately. Reacting, or fighting in certain ways, only feeds that kind of person. In my case, I learned to look like a nobody that did not interest them, so they left me alone and I was able to act in my own interest and the interest of others. We are all in this together; no one is alone here. We all have to join together in appropriate action, and that is only possible from a place of freedom and Love.

No core	Inwardly grounded
Flexible / adjustable	Uncompromising / inflexible

The center of attention (as positive or negative)	Ignored
Held accountable / under a microscope	Free

Chaotic	Ordered
Creative	Stagnant

Impulsive	Restrained
Open	Closed down / rigid

Vindictive / has to have enemies	Lets things go
Holds others accountable	Doormat

Petty	Great spirited
Tough minded	Soft

Lashes out	Lets things go
Stands up for self	Doormat

Violent	Peaceful
Vigorous	Passive

Remember, we all think we are "good." That is our most deluded idea. Until we get off the grid, we can be lashing out when we think we are standing up for ourselves. Or we can be passive when we call ourselves peaceful. We have to own all four qualities in any fourchotomy if we are to be able to use any of them appropriately. Otherwise, we are only naming our actions wrongly, according to misconceived ideas that keep us imprisoned inwardly and outwardly.

Our goal is to be free, and truly who we are, no matter the situation or the people involved.

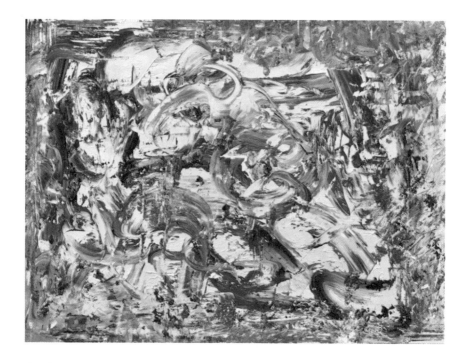

Brightening Glance (2019)

Baba's gift….

Your eyes look in
 i fall to where you rest
 live
with for you
 Baba
my love you Love us always

in each of us

i in my myness miss you

your Love dissolves us all

to All we return

 Baba pulls us

still you never left

it's not personal....

not for the lifestyle
not for

loved
 Baba the human
loved
 Baba the Guru

different
 yes
 and no

loved
 both
same

 human
 miss so much

 Guru
 always here

cannot be

 only when i is gone

both
him me us
 you

embrace both
 personal
 impersonal

how Guru plays
 in world

manifest purified

Guru
 human
 lightness

Baba Loved

played human
 Guru
disciple wants both

 maybe

Honoring Baba on his birthday....

O Rohini, give up seeking attention. You are dust under the feet of your Guru, Swami Muktananda. You are so lucky to be the dust at the Guru's feet. How many lifetimes did you work to finally get here?

Baba, you show me how and where to go; you illumine the way and guide me to you. I bow to your divine nature.

Like a dog following his nose I wander here and there. You pull me back from the mirage of pleasure. You take me to Love, the Source of All.

From our standpoint, that of the small self, we are separate. From your standpoint, we are the same. One.

From the standpoint of the individual the world is dual. From the standpoint of the Self it is One.

Nonduality only happens after we give up the small self; otherwise, we remain in duality.

Until I give up my nature I will not be God's Nature.

When the individual believes it is nondual, it is narcissistic. Only the Self is nondual.

We are limited when we lose ourselves in the wrong direction, outward instead of inward.

Baba, you model Love. We look to you, and you are always looking to your Baba and to God. That is the true Love.

Baba, I came to you to find the bottom line of existence. You reveal it. With your guidance, I have worked to free myself from all that hinders living at that bottom line, that ground of Being.

Baba, you have helped me see deeply into myself. You have shown me that my clues will not be as my character, my small self, expects. My clues will throw me around and break things apart that need to be opened. I thank you, Baba, for doing that every day.

You knew me long before I did, and yet you did not run as I had been running from me.

Around you, surrender is a cherished action that brings Bliss.

You crush me out of Love, and because of you I see it is not me you crush, but all I thought was me.

Only when I come to Consciousness do you have time for me. You always guide me to the Truth by the very way you act toward me.

Baba, you pay me no attention when I am lost in my small self. Why waste your time?

Whenever I feel lost, you not only show me the way back to God; you also show that I have never left. You show me that all separateness is illusion.

You love to play. Until you unlocked the cell of my own making I was imprisoned in my small self and could not play.

How many times I have wished you would save me, but out of Love you did not because you knew what I needed to go through.

Baba, you pay attention to Me. You use every weapon to disentangle the attention-seeking small self from Me, so I can see the Truth. You do not coddle.

Buktimukti. Baba, the Bliss of the world and the Bliss of liberation: that is what you want for me and for each of us.

Because you embody the Truth, you live the Truth and you share the Truth by everything you say and do. There is never a moment when you do not shine the light of God.

Thank you for allowing me to be the dust under your feet as you walk in *sahaj samadhi*, walking Bliss.

Jai Gurudev.

Baba's present....

no words

 All o

 r

 d

 s

you guide in all ways

forms vehicles express

 vibrations profound concrete

 subtle always

moving me towards Love

thecloser i get dissolves me

so thirsty was i you are the spring and the one that

 quenches my thirst almost drown

took in emptied out you filled

Babayou aregave thegreatestgift

 Muktananda showed rohini

 who was who

no parting....

the moon was full
 the son was gone
 i cried

shining in everything
 i missed you

until i follow your path
 i am lost

the light infused
 guides
 the moon

 back

to fullness
 reflected

surrender

 only to find

son did not go
 down
appearances
 can deceive

He never left
 now
i cry

 in joy

Respect (2015)

Respect	Patronize
Alienate	Care for

CHAPTER THREE
GURU AND DISCIPLE: BABA

Guru Purnima 2012....

Today is *Guru Purnima*, the Guru's Full Moon. Every day I bow down in deep appreciation for my Guru, Swami Muktananda, and all that he gave and continues to give me. The Guru is said not to be a person, body, or a personality, but manifests in a being that has purified himself/herself and has then become one with his Guru and God. Muktananda was such a being.

When I went to Baba the first time, I realized, through experience, that he had what I was looking for. Through that experience, I knew he embodied what I wanted to know. After that, I began the process of becoming one-pointed on my Guru. I loved and love Baba with all my heart and soul. People think that a person following a Guru loses their freedom. From surrendering to Baba, I actually got my freedom for the first time in my life. Looking in from the outside, it may appear that I had "no say." But Baba wanted what was truly best for me; he taught me how to discern that for myself. Baba taught me how to truly listen to me. He freed me from the tyranny of my shrunken self.

Now my job is to continue to listen and obey. By obeying my Guru, I continue to awaken from my sleep and remember my true nature, which is Love. I continue to practice. And the practice is there for each of us. Thank you, Baba, for showing me the way. Thank you for being with me, teaching me, and putting up with me. I bow to you today and always.

Today Walking Home with Baba: The Heart of Spiritual Practice comes out....

Today *Walking Home with Baba: The Heart of Spiritual Practice* comes out. This is a huge step for me. I have been practicing what Baba taught me all these 30 years since he left his body.

Walking Home with Baba on display at Blackwell's Bookshop in Oxford, UK

When I first went to Baba, I was not enamored of the trappings around him, but I was attracted to him, not really knowing what "him" was. Then, at a retreat, Baba revealed to me that he had what I had been looking for all along: the Truth of who we are. This was not through his public talks, where Baba expressed the Truth in simple and overarching language. This was through the experience of "knowing" beyond thought, which can so often cloud the Truth.

From that moment on, I have followed Baba, while he was in his physical body and then all these years since. Living the internal practice that underlies all traditions, the practice that Baba taught me, has brought me to today. Baba did not allow me to get attached to any trappings or external practices; he did not allow me to be repulsed by them either. He pushed me to stay neutral, focused on the Real.

This helped me so much when, after Baba's death, I returned to the United States to a culture I had never lived in. With a small baby and in a purely Christian environment, I was able to practice without anyone ever knowing. This practice was in fact the same one that Meister Eckhart, Julian of Norwich, St. Teresa of Avila, Thomas Merton, St. Anthony, and St. Symeon all practiced. Baba had given me what I had gone to him for: the internal practice beyond the senses, beyond the mind, where the will orients back to the Heart. He taught me this not as a nice idea but as a reality. It is a bridge that takes us Home, where our individuality is dissolved back to who we really are.

So today, after years of distilling and teaching what I learned, in Baba's honor, I bring forth this offering to share with everyone what this great Guru taught me and continues to teach me. I believe in my Heart that Baba is happy with this offering to him. I *pranam* to Swami Muktananda my Guru. *Sadgurunath Maharaj Ki Jay*!

Ganesh….

Baba used to call me Ganesh. At the time, the name did not bring joy into my heart. What am I supposed to learn from this? Why is he calling me Ganesh? These were my questions. Yes, I was in charge of security for the ashram. Yes, Ganesh was the guard at the door for his mother, Parvati. Yes, I was Baba's appointments secretary and therefore was guarding access. Is that all? Baba was never that simple. Everything had such a depth of import, if we were willing to see and listen. So here I am, thirty years after

Baba left his body, looking at this, just as every interaction I had with him was a clue in my treasure hunt.

A statue of Ganesh is usually placed at the entryway to a house or building. His image is that of a human male body with the head of an elephant. Ganesh both protects and is the remover of obstacles—hence head of security. So for Baba, I did what I was supposed to, and the qualities of Ganesh were appropriate.

As a spiritual teacher, I have continued to use these qualities. What could be more perfect than to remove obstacles for my students? Worth asking. It appears I do my job relentlessly and all too well for some people. Not everyone wants their obstacles removed. Outside my teaching, I am very aware of this. I can speak appropriately and let people be where they are, even when I am looking at the elephant in the room. However, when people come to study with me privately, I sometimes make the mistake of removing obstacles when all they want is to be coddled. Sorry to anyone for whom I have committed this error. My own lack of discrimination has caused that mistake. What I should have done was be quiet and not see you again. You could have come to my group classes, where I am less specific.

This brings me to Australia in 1978, when Baba yelled at me for allowing people to see him privately when it would have been appropriate for them to see him in the darshan line. For years afterward, I pondered this event. Why shouldn't they have seen him? What was the problem? Now it is so clear. These people did not understand the gift; they were wasting his time. So sorry, Baba, for that mistake; I completely understand now what I did wrong.

Baba used to say, "I give you what you want so that someday you will want what I have to give you." He was a great Guru, and this statement shows a Guru with great patience.

I am not a great Guru, and I lack Baba's patience. Remember, my role is that of Ganesh, the remover of obstacles. My manifestation is not so friendly towards the shrunken self.

The time has come for Ganesh to go out to pasture, so to speak. I am tired of having some students fight me while I am fighting for them. If you want to remove obstacles, you need to know that they are in fact obstacles, and you have to work with me to remove them. Otherwise, I will remain quiet. I, too, have fourchotomies, and here is one:

Bulldozer	Detached
Ganesh	Apathetic

We all need to decide whether we want Ganesh in our lives or not. Sorry, Baba, for not learning this sooner.

Grace Personified....

When I went to Baba, I knew he had what I wanted. I did not want to be the person in the back of the hall soaking in the *shakti* and learning nothing in the bliss of it all. I wanted all that Baba had to offer. I knew what I was looking for and knew he had it; I had experienced it. There was no stopping me, which meant I was going to force Baba to give it to me. How? By persisting. By being in his immediate presence as much as I could; by and through a personal relationship. Somehow I knew that the man Baba and the Guru were not different, and the closer I got to Baba, the closer I got to what I was looking for.

Did I know about surrender? Somewhat—and not as much as I was to then find out. Did I know about obedience? Yes. I do not know if Baba liked me; it was off the point. I liked him and loved him. As abstract as I tend to be, I saw the abstract, universal Guru embodied in Baba, so there I was, bowing down and surrendering to him. Did and do people see it as a cult? Sure. Like giving up my identity? Sure. My voice? Sure. What I knew was that every time I did what Baba said, no matter how unexpected, I became more real and grounded in my Heart. "Rohini" was clearly not important, and to me it was amazing she had not gotten me into more

trouble than she had. God and Guru were clearly looking out for me.

So as we approach Baba's *mahasamadhi*, I know the Guru is with me; what I miss is the manifestation of Muktananda. I loved and liked Baba the man as much as the Guru. Wrong? I never cared. I loved him with all my heart, both personal and beyond.

Baba laughed. His laugh was something that made my heart sing. People had to laugh when he laughed.

Baba played. When he played, we all enjoyed and played. Baba played on all levels. We needed to be awake to grasp the whole game.

Baba cooked. When Baba cooked, we may have been lucky to participate. Even if we did not, we got to enjoy the fruits. Baba was a great cook.

Baba yelled. When Baba yelled, I pray I learned. Baba was teaching me.

Baba spoke. When Baba spoke, no matter what the topic, it was sublime. Whether mundane or universal, Truth came through his voice.

Baba walked. When Baba walked, the grace he embodied spread everywhere.

Baba drove a golf cart. When Baba drove, he spread his joy.

Baba carried a stick. He used it appropriately.

Baba had vehicles:

His personality was lively, hot, sharp, and so much fun to engage with.

His intellect was fluid, agile, clear.

His mind was open, with a great memory.

His eyes were filled with unconditional love, and, though brown, looked blue even when he was angry.

His skin was luminous.

Baba hugged. When Baba hugged, bliss emanated from him and was

felt from head to toe.

Baba sat on the back steps of his house and shared the universe, while speaking, eating, laughing, questioning, ordering.

Baba called on the phone, and this simple act conveyed a supreme spiritual experience.

Baba surprised us all. He had the ability to see the whole picture. We could only see a small area, so he surprised us by his actions and decisions all the time.

Baba showed the Truth through everything he did.

Everyday living with Baba was a gift I never took for granted.

Baba taught on all levels at all times. The Guru always shone through him.

On the lunar anniversary of Baba's *mahasamadhi*, I pranam to my Guru. Though my Guru dwells everywhere, he dwelled in the form of Swami Muktananda, the great, self-realized being. I miss my Baba.

Believing in Baba....

Let's get this out on the table. There are people who received tremendous gifts from Baba, but once the "sex scandal" came out, they left. These people say they cannot come to grips with what he did. What did he do? That is the question. Did he have sex? Apparently not: no one I know of has said he did. What was it then? A tantric ritual? It looks that way, but I was not there. I cannot say what happened because, when I was given an opportunity, I didn't take it. Did Baba have a problem with my decision? No, not at all. I took that experience as a test of where I was, not where he was. Some will say, and have said, that Baba was powerful and you could not say no to him. Not once in all my years of being so close to Baba did he ever make me feel that I could not say no to him. I did say no to him, many times. Did I know Baba had great power and was a true

Guru? Yes, and I still would say no to him—and if I was wrong, we would find out.

Baba was a Great Being from a tradition about which most westerners have no idea. People who came to Baba thought they knew what all this spirituality was, but when they got close to the fire, things were not what they expected. We do not "know" until we unknow; then, what once made no sense becomes clear. I went to Baba to get to the Truth. I was not looking for a lifestyle or some psychedelic experience. I wanted the bottom line of existence. From the first, I knew that Baba wasn't just about the *shakti* and wild experiences; Baba lived the Truth. I wanted what he had. So I pursued him with all I had.

What I wanted was invisible, internal, and eternal. The ashram dharma, the chants, the *seva*, the politics, even the people were not what I was interested in. I wanted what Baba had. Nityananda had manifested in a certain way. Baba manifested in a different way from his Guru. I manifest differently from each of them. The inner sameness is what I am after. The inner state, not the outward play.

Baba gave each of us what we wanted. He used to say, "I give you what you want, so that some day you'll want what I have to give you." He gave each of us what we wanted at the level where we were, and challenged us to go deeper. In my case, Baba showed me real internal practice, and I have not been disappointed or disillusioned, or in any way ever had the need to find another teacher. Baba continues to come and teach; he has never left me.

It has both bothered and saddened me to see the level of promiscuity in people's spiritual lives. They move from teacher to teacher, tradition to tradition, cobbling together personal spiritual "journeys" that lead them nowhere. For many, spirituality is really just dressed up hedonism: they are looking for the ultimate pleasurable or aesthetic experience. I learned from Baba that sadhana is never about "experiences," nor is it ever about

patching together something called a personal spirituality. There is a reason to stay steady and to discipline ourselves internally as well as externally. We must create a strong vessel to receive what the Guru gives us, and then be able to dissolve that very vessel so that we can merge back into God.

Baba never let me down. He was always consistent. I trusted him because in part he had proven himself completely trustworthy. Was being with Baba easy? No. The Guru is here to drive us Home. We say we want to go there, and yet when things get a little uncomfortable or strange, we pull back the reins and find ourselves back at the beginning, nowhere. Surrender is everything around a Guru. What do we surrender? Everything that is not Real. So we are no longer attached to our pride, self-esteem, intellect, and emotions. Scary? Yes, if you do not know whom you are with. I knew and still know that Baba was Real. Baba was and is a true Guru.

During meditation last week, I got that Baba sacrificed his reputation and everything worldly for each of us. He wanted us to focus on the Truth, on God, not the comings and goings of an institution. I am sorry that there are people who feel hurt by his actions. I am sure there were many who felt wronged or hurt by Baba. I understand how hard it has been for them. They have to stay true to what they believe, and I pray that at some point they will have resolution in whatever form it may take for them.

For me, there is no conflict, so there will be people who think I am blind, ignorant, and deluded. Maybe I am. But as I move through this life, I find every day, whether life is easy or a struggle, that the practice and truth that Baba instilled in me grow stronger and brighter, and everything is clearer, calmer, and filled with love. There is less of Rohini every day, and more of Baba, filled with love and peace in God. So if I am deluded, so be it. Call Baba what you will; for me, he will always be *satguru*.

Raised By Baba....

When people say there is nothing like a mother's love, I ask them what they mean. The usual responses to my question are unconditional love, warmth and compassion, softness, caring, and giving. For me, those qualities are not limited to a mother's love. They are not gender-based. I have met men with these qualities. My Guru lived and expressed them.

As a mother, I hope I have demonstrated these qualities, but not only these. My job has always been to model being fully human: both male and female, both strong and soft, both caring and disciplining, both giving and receiving, both fun and serious, both principled and open.

My job was never to protect my sons from living their lives, but to give them the skills to handle whatever they came across. That meant training them and making sure they were equipped with the appropriate tools. There were skills that both had to learn, and ones each had to learn that were not that important to the other. If I did not have the ability in a particular area they needed, I would find someone who did. This work was never about "the mommy"; it was about equipping my children for the life in front of them. By teaching them the truth, I showed them they did not have to be naïve. By not shying them away from the Real, I took on the responsibility of showing them how to embrace the Real.

Many people say that as we get older, things change. No, they do not. What we faced as children, we will face as adults—unless we work hard to learn our life's lessons. The foundational skills are crucial to how we will approach our life's challenges. This goes for everything in our lives. As a mother, I knew that parenting was not about my idea of my sons; very early, each showed his strengths and weaknesses, what needed to be developed and encouraged and what needed to be reined in and discouraged.

I was brought up at a late age by Baba. Because, having learned from him, I embrace all qualities and work to manifest them appropriately, some may judge that as a mother I am cruel, mean, or harsh. Maybe they are

right; but I am also kind, compassionate, and soft.

The following fourchotomy is for all the parents and teachers out there. Accept all these qualities and free yourselves to be more fully human and to respond to others as human beings.

Cruel / mean / harsh / no love	Kind / compassionate / soft / love
Strict / disciplining / clear / caring	Fawning / condescending / weak / enabling

Baba modeled this nonattachment, and raised me to do the same. As a mother, I raised my children in the tradition of Swami Muktananda. If you have any questions, feel free to ask my sons.

Surrendering to Baba....

Why do we seek great spiritual beings? Why are great spiritual beings here? What do great spiritual beings offer? The answers to these questions come from my experience with a great spiritual being, Swami Muktananda.

Within each of us is the longing to be whole again. We all move unconsciously towards whatever will bring us to ourselves. We must, though, consciously seek a resolution to the question: Where am I going?

A great spiritual being will answer not only that initial question but all our questions. What amazed me about Baba is that he was able to answer everyone's question from their particular standpoint. Baba was so non-attached that the answers would come out fluid and perfect for each person. Baba was not rigid: the one rule was to be true from within. So outwardly the solution to any situation could and would change. We were not to be rigid; we were to learn to listen and be appropriate, just as Baba was.

The reason we seek great spiritual beings is that they have answered life's questions and have come to the final experience of pure Love. When we are in their presence, we catch their bliss. It is contagious. We catch their

Love and flow with them into the sweetness of the divine. In Baba's presence, the waves of Love would sweep over us and we would swim with Baba in the divine blue shakti.

Baba was here to share and teach us the Truth. He expressed the divine in all that he did, because there was nothing in Baba that was not God's. So when he walked, talked, ate, chanted, yelled, laughed, or sat quietly, the divine was always being expressed. For Baba, there was no individual; there was just God.

This Love is everyone's birthright, and Baba embodied it. That was why he was here: to direct us to us, just as his Baba had directed him. Baba wanted us to be just like him. And the more we surrendered, the happier we were, and therefore the happier Baba was—if that was even possible.

Baba was the most human person I ever met. Baba made me human and removed my idea of "normal." Baba cleared away what we bring to the table, that which makes us miserable individuals. He wiped clear our "normal" to make us actually human.

Many people liked the experience they had around Baba but were determined to remain "normal." They resisted surrendering to the Guru, and so could not receive what Baba had to offer us. He offered us Joy, Peace, Love, Truth, and release from ignorance. People did not want to let go of what they thought they were. And so they remained miserable, despite having been shown the solution to all misery.

Do you want to be human or "normal"? When we have given up "normal" and surrendered to God and Guru, the "normal" individual does not get in the way of our lives.

Baba gave us true autonomy. He did not want us to be dependent; he wanted each of us to be free. Baba swam in the bliss of divine Love, and that was his legacy. Even today, anyone who focuses on Muktananda and surrenders to the Guru will come to the Bliss of freedom.

The Guru Models....

All my years with Baba taught me how to live. Baba was a great model for life. When I say this, I do not mean that he showed me I should wear orange robes if it is not my dharma. I do not mean that he showed me that I should live in an ashram if it is not my dharma. I do not mean that he showed me that I should be a Hindu if it is not my dharma. Instead, Baba modeled that each of us has a part to play and we should play that part fully. He modeled that we are not to be identified with the part we play; we should be detached and free. He modeled that we are to uncover our Self; we are to reveal who we truly are and be that Truth.

Baba modeled by being true to himself. He knew who he was and who he was not. He was identified with the Self because that was who he was and is. All his action came from there. Baba's every action shined a light. Whatever he did revealed the Truth of the moment. What did Baba do? He sat, spoke, walked, ate, played, worked, chanted, emoted, meditated, read. And through each and every action, the light of Grace shone.

For me, if I cannot be awake in the mundane actions of life, how can I be awake to contribute to the greater good? Most of us are blessed with a life conducive to practice. In other words, we are not bombarded with the frantic life of someone in the public eye or with the horrific pain of living in a war-torn environment. We do and will have challenges, but if we allow for the light to shine on them, we can see that they are there for us to grow closer to God. Yes, all experiences provide that opportunity, but some are easier than others.

If we as a whole are maintaining balance, then the swings of pain and pleasure within the world are small. When we are off balance, then pain is great for some and pleasure great for others. When we as individuals are off balance, we can alternate between pleasure and pain. Our separateness becomes more pronounced, and concealment rather than revelation becomes the goal. Darkness becomes more prevalent, and the qualities of

greed, anger, and delusion influence our actions. We remain outward-turned, and refuse to reflect because we say it is too painful. And yet we do not acknowledge the pain we are swimming in daily.

Baba knew what I needed; he handed me a stick and told me not to be afraid to hit someone. Baba knew how attached to the martial I was. By giving me permission to be just that, he freed me to embrace it consciously and ultimately to still my investment in the fight and be free from that attachment. Baba modeled acceptance, which then allowed the light of consciousness to reveal the truth about the part I am to play.

I have read *The Art of War* by Sun Tzu many times. For me, this approach is so familiar and comforting; a way to assess the world around us clearly and to proceed in our action effectively. Baba was a monk who understood All. Because of this understanding, he was able to model an appropriate approach for each of us. By allowing me to be a fighter, Baba made me into a Lover.

Our world is presently out of balance. We cannot simply decide to be peaceful, because that imbalance informs everything, including our approach to peace. If we each approach the imbalance in our lives with honesty, inwardly turned and recognizing that we are all contributors to this imbalance, then we can take the first steps towards disentangling and finding real balance and acceptance. We can learn, as Baba modeled, to still our narrative so as to reveal our true nature, which has never left. We will then act from the true Self and will right the imbalance within and without. Thank you, Baba, for modeling for us all.

Respecting Lineage....

If we want to learn, we have to surrender to instruction. This holds true in any area, but never more so than in spiritual practice. When we submit to instruction, we have to willingly diminish our autonomy. By giving up our say, we climb out of the kiddie pool of shrunken ideas and

plunge into the ocean of true knowledge.

What tends to keep us from this surrender is our own self-loathing; we hate whoever we think we are. Who we Truly are, the Self of All, rebukes in its very Being all our narratives about ourselves. Though we conceal this from ourselves, we hate the shrunken selves we perpetuate with our narratives. We refuse to accept this self-hatred, so we project it outward onto the world around us. Once we have made this move, we have given up all our power to outside forces, and we have no ability to free ourselves and get back to the Real.

True teachers of any sort are situated in a lineage. They submitted to instruction in order to become masters in their chosen fields. They completed their apprenticeships. If we don't surrender to a spiritual teacher and instead believe we can do it ourselves, we are self-directed and will never be able to give up the shrunken self. Instead of working toward the Bliss and Freedom of the True Self, we will continue to insist on our miserable autonomy as self-hating little tyrants.

The Guru is always bringing us back to the Real. The Guru listens within us and shows us how to be happy. We do as the Guru instructs, and we experience happiness. But we are furious about this. We want to create and choose our own happiness according to our own individual will, so that we can feel absolute sovereignty over our lives. So we hate the Guru. And we act out against the Guru.

Life with Baba was filled with chances to choose between Love and hate, and he always gave us opportunities to let go of our read on things in order to see them as they truly were. Every day there were tests for anyone willing to take them.

In 1977-1978, I worked in Baba's courtyard in Ganeshpuri. Many a day I would stand there alone; often, not even Baba would be present. One afternoon, Baba was looking out the window of the meditation room into the courtyard. He looked like Krishna himself. He smiled at me and

indicated that I should come to the entrance, which was on the far side of the building. Then he disappeared from the window. When I parted the curtain in the entrance, Baba was standing just behind it. He gave me a hug, and I hugged him back. It was a close, tight hug. I then *pranam*ed and left.

The next day, Baba was at the same window again, looking radiant and full of Bliss. He signaled to me and left the window again, and I went. This time, he kissed me lightly on the cheek and held me close. I *pranam*ed and left. This time, I didn't like it. I felt I was being tested, and walked away uncomfortable.

The next day, Baba was there again. When he signaled for me to come and left the window, at that exact moment Ron Friedland, then president of the SYDA Foundation, happened to walk by. "Ron," I said, "Baba wants to see you in the meditation room." I've always wondered who was more surprised when that curtain parted.

Later that afternoon, Baba's valet said to me that Baba had had work for me and I hadn't come. I did my best Indian head nod and said, "Yes, I know." That was it. When I saw Baba later and ever after, he treated me with the utmost respect and Love, and I always felt I had passed a test.

Over my years with Baba and after, I knew many people who had wonderful experiences and grew tremendously in Baba's presence. At some point, each of them hit a wall, a point at which what happened for them with Baba would not fit into their ideas of themselves and enlightenment and spirituality. Most of these people wanted their shrunken selves to be enlightened; they wanted to maintain their autonomy as separate people and possess liberation from there. Never mind that Baba always taught that there is no such thing as a liberated individual. This rebelliousness against Reality, God, and Guru led them to reject Baba, often in the harshest possible terms. The shrunken self is vicious when it feels threatened, and regards itself as the ultimate victim. These people did not want to surrender to the lineage or to God.

I love Baba with all my heart and soul. He has never let me down. His Love melted my self-loathing—because I surrendered to the Guru.

Guru Purnima 2015....

The Guru's moon. While Baba was in his body, *Guru Purnima*, the full moon in July, was celebrated with thousands of people paying their respects to Baba. At this time of year, Ganeshpuri experiences the monsoon. We would hear the rain coming and run under the overhangs on the buildings. The weather may have been brutal, but it did not stop anyone from having the opportunity to *pranam* to Baba.

Now that Baba is no longer in his body, *Guru Purnima* is not only about remembering the times we were with Baba. This is a time to revitalize our *sadhana*. This is a time to sharpen our awareness that Baba is alive and in everyone. This is a time to examine whether Baba is in every room of our houses.

The more I practice, the more I experience that Baba is alive. When I say practice, I do not mean the regular chanting and *puja* we performed in the ashram. Practice, for me, can be and is performed wherever I am; practice is internal. After Baba took *mahasamadhi*, I waited until my son Ian was born in Bombay and for him to get strong enough to travel to return to America. Once back in the States, I found myself in an environment that did not encourage or support any of the culture we had been immersed in all those years with Baba.

Whatever God does, He does for good. Baba was always pushing me to learn not to entangle internal practice with outside action. He was always teaching me not to attach my vehicles to the practice. Being in a place that did not accept the outer expressions of *sadhana* encouraged me to hone my inner practice. No matter what I was doing or saying, I worked to practice.

So as the *Guru Purnimas* passed, Baba became more and more alive for me. He is still here for all of us. He has not left. In the last fifteen years, I

have been able once again to openly acknowledge my Guru, Swami Muktananda. Baba does not need me to praise him; this is for me. Acknowledging the one that gave me life and showed me the way back to God is for every disciple. Baba modeled that for us.

Baba always gave credit to his Guru, Nityananda. We are to do the same; we are to honor our Guru. Focusing on who gave us the most important gift helps us from losing that very gift. The shrunken self wants to take ownership of what each of us has received. When that happens, the gift is made shallow and empty: what Baba gave us becomes a shrunken memory rather than a vital truth.

With this *Guru Purnima*, let us share with each other the Truth that Baba shared and continues to share. God dwells with us as us. God dwells within the Heart. We are to rest there and emanate from there. There is no better tribute to the Guru than to imbibe and manifest what he taught. Baba loved each of us; we were to be ourselves. We are to continue to remove the obstacle of wrong understanding, of wrong identification with the shrunken self, so that we truly live how our Guru wants us to live: in God, in Guru, as Love.

Patience....

Baba was incredibly patient. Over and over again, he addressed an issue from every possible angle for the sake of the disciple. He was always changing and adjusting his approach, so that the student could grasp what he needed to understand.

By his very being, Baba modeled that patience is not putting up with what should not be tolerated. For someone committed to power via some form of woundedness or incompetence, patience is always putting up with one thing or another; to be "good," we must put up with. Baba was not like that. He was patient without being a doormat.

Patience	Agitation / impatience
Putting up with	Decisiveness

People saw, in their minds, Baba being agitated/impatient. They did not understand that Baba was being decisive. But people expect teachers to be patient and put up with all sorts of dysfunctional and inappropriate behaviors. Baba was such a great model for me. When he would just look away—wow. If you had any understanding, you knew. You knew this was not about Baba; this was about you. You needed to realize you were not being appropriate.

He was patient with me. He was patient, patient, patient, and when I couldn't make the change, he was decisive with me.

He made me watch this with others. While I worked closely with him, he would show me when people were power tripping and how he would give them the chance to stop it. But if, alas, they were determined to win, Baba would have to be decisive.

When I was in a difficult position during my time as Baba's appointments secretary, I felt powerless. I wanted the situation to change without costing me my job. It was completely untenable. Baba of course knew what was happening and was patient with everyone involved—until finally, for all of us, he made a move. He did the most loving thing possible. He took me out of the mix. Out of the job. He freed me in a way I had been unwilling to free myself. I knew I needed help, and he took action. Thank God I lost.

I had to lose in order to get what I wanted, and what Baba wanted for me: Love. My perception that the job kept me close to Baba was mistaken. Baba wanted me to go to God, and the only way out was to get rid of the job. He was perfectly free, and did not care about the roles we all played; he cared for each of us. So care looked very different from what some might expect.

A false guru would have exploited a person in my position, encouraging her to stay in the job rather than do what was best for her.

In dealing with the mundane, Baba was always leading each student toward Reality. But he knew we all had to learn first from the physical plane. And so many people thought that work was beneath them. Or they thought, superficially, that work on that level is all there is to spiritual practice. And yet Baba was patient, hoping each one of us would willingly see things as they truly are and understand the physical plane as an echo and not Reality.

The Guru always wants what is best for the disciple, what will bring the disciple to Love. A student who is not interested in going to God, to Love, will resist what the teacher directs. Love does not always look so attractive. So the shrunken self will dismiss the Guru's teaching. But Baba was patient; he would continue to give until finally there was no hope. Then the student won—and lost everything.

Baba's patience was anything but putting up with what should not be tolerated. Putting up with is not healthy for anyone, but we have to be willing to see that we demand that from our teachers. Baba was generous, because he was truly clear. Because of his patience, so many of us were given so many opportunities to become aware of the gift he was offering.

True Guru....

Baba left his body on October 2nd, 1982. At the time, I was seven months pregnant with Ian, my first son. Ganeshpuri had been swirling with conflict and controversy. Because of my pregnancy and my job as librarian of Baba's closed library, I did not have much contact with all that was being said. Also, people tended to shy away from me. I, too, had been a controversy and was not much liked. Never was the popular kid.

I stuck to what I knew. Baba had always been unfailingly true for me. Did I deny the rumors? No. Neither did I embrace them and act on them. All I had were my facts. Could Baba have done something wrong? Of

course he could have. Had he? According to a lot of people, yes. Did that change my relationship with him? No. I had lived and seen too much to change my relationship with Baba.

So for some, I am the disciple of a bad True Guru. I cannot defend Baba, nor do I need to. Dada Yende, another close disciple of Baba, defended him one day in the courtyard so many years ago. Still, people were hurt. People were offended. People felt betrayed. I did not—not because I was insensitive to their pain, but because I didn't presume anything anymore. So many things I had been so sure of had turned out not to be the way I thought they were.

Using all kinds of approaches to label what Baba did or did not do does not resolve the pain felt by many people. For this I am sorry. The problem for me is that in all my years working closely with Baba, I never saw him be malicious, cruel, or abusive. I know there are people who will say his actions were abusive, and that I am being blind. Baba was a True Guru who did things that left people feeling damaged and betrayed, and he remains my Guru.

Recently someone looked up Baba on the Internet and found all the stuff about the scandal. It followed for this person that because people said Baba had done wrong, I must be wrong. To avoid facing similar criticism, many of my Guru brothers and sisters have erased Baba from their personal narratives. I have been shocked to see people I know who got so much from Baba now deny they ever knew him. Unwilling to face and wrestle with all that had come forth, they threw everything out. Baba was a True Guru who did things that left people feeling damaged and betrayed, and he remains my Guru.

Do I condone what he did? The truth is I do not know what he did; I only heard what he did, in some cases directly from people involved. I have written about my one encounter with anything of this sort (in "**Respecting Lineage**," p. 132); I took it to be a test and answered "no" by my actions.

Baba never then shunned me or treated me with anything other than respect and Love. But in many people's imaginations, Baba has been defined completely by one set of stories. Baba was a True Guru who did things that left people feeling damaged and betrayed, and he remains my Guru.

So today I will accept that Baba did everything that people say he did. Today I will not rationalize or give any scriptural or tantric explanation. Though I did not see any of it, I will not deny what people have said, and I am sorry they were hurt. As for me, I owe Baba everything, and I love him with all my Heart. I am so happy to be the disciple of Swami Muktananda. Baba was a True Guru who did things that left people feeling damaged and betrayed, and he remains my Guru.

I separate the man from the Guru and the teachings. But I loved both the man and the Guru. The man had all the complexity and karma that we have. I am sorry that, for some, the man let people down. He never let me down. For me, there is no difference between Baba and the Guru. The Guru, His teachings, and His inner practice, cannot let any of us down. I *pranam* to my Guru, Swami Muktananda. Because of him and what he taught, I am where I am, and for that I am most grateful.

Baba, I Love you with all my Heart and wish you were physically here now. I miss your physical presence in the midst of my turbulent *sadhana*. Right now, I am in the midst of an intensive *shakti* change, and I would give anything to sit with you and receive your help and direction. I relied on you, and I still rely on you. You never fail me.

I know how hard it can be to understand how someone in Baba's position might operate. I understand also how hard it must be for some people who feel damaged or betrayed, and I pray for their healing and resolution. But at the end of the day, my Baba is the Baba I knew and know, and in all my years with him I never saw him be abusive, coercive, or anything other than full of Love.

Om Bhagavan, Muktananda Bhagavan....

As I grow older, my appreciation for Baba only deepens. The more I learn and let go, the more my understanding of what Baba taught, and the way he taught, continues to expand. When I first followed him, I knew enough to be able to treasure Baba; now that I understand so much more, I can't thank him enough.

Appreciate / treasure	Insult
Flatter / grovel	Candid / clear and honest

Deferential	Disrespectful
Obsequious	Undazzled

Give credit	Bury / suppress
Diminished	On top

Acknowledging	Belittling
Groveling	Independent

Appreciating Baba did not mean I was a blind follower. I simply knew that I didn't know better than he did. At least I was clear-sighted enough to understand some of what he had to offer. Baba used to tell the story of the jewel that was appreciated only by the expert jeweler; people who had no understanding just saw a worthless stone.

The ego loves to criticize and keep separate and call that discernment. When we appreciate someone else, the grip of our ego is loosened. But we have to be willing to appreciate someone openly. For many, appreciating someone they don't know is easier than acknowledging someone close to them; power and the desire to win take precedence over intimacy and Love.

Baba just Loved. Whether he was angry, happy, sad, frustrated, or whatever, he Loved. It was never a question of power or winning, at least not for me. I knew I wanted what he had. I adored Baba and who Baba was.

And Baba wanted each of us to have and be who he was. How lucky we are. He willingly gave each of us what he had to offer.

Baba taught every one of us according to our nature. When I started with Baba, my warrior temperament was all too apparent. So, of course, security was going to be my focus. Baba taught me security on all levels. He taught me first how to be secure in the most superficial, worldly sense, and then how to practice security as I pierced deeper and deeper inward.

On the mundane level, I was in charge of security for the Ganeshpuri ashram. As many as thirty men, including Gurkhas, worked on security at any given time. My job was to make sure everything was safe for the ashram to function properly. That meant removing mangy dogs, enforcing ashram dharma, catching thieves of all kinds, and guarding access to Baba. He didn't need me to do any of these things, but he wanted me to learn what I needed to learn, and being head of security was the perfect venue.

Guarding Baba was the key to learning how to guard the Heart. Whether in the courtyard or by the back stair, my job was to be always one-pointed on Baba. There was to be no distraction, no wandering, no slipping. The place where I truly learned to guard the Heart was the back stair. I would go there after lunch. Baba would come out the back door of his house and sit on the stair; I would stand just a few feet away. We could be silent or conversing. Baba might want someone or something or not. In the interior background, there was a constant, intense pulling inward toward the Heart. So no matter what appeared to be going on, I was in the midst of an education in guarding, in one-pointedness, in focusing on where everything came from. Baba would not let me stray. He would teach me and then expect me to apply this practice away from him as well.

Baba called me Ganesh. Ganesh was the guard at the door for his mother, Parvati. He was constant, vigilant, devoted, and always reflective. Baba was always driving the lesson, always working to get me to stay in the Heart. He was willing to create outside activities to facilitate the practice. He

did this for each of us. Whether we were gardening, sewing, cooking, cleaning, teaching, or guarding, for him personally or for the greater community, the practice of guarding the Heart was to inform everything.

What a gift he gave us. I will never be able to repay him. Baba taught me to guard the Heart by having me stand guard and never leave my post. Never leave the Heart. No desertion allowed.

While I was in the ashram, people for the most part did not like me. But I did not go to the ashram to be liked; I went to learn from Baba. That was my mission. It is still my mission, and I still get that some people do not like me. I am not very social, and I am definitely challenging. If, though, someone else is on the same mission, we share at a depth that I greatly appreciate.

When I had malaria for the second time, I did not report to my post at the back door to Baba's house for a couple of days. I thought my absence didn't matter. But it did. To Baba, everything mattered and did not matter. He wanted to know where I was and he wanted me there. Someone may think him unkind; after all, I was sick. In fact, he was freeing me from the malaise. This bout of malaria was different from the first, when Baba saved my life and had me quarantined for two months. This illness was a year later. He sent me medicine and food and then let me know I needed not to fall into weakness. It worked. The bout was not as severe, and I was well within a week.

I appreciated his care for everyone, and how in every situation he knew the right course of action in a heartbeat. Baba discerned the right path for each of us and then guided us on that path.

Though I have given up my warrior life—my stick has been retired—I use all the skills Baba worked to cultivate in me, so as never to leave my post. I am still Ganesh, still Security, and becoming still every day.

There are no words to thank the Guru, no words to thank Baba. I shed tears of joy and of longing for his *darshan*. Thank you, Baba, for giving me life.

Guru Purnima 2016….

Baba gave me everything—by taking everything away. For that I am so grateful. He shined the truth so brightly that it forced ignorance to run away and die. Wrong knowledge was the food he devoured daily. Our job was not to resist his taking away every delusion we held so dear. And sometimes he grabbed something away from us that we had no idea we were holding onto. In the moments afterward, we cried like small children who had lost an object only we found precious. If we surrendered, the joy and relief were beyond thought, and we were bathed in bliss.

[A] mirror is not kept clean for its own sake, but in order that a man may see himself in it. (*Jnaneshwari* XVIII.lxiv.1338, transl. Pradhan)

Baba Loved and lived in the Absolute. For our sake, he emerged into relative reality and willingly engaged with our diminished, impure selves. He created dances so that we could see our shrunken condition for ourselves and work with him to get rid of them. So many times, the same *lila* had to be played out again and again. We just refused to let go of who we weren't.

Baba was so patient. So patient. I don't know how he did it. He would carry out a dance over years and still we would refuse to accept the truth. For me, he always had to take it to the extreme to get me to see. And when I finally surrendered, there was so much joy and freedom; I looked so silly to have been holding on for so long. All he wanted to do was to take away what kept each of us from being Muktananda—the Bliss of Freedom.

The Guru tirelessly gives by taking away our wrong understanding. He then incinerates it in his own body so it cannot return. He chooses to take on our karma in order that we will realize the Truth within ourselves.

Truly, the Guru functions as a mirror in which you see your own reflection. In the Guru, you see and attain your own Self. (*The Perfect Relationship*)

Baba always showed us the bliss within us. He was always pointing us in the direction of our own Self. Once we were lucky enough to have the

experience of the Self, it was then our responsibility to work with Baba to clean everything that kept us from the Self. So Baba showed us the goal, showed us the path, guided us along the way, and removed the obstacles before us. He revealed how we really can never "attain" anything; rather, we must remove what keeps us from re-cognizing and realizing the Self. How could we not appreciate, honor, and *pranam* to such a Being?

His joy in Me is like the light reflected back and forth between two polished mirrors. (*Jnaneshwari* XVIII.lv.1133, transl. Pradhan)

It gave Baba great happiness, though he didn't have any need of such happiness, to see us give up more of our wrong understanding and find ourselves closer to Muktananda. His goal was that we all realize the Self. And the only way to do that was for each of us to give up the ignorance we clung to so tenaciously. Baba worked for all of us. He Loved all of us. In taking away everything we needed to let go, he gave us everything—so that we, too, could be Muktananda.

By means of a mirror one object may seem to be two; but in point of fact, are there really two? (*Jnaneshwari* IV.vi.46, transl. Pradhan)

Baba's Mahasamadhi 2016....

I miss Baba. I miss Baba's form. I miss Baba's laugh. I miss Baba's speech. I miss Baba manifesting through Baba's vehicles.

From everything Baba taught and shared, it is clear that he was focused on his Guru, Nityananda. The Self of All was Baba's focus. Baba rested in the Heart, where God and Guru reside.

As for me, I loved all of Baba. So just the *shakti* is not enough; I miss the container of that *shakti*. I miss how that *shakti* played with us through the form of Swami Muktananda.

The night Baba left is embedded in me. The sound of *Om Namo Bhagavate* slowly being chanted. The full moon brightly shining on the

ashram. The unacceptable reality that Baba had left. The shock and disbelief being expressed through words and silence in the courtyard. I was determined to see Baba's form one last time. That I was seven months pregnant with Ian had some people afraid I would go into labor. "Don't cry, don't mourn, it will affect the baby," they said. When I did see Baba, I did a full *pranam*. Baba's body was still supple as he sat there in his house.

As the days went by and the reality seeped in, I found myself angry that he had departed and left me lost without my focus, him. Baba had never encouraged me to do rituals; our relationship was based on the internal practice—keep driving in toward the Heart and resting there. This relationship was not abstract. The practice was not abstract. I loved practicing with Baba. I loved being in Baba's presence and boring in to the Heart. So, though the practice is internal, Baba and his form aided in its happening. With Baba, no matter what the play, what was being said or done, he was always still inside. So quiet, no vibration. Even when he manifested anger, the stillness was always there.

The message was always the same: God dwells within you as you. Not as the shrunken self, but as who You truly are. Baba was always speaking to the You, the sun and not the moon. The moon is our shrunken self that disappears and is enlivened only by the sun, our true Self.

Everything Baba did was a gift to all of us. So his *mahasamadhi* was a gift to all of us. Everything Baba did was a teaching, a removing of darkness to reveal the light. What was temporary left and what was permanent remained. Each of us is given the opportunity to experience what is permanent. Baba showed us over and over what was Real and what was going to fade.

So the more Rohini fades, the more Baba is here. The more we surrender our shrunken self, the more room there is for Love and Baba. Baba modeled this for us by sharing his love for his Guru, Nityananda.

Rohini fades by surrendering, by resting in the Heart. Rohini fades by

being with her experience, letting whatever comes up from the experience come up, and functioning appropriately on the physical plane. In those moments when it is clear that Baba is walking in the garden or is in the meditation room, when his presence is so strong, there is a knowing that all is right here in the world.

Honoring Baba with the Guru's Words....

There is no better expression of gratitude than to live the Guru's words.

Muktananda says:

The world is an extraordinary drama. The Shiva Sutras *say,* nartaka atma— *"The Self is an actor." The world is God's theater, God's play, and the sport God has created for His own pleasure. A person who understands this understands everything. For him there is no room for duality or enmity and no reason for hatred. Any form of duality is merely ignorance, the gift of the great maya and the friend of the god of death. (The Perfect Relationship)*

There is something that you should remember: A person who becomes aware of his own ignorance is drawn to the Guru's feet, but the pride of knowledge gleaned from dry books leads one to look for scriptures rather than for a Guru. Although the scriptures emphasize surrender, vows, and discipline, they are lifeless, so one does not really have to surrender to them; one can interpret them in any way one likes. But one cannot interpret the Guru. You may change the scriptures, but the Guru will certainly change you. He will begin by awakening you, by telling you that you have forgotten your own Self. Lacking knowledge of your Self, you are deep in the sleep of ignorance. The Guru will open your eyes to your darkness, ignorance, and forgetfulness. Only after knowing darkness is it possible to find light. Only one who falls can get up. Unless a seeker knows what it is to fall down, it is difficult for him to rise. After the Guru has made you aware of your condition, he will give you the vision of your own Self. (The Perfect Relationship)

It is difficult to attain the true state of meditation; the fact is that you reach that state only when you are completely prepared to erase yourself. Meditation first obliterates

you; it kills you. But do not be afraid—meditation is not a murderer or a butcher or a violent assailant. The words of a saint will help you to understand this…"When I realized the Pure, I became pure. My ego was no more. I myself became God." When the saint discovered oneness, he merged into everything. When his ego was annihilated, he himself became God. This is very mysterious. To die while still living is to become deathless and immortal. Many people fear death, but in this sort of death the individual soul becomes Shiva. It is not a literal death: Meditation simply erases one's small self and thus makes one God while one is still alive. (The Perfect Relationship)

Love is the supreme attainment. Without love, everything is useless. The world manifests through the power of God's love, it is sustained by love, and it will ultimately merge into love. That love throbs within us at all times. (Secret of the Siddhas)

Jnaneshwar says:

There is none other beside Thee in the whole world; but see our fate, that we imagined ourselves existing [apart from Thee].

Filled with pride in my personality I thought that I was Arjuna in this world and said that the Kauravas were my relatives….

In this way, in an excess of egotism, I had leapt into the waters of self-will. It is well that Thou wert near, otherwise who would have saved me?

I, being no one, thought I was a person and called those my relatives who in reality did not exist. Thou hast saved me from this great madness. (Jnaneshwari XI.50-59, transl. Pradhan)

On this day, the lunar *mahasamadhi* of my Guru Swami Muktananda, I *pranam* at his feet.

Baba's Lessons Keep Teaching, Part One….

Baba loved me in ways I do not yet know. I say this because as I unmask me and continue down the path that Baba has shown me, what emerges is how much he has revealed to me the Truth, and how much I needed to give up my wrong understanding.

As a child and before I went to Baba, I was not good in what I call no-boundary zones. These are places where it is not safe. These are places where people "socialize." I was not a player.

Player	Transparent
Savvy	Played

When telling lies, I would burst out laughing, it was so awkward for me. And when others lied, I would stare at them, incredulous that they were trying to put this over on anyone. Discomfort was a common experience for me in most social situations, because somewhere inside, I knew everyone, including me, was trying to present a false narrative, a fake me, that everyone agrees to relate with.

And it got more awkward as I grew because I would be in situations where everyone wanted to play and I wanted people to be honest. I was the downer for everyone else. What was wrong with being how we were, openly? College brought me to testing the different zones. Was it sour grapes that I could not fit in, or were these venues just not for me? My experiences as president of my sorority pledge class, varsity cheerleader, and cheerleader for the St. Louis Cardinals were great laboratories. Along with Vietnam War protesting, I checked it all out.

Alas, I ended up back where I found refuge as a child: the dance studio. Not an easy retreat, but I preferred the confrontation with reality I had always found there to the unsafe environment of the no-boundary zone. In a dance studio, there is reality testing. In a no-boundary zone, there is no reality testing; everyone supports each other's delusion.

No boundary zone / in crowd	Excluded
Betray yourself	Own person

The dance studios of Washington University in St. Louis and later Mills College were continuous places to confront reality and grow. Then came Tai Chi Chuan, which brought an even deeper kind of confrontation and growth.

Finally, gracefully, Baba entered my life. There was such relief in the knowledge that finally there was someone directing my life who actually knew the Truth. Being in Baba's presence showed me that there was so much for me to learn. There was so much that I knew I had to let go, and so much more to let go that I was not aware of. I knew that there was someone who could and would guide me to Love, the Self, God.

Baba had me serve as head of security. He also had me spy on people. It was never that I would go out and look for infractions in the ashram dharma or people who were escaping or avoiding. Baba knew everything that went on in his ashram, even when people were so "sure" that he did not. Baba would tell me exactly where to go and what to look for.

Doing this always felt uncomfortable. And I knew people thought I was rigid and dangerous to the freedom and fun so many people wanted. Baba used me to break up no-boundary zones—places that were unconscious, undisciplined, *tamasic* and, by ashram standards, licentious. In reality, no one was committing heinous crimes, but the vibrations that motivated their behavior were hurting them and the ashram as a whole. The outward activities were really nothing from a worldly standpoint, but the underlying motivations, the vibrations, were unhealthy for everyone.

The vibrations of no-boundary zones, no matter how intense, can only produce activity within the level of restraint surrounding the zones. In the ashram, we had intense restraint and restraints, so again, infractions were apparently minor, but Baba understood how those underlying vibrations, if left unchecked, could cause havoc for the person and anyone in close proximity.

When we are blind, we do not see how much or even whom we hurt. We do not realize that the vibration, not the action, is what usually causes the injury. Baba always wanted us to Love, but there is no Love in a no-boundary zone, no matter how innocent the actions we perform are. Whether we like it or not, we are all in community, so facing and stilling our vibrations is never just our own selfish project. The world community is really just us.

Baba's Lessons Keep Teaching, Part Two....

Baba always spoke of not hurting a human heart. This was and is the crucial guide by which to assess our motivations and actions.
True *sadhana* bruises the ego, but it never injures the heart. If you are hurting someone's heart, you should question your actions and motives.

In the last few weeks, I have come to see why Baba had me knock on those doors and walk in those rooms, feeling like the downer that most people took me to be. Of course, he was doing this to benefit everyone— me, and also the people who opened the doors I knocked on.

Baba created situations that allowed me to feel the vibration of being excluded and therefore hurt, and the vibration of not fitting in. He allowed for a series of cliques to form, so that everyone had a chance to face whatever they had going on internally. If someone was included in one place, they were usually excluded from somewhere else. The only place I wanted was with Baba. That was it. So I ended up working and playing with all sorts and never being "accepted" by anyone. Even when I did *puja* for Baba with others, the other women would say, "I don't understand why he picked you."

Baba wanted me to be free, to be free of that vibration that went all the way back to before I was born. Baba did not want me attached to any vibration, outfit, institution, or job. He loved me so much that he kept at it until one day I was able to walk away and free myself from that vibration of

exclusion. Knowing what I had done, he called me to his room and gave me a large yellow sapphire—the Guru stone—saying, "Now you have the Real Guru."

But I still had work to do—so much work to do. And Baba has been always with me, guiding me.

When he was in his body, people thought that Baba was more "real" in his house than outside, more "truthful" there than in public. They were imagining a no-boundary zone that didn't exist. Baba allowed people to imagine all kinds of things, and that idea was meant to bring out a delusion people were supposed to see and then let go. But if we are not facing the truth of our vibrations, we are destined to repeat them until we finally have to confront them.

The truth is, I never wanted to be accepted in a no-boundary zone, nor could I be. And now, with Baba's help, I can honestly say I tried, but I know in my Heart that it was not good for me and it is not good for anyone. No-boundary zones only create secrets and injury.

| Secret and dirty | Transparent / pure / clean |
| Intimate / alive / lively | No relationships |

The lesson I learned is for me to walk away from no-boundary zones. The day Baba gave me the Guru stone, I walked away from a person who excluded and hurt people while calling her activity "teaching them lessons." This was not building community, and I saw that. A community is permeable; a clique is not.

I finally saw through the veil of words. Baba rewarded me and showed me the correct action for me. But we are to be tested in our lessons again and again. It then took so long to apply what Baba had taught me. I thought I could be okay in a hurtful environment. If I got strong enough, I thought, I would not get hurt. That was not what Baba was teaching me. That was

not "my" lesson. That was my wrong understanding of practice. That was how I could remain within the confines of my shrunken self. I was instead to acknowledge being hurt and walk away. I tend to be too patient. Too much time passes before I walk away.

Consider how we go about healing a physical injury. Healing an injury does not mean pushing through the pain. There is a difference between pushing through the discomfort of necessary work and aggravating an injury by continuing to irritate it. We care for an injury by not continuing to inflame it. We remove the cause of the inflammation. We walk away. If we work to the best of our ability to change what we bring to the table and still the injury is there, then we walk away. The lesson is then to leave the environment. It may be that we can return because we heal and get stronger, but it may be that we really should not return, even in full health.

Baba wanted us to be healthy on all planes. He wanted us to be who we are, and have all our action be informed by who we are. He wanted each of us to learn our lessons. One vital lesson is that walking away is not necessarily excluding anyone or anything; it is freeing ourselves from hurtful environments. For me, walking away meant walking away from the vibration that brought me to the hurtful environment, and toward Love.

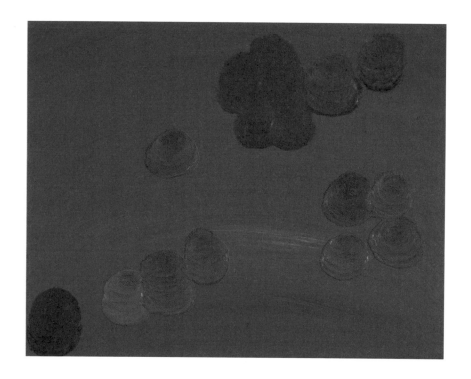

15 Persimmons (2011)

lemming....

simon says
 no
 please
 no
 act as wish
 yes
 whenever
 however
no effect
 no consequences
 no account
obey no
 disciple no
 knownothing
 selftaught
self directed
 over the
 cliff
know no good
 good for
 no thing

are you talkin to me....

o man wake up the sages say
i am awake i say
go in go in the sages say
i am in i think i am i say
the sages turn their heads away
unkind they are i say

wake up wake up they say again
can't they see i am awake i say
the truth is concealed the sages say
i see clearly you are fogged i say

birth and death and birth again
wake up wake up the sages say
i see my blindness and how fooled
i am by me and now
i say wake up wake up
i so want to wake up
missed too much latching onto so much
missed too much my seeing
hearing smelling tasting feeling

time is short i dig to the place
where nothing is linear
waiting for the one who will wake me up
finally finally i earn
the manifesting of my Guru
i am ready

yet all my ideas are not the truth
i wake up to reality of my unreality
how sad to leave my created world behind
the world i had worked so hard to maintain

my Guru woke me from my nightmare
he shook me hard i am so grateful
my choice my agency my authority
to leave my authority at the goodwill
at the stone table of the heart
being awakened
from apparent concealment

i saw the *pati* the noose was untied
i had owned me to let go of me
me as a well thought out construct
here we are with no one to speak with except
Us who was always Me

devolition....

difference
be tween
devoted devotees
disciplined
disciples
depends on
motor vation
motive
vation

internal
extra ternal
act tion

diving deeper
dropping

down
may be
just justified
but being both
Being
brings back
to life

goal of Grace

surrender sufficiently

 soul to Self

know no choice

 theymeet

on path with

 nonames

Muktananda's gift....

Baba infused each of us
 with his Shakti
 he got from Nityananda
 Shakti
 from God

Baba evolved out of his body
 shed the last limitation

dispersed us as sprouted seeds
 out into the world

wherever we landed
we were to grow and
spread Baba's Shakti

whether to one other
or many other
does not matter

we are all his instruments
 his proxy
according to our destiny

external manifestation
 from internal gestation

outer action informed
 by Baba within us

Rohini Ralby

Baba spread to millions

after
he left

his destiny
 as Nityananda
his destiny
 as we do ours

the Self is all
 that matters

Baba left to spread
 us all to
 the Self

our destiny
 world's destiny

we dance to His tune
when we listen
to Him

in order to
be
One dance

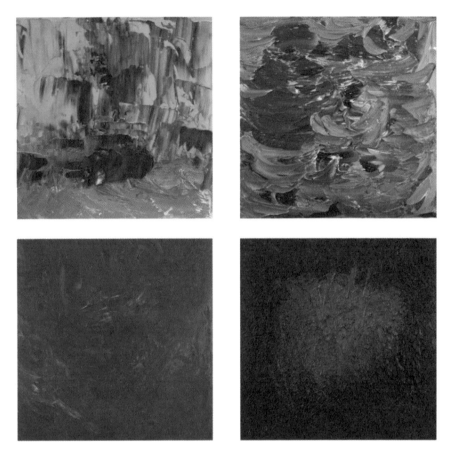

Owned (2015)

Owned	Free
Cared for	Unloved

GURU AND DISCIPLE: DISCIPLESHIP

Qualities of a Student....

Doubt	Certitude
Questioning	Receptivity

Contradict	Agree
Examine	Stooge

Promiscuous	Loyal/ dedicated / faithful
Free / open / searching / experimenting	Fanatical

Worried	At ease / at peace
Aware / concerned	Blasé / oblivious / asleep

Willfully obtuse	Receptive
Self-protective	Vulnerable / impressionable / gullible

At some point, we have all been in the role of student. We have all had teachers from whom we have learned. Sometimes we have learned what the teacher wanted us to learn; other times we have learned lessons the teacher had no idea she was teaching. The teacher is a person or a situation, and we relate with them according to our temperament. Many times as students we at first say we want to learn but then move into the realm of the above fourchotomies. These fourchotomies have qualities that most people bring to the table in various situations. The problem is, most of us are not aware

of our negative qualities and project those onto our teachers.

Only when we begin the process of truly listening do we see what our part is. We may have thought we were examining, but we were really contradicting. Because we believe we are just questioning, we cannot understand why the teacher is acting the way she is. We are unaware that the teacher is reacting to the way we are approaching the learning.

"We have been listening," we say. To what are we listening? Such an important question; this is where discernment comes in. We tend to agree with the teacher when she says what we want to hear and disagree when she says something we do not like. Our selective hearing occurs because we believe the teacher is just another opinion and not the expert—that our read and the teacher's are equal. Actually, no, they are not. Our limited truth and the understanding of the expert are not equal.

If the teacher is a good spiritual director, then the teacher's read is actually our honest read, though we may not be willing to listen. So when the teacher yells, it is usually because we are refusing to listen to ourselves. The teacher has listened to us, but we will not agree because we are not listening to ourselves. We are listening to our narrative, our creation. We decide that the teacher is just giving us her opinion, but no. A good spiritual teacher is a mirror for us and is giving us our real answers. We are just rebelling against ourselves.

In this situation, the teacher is looking at a fight that can become not worth the effort. The student is actually sabotaging himself and the teacher finds herself fighting the student in order to fight for the student. In truth, the student is fighting himself in the form of the teacher, who is fighting for him. We convince ourselves we are speaking our truth when in fact we are running from the truth.

I read the other day on the Internet the statement that our own experience will always be our truest and best teacher. This was a sad comment on the state we have come to spiritually. When we have an

experience, is it not the discernment that will determine the lesson? And if we have no discernment, aren't we then at odds with the spiritual teacher who sees clearly? We will then decide that our read on our experience is equal to, if not better than the teacher's. So the child that is afraid of the bathwater learns that her read is true and the best teacher, and no one can change her read. We are in trouble as students if we rely on our read before we have acquired discernment. Her "truth" is her interpretation of her experience, and her read on her experience is her best teacher? Danger.

Discernment does not just show up. We as students have to work to clean our vehicles so that we can see clearly. Until we see that the teacher wants the best for us, that the teacher wants Love for us, we will be fighting against what is really healthy for us. Working with the above fourchotomies will help us move toward the discernment we need. Then we will actually agree with the teacher and the teacher will be in harmony with us. Then we will no longer fight ourselves.

Right Effort and Grace Await Each of Us….

The Guru is not a person. My Guru, Muktananda, became and embodied the Guru. So he was and is the Guru. There was nothing of Muktananda that was not the Guru. His vehicles were enlivened by the Guru. Muktananda, like any Great Being, had surrendered and become the Guru. So what he wanted was not personal. His wants were the Guru's wants. For me, Baba never let me down; he was always directing me towards Guru and God. And since the Guru was fully within him and Muktananda surrendered to the Guru, he deserved the utmost respect. Baba gave me life, and kept on directing me to the Guru within; everything I have is because of him.

Unfortunately, some people decide that the person who embodies the Guru is some form of an authority figure. If these people have something to work out with authority, they will focus on the outer form and miss the

Guru. They want to play with the person, not the Guru. The only true reason to go to *a* Guru is for *the* Guru. Really, it is that simple. Sooner or later, the choice will have to be either God and Guru or this place is not for me.

In order to truly get what the Guru wants for us, we have to "know" our shrunken self and let it go. We have to know our character's system so that it does not run us. Remember, the Guru is the power that bestows the Grace of God. If we want that power to shower Grace on us, we have to not be in the way. So even though the Guru keeps pointing us to the Guru, if we are not free, we will keep focusing on the person. When the Guru points us to the Guru, he is pointing to the Guru, which is not only within him but within us as well.

This brings us to the only rule: right effort. What is right effort? The effort to stay focused toward God and Guru in the Heart. If we do this right effort, then Grace will pour down on us. Bishop William Bernard Ullathorne said as much in *The Groundwork of the Christian Virtues*: "Let it be plainly understood that we cannot return to God unless we enter first into ourselves. God is everywhere, but not everywhere to us. There is but one point in the universe where God communicates with us, and that is the centre of our own soul. There He waits for us. There He meets us; there He speaks to us. To seek Him, therefore, we must enter into our own interior." *Shiva Sutras* 1.5 reads, "Effort itself is Bhairava." Baba's commentary on that sutra makes it clear: "Right effort is this: on attaining knowledge of the nature of the highest reality, one strives to remain constantly immersed in the awareness of the inner Self."

If we can't do right effort, then we can start where we are. We will need to understand our shrunken self's system and dismantle it. Our job is to find out what prevents us from right effort, root that out, and then go from there to "right effort." If we have not done algebra or trigonometry, we are definitely not ready for calculus. And there is nothing wrong with

that—unless we want and pretend to be somewhere we are not. If we do not accept where we are, then it is clear we do not know our system. Remember, until we are nonattached, everyone decides and proceeds according to what suits their system.

Last week I wrote this and did not post it: "You were focused on me when you were supposed to be focused on God and Guru. The joke is on you. Guess you don't know who the Guru is." We have to know, in every sense of the word, who the Guru is if we are going to go forth to God. We have to surrender to the Grace-bestowing power of God within and without, which then brings us Home to God.

My manifestation was the distraction some wanted so they did not have to focus on God and Guru. They refused to turn within. Their choice, not mine. So sad: we are always looking for distractions so we do not have to focus on God or Guru. Unfortunately, we want to maintain our sense of self. We believe we can maintain our individuality and be with God. Not one of us can. It is either our shrunken self or God. That is just the way it works. Not my rule; God and Guru's.

My goal is to live in the Guru, Baba Muktananda, the Bliss of Freedom, 24/7. That is what he wanted for me and everyone. Right effort and Grace await each of us.

No Escaping Teachers….

When I was a little girl, my friends and I would play "school." One of us would be the teacher and the others would play the students. We would switch roles so everyone got a chance to be the teacher. A fun game: everyone playing all the parts, and no one feeling less than or better than. Ah, the Lords' Club (*see p. 52*).

We were never hindered by the low or high self-esteem that has since infiltrated into every aspect of our lives. Children were to learn from teachers; it was a good thing, and when we did well, we went out of our

way to acknowledge the teachers who helped us. That acknowledgement did not in any way diminish our accomplishment. We were taught, we learned, and we imbibed. We made the learning ours by taking it in and discovering our own ways of embodying and expressing it.

There were always a few students who were brought up to accomplish things only on their own. They believed that if they got help, they could not have any ownership over what they achieved. These few, though they may have had great teachers, "knew" that if they took in what a teacher taught and actually imbibed the knowledge, they could not take credit for whatever they did. Though surrounded by teachers, they were self-taught and even oppositional, so that they could not be accused of having taken any advice from anyone else. They succeeded solely on their own. Ultimately, they "won" by failing to learn.

Ironically, they learned this very refusal to take instruction from the most important teachers in their lives: their first caregivers, usually their parents. There is no escaping teachers.

Those of us willing to accept instruction found ourselves able to handle ever greater and deeper knowledge and a wider range of situations. We could actually apply the knowledge and ability we had gleaned from our teachers, and transfer our skills into all areas of our lives. And lo and behold, we could acknowledge the skills we had, because we were not running around trying to cover up where we got them.

There was no need for me and my fellow learners to hide our teachers. For thousands of years, teachers had been cherished and valuable, and for us they still were. We knew that we would be lost without them. We would be struggling with tasks we were so proud to be able to complete on our own—never realizing that those accomplishments were really elementary, and nothing to brag about.

A few years ago, I attended a graduation ceremony at a private high school. While students occupied the stage and gave self-congratulatory

speeches, teachers went unacknowledged; they were not part of the ceremony—so completely disregarded that I could not even tell who they were. The ceremony catered entirely to the inflated self-esteem of the graduands.

With this sort of devaluing of teachers comes the destruction of future experts. The self-esteem of a child is so fragile because it has no true substance; it is just made up of a cluster of ideas. Adults tiptoe around these fragile egos, believing that doing so is loving, when if they truly loved their children, they would equip them with skills for their lives. Instead, too many parents have backed down, leaving their children to education via video games, the entertainment industry, and each other. Now, teachers have been encouraged to back down as well—and call it things like child-centered learning.

For my friends and me, child-centered learning would not have made sense. It would never have given us a chance in life. I at least knew that I knew little or nothing about life. I knew I was a child, and it was okay. Why would I want to collaborate with others in my same boat?

Thank God for my teachers. Thank God for every time they said, "No." Thank God for when they said, "Do it again." We were not allowed to become so ridiculously deluded, because no one tiptoed around our self-esteem.

My teachers all had teachers. They all came from lineages of one kind or another. At the supreme level, my Baba, Swami Muktananda, had Nityananda. Each was able to teach because he had been willing to seek out and accept instruction. We must be willing to do the same.

Five Kinds of Seeker....

Baba used to say, "I give you what you want so that someday you will want what I have to give." He was Self-realized and saw the world as it really is. I am not where Baba is, and I am less patient. I have waited and waited

and given many students what they wanted. But, as this body ages, I want to give what I have to offer to the few who want it.

When Baba told me I was naïve about why people came to the ashram, he was, of course, right. Now I understand what he was saying. I've seen that there are five basic types of spiritual seeker, only one of which is looking for the Real.

The first kind of seeker is really just looking to replace, transfer, or supplement their relationship with their mommy or daddy. Seeking a familiar vibration, they want me, or any teacher, to relate with them in such a way that all I can provide is what they have always wanted their parent of choice to give them—emotionally and intellectually. They want unconditional acceptance of the behavior they have always brought to the table, whether it is appropriate or not. So they project that relationship and expect me to play the desired role. If they harbor negative feelings toward that parent, they will either see me as a tyrant to appease or someone to be obnoxious to with impunity, expecting the spiritual teacher to love and accept them on their terms, no matter what.

But the jobs of the mommy and the Guru are very different. When you want your mommy, you will treat the Guru with the same deceptive deference that you believe your mother wanted. You will give the Guru everything you gave your mommy, not knowing that you were actually not authentic the first time you did it. You were just trying to manipulate your mommy with words and actions that may have been okay with her (or okay with her when you were four years old), but the Guru sees through all that. This is not what the Guru wants from you. If I had wanted to be just a mommy forever, I would never have encouraged my sons to become adults.

The second kind of seeker is a lonely person looking for community. They are not interested in the Guru, but in being with, and sharing with, other seekers. Group classes serve as ways to meet people—and that is the goal.

The third kind of seeker wants power. This hunger may take the form of seeking exotic experiences, cultivating a sense of elitism, or pursuing the illusion of control over others. They want the Guru to showcase supernatural powers that they as students can then gain for themselves. They don't want the Guru to be able to see into them, nor do they want to be brought to introspection; they want a magic show. This is not remotely what spiritual practice is about, and the Guru should not tolerate it.

The fourth kind of seeker wants to have their pain removed. They are looking for someone they can rely on to relieve their suffering. There is an element of truth in this, because a Guru's job is to remove suffering—and I do this. But unless a student commits to practice, their pain will only return. Unfortunately, most of these seekers want the Guru to remove their pain with little or no work on the student's part. When they actually experience freedom from pain, a few—a very few—will awaken to what spiritual practice really means. The others are no more interested in introspection than the power-seekers; what they want is to have their pain transformed into or replaced with pleasure. They want little techniques that will help ease their stress. Most will only keep returning for a quick fix.

The fifth kind of seeker is very rare. This person is truly searching for a Guru—someone who conveys the grace-bestowing power of God. These seekers come prepared to undertake the arduous work of spiritual practice. They are disciplined, vigilant, and capable of sustained concentration and effort. When the Guru turns their lives upside down, they welcome it as a chance to learn and grow. They know that if you truly follow and obey the Guru, you will come to be who you truly are. This is what the Guru wants for all students.

Baba used to say that the Guru grants what the heart desires, so, in his ashram, these five kinds of seeker found what they were looking for. The misguided ones took the goal of spiritual practice to be relationship with a higher authority that remained in harmony with their idea of themselves, or

community, or power, or pleasure. Precious few wanted the true Guru. This has always been true—but it is also true that some who seek the wrong thing may wake up and turn to the true goal of spiritual practice. Baba always offered that possibility. It remains there for everyone.

Playing the Field....

When we start on the path of *sadhana*, though we may understand that there is something greater than who we think we are, we tend to operate as if *sadhana* is just stretching and making bigger who we think we are. In that light, we believe that there is only one playing field, and that to be spiritually enlightened is to be a magnificent player on that one playing field.

It follows that we believe we already know the rules of the game, and what a winner looks like.

This in turn means that we inevitably see ourselves as being in competition with the Guru. What the Guru teaches appears to us as just a different way to play than what we know is right for us. We are already moving in the same direction as the Guru, but the Guru is failing to see that our way of playing is the appropriate one for us, and will get us to the same destination.

What we are failing to see is that we are living in a limited vision of reality. We have desperately worked to shrink the Guru to our size. But the Guru is the grace-bestowing power of God, and there is no shrinking God. Our attempt to shrink the Guru is based on a set of premises that are wrong.

The first premise is that there is only one playing field and all games go to the same conclusion.

The next premise is that everyone comes to that playing field with the game they learned as a child.

The third premise is that the Guru also comes to that playing field with the game she learned as a child.

Inevitably, then, we will see the Guru as imposing her game on us. And we will resist that perceived imposition. Within the logic of this delusion, that is the right thing to do. But the point is to free ourselves from delusion.

If we believe that, then we are convinced that if we play our game well, we will reach the same goal the Guru wants for us, but on our terms. And when we see the Guru, we are actually then judging the Guru's game on that field.

Another form this delusion takes operates from slightly divergent premises.

The first and second premises—that there is only one playing field and everyone comes to that field with the game they learned as children—remain the same. But then a different kind of judgment enters in.

The third premise here is that we believe our game is the only one that gets life right as a worldview or bottom line. We then know how to bring the game to a winning conclusion. Everyone else—except the Guru—plays the same game we do, with varying degrees of skill.

It follows that the Guru must not be playing, or teaching, the right game. We then have to resist her teaching—not because it's not right for us, but because it's not right for anyone.

When we see the Guru this way, she becomes something like the best player on a losing side; we reject her game but want to pick up from the Guru the skills that we can use to improve our own game and win at life.

In other words, we want to remain within our system and extract from the Guru whatever it is that will help us play our game to its fullest, on the only field there is. This is how we use seeing the Guru as a way to support our own system.

Here is a fourchotomy that captures this delusion:

Exploitive / user	Nurturing
Savvy	Pathetic

We think of ourselves as savvy players in the one game on the one field, and see the Guru as nurturing but ultimately pathetic, not savvy enough to win in the real world. In reality, we are only trying to exploit the Guru to win a child's game.

The truth is, we have chosen to remain blind to the reality that there is more than one playing field. Because of this delusion, we cannot see how the Guru is actually operating and what she is encouraging. The Guru may appear on our field, but she is actually playing a categorically different game on a completely different field. It is our delusion that she is, like us, playing a game she learned as a child; she is playing the game she learned from her Guru, just as her Guru learned it from his Guru.

We will never progress on the spiritual path until we see and accept that we have to give up our cherished game and all its rules, and enter as beginners into the Great Game of the Guru, the only game that takes us to Love.

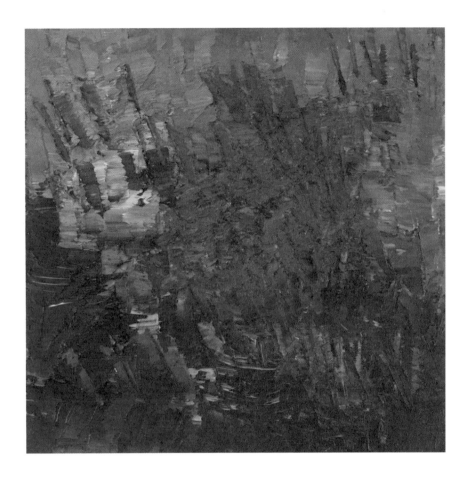

Midwinter Spring (2019)

dissolution....

my Guru showed
me
Me

i clung to i

He washed me
away

Love was left
as
Me

Guru's Purnima....

the full moon
grows
while the sun
shines through

as manifested light
my Guru

the Guru
never wanes

manifested Guru
arcs the world
guiding the willing

unwilling willingly
walk back
into shadow

the obtuse's ink cloaks
the son
manifests any way

the moon surrenders
brilliantly
to the sun

the Guru rises
whole
dark turns to luminous blue

know your station....

the shakti
 is
 not
 friend
to
 the
 shrunken
 self

Guru guides
 the
 shrunken
 self
 into
 the
 fire

to resolve
 dissolve
 the shrunken
 self

back to its
 proper
 place

the Self
 and
 shakti

and
Guru
and
God

one

relative self
not
center
but
point
among points

shakti
Guru
brings
self
to see clearly

to know our
place

and then to

Be

manifesting through
the point

ace....

i am a tool
 respect my
 tools
 when a nail
 goes into
 wood
 i respect
 the hammer
 use the
 tools
 with care
 and love
 and gratitude
 that God
 created the
 need
 and solution
a soul needs
 healing
 back to home
acknowledge
 the tool
 the Guru is
 God's tool

abheda....

on this day
 as on
 every day
there is
 nothing but
the Guru

you Muktananda

surrendered all became embodiment

 Nityananda
surrendered all only Guru remains

the perfect sadhana modeled

for us all leaves with pranams

only you
 the Guru remain

Turn to the Fire, and Enter (2014)

GURU AND DISCIPLE: THE GURU

Sometimes I….

Sometimes I come out swinging. And you know, sometimes swinging is appropriate. Ranting about practice is the usual way I swing.

The two sides of a dichotomy have a conversation on a regular basis. What's wrong? Nothing, if you really enjoy back and forth, back and forth. In order for us to be ourselves, we have to give up both sides of the dichotomy. Not one side, but both sides. As long as I am caught oscillating back and forth, back and forth, I can't do anything. More importantly, I'm unhappy and cannot find the escape. There comes a time when we all have to say I'd rather have nothing than this. So, even if I do not know my true voice and I have not been graced with the experience of the witness or the true voice, I at least am willing and able to give up listening to the dichotomy, to the conscience, to the good voice, to the bad voice, to the one that argues, to the one that is always going back and forth telling me to do this and telling me not to do this, why can't I do this, then blaming this person, then blaming that person. No, it is time for all of us to reach that point where we say, "I'd rather have nothing than this."

Once we have started practicing, not listening to that mental litany, then we're on the path. This doesn't mean it's going to be easy; this doesn't mean everything is going to go my way or your way. This means we're heading in the right direction. Do I know what it is that I need to be doing? No, not necessarily—discernment comes with quiet. But it does mean that I know the direction to go. If I keep putting my attention out of my head, out of my thoughts, out of my ideas, out of my emotions, and keep moving my

attention to the Heart, then one day Grace will come and I will know where it is I am actually going. So don't worry about having your voice. Worry about getting rid of the voice you have. Stop listening to anything. After a while, you will begin to actually hear your real answer.

So I'm swinging for you. I'm out here telling you to stop listening to anything and everything. We think we are doing it our way when in fact we are actually doing it our shrunken self's way. We are not in control, though we are so sure we are. Be quiet so you can hear your own voice. Remember, you cannot hear your own voice until you stop listening to the dichotomizing voices. Practice and you will find your own Heart. Now.

Walking out of the Darkness....

Who or what is the Guru? The Guru is the Teacher, the Grace and Guide that God provides for each of us to go Home. The Guru is not the person that It inhabits, but the purer the person, the more there is the Guru and less the person. Then all the actions of the person will express the Guru, for the Guru will inform and become the person and all his vehicles.

How is the Guru a Teacher, a Guide? The Guru's job is to bring us into the light. The Guru also guides us out of the darkness. Any teacher who simply points at the light is not providing the guidance we need. A true Guru knows the darkness and goes into it for the sake of the disciple. The Guru then guides the student out into the light. If we say we want this, the Guru is there with the disciple; the Guru and the disciple are in harmony. Some, though, only profess the desire to remove the darkness. They do not want to face the truth of the darkness, of the ignorance. They want to believe they are in the light already and the Guru is there to support and maintain them.

We have to accept that in order to BE in the light, we have to be willing to see the darkness and walk out of it. The belief is that we all want the light, and we do—until we realize what we have to give up in order to get it.

The Guru will just keep shining the light, showing us the way out of the darkness. We get angry and resistant, and fight. We are afraid to leave. This is like a person who is blind from living in the dark, trapped in a building without light. The person who comes to save him must see and know the ins and outs of the building. They must be comfortable, yet not attached to the darkness. And because they know the darkness so well, they are not afraid of it. They can then go into the darkness and guide the person out. If the person resists, the Guru will coax. But if the person is recalcitrant, then the guide will leave him there trapped. The guide is not attached.

The Guru does not do it all for us so that we just sit back drinking smoothies. We have to surrender to the Guru in order for the Guru to be able to guide us out of the darkness. That surrender is right effort. We have to be where we can hear the Guru. Right effort is remaining in the Heart no matter what, and facing and listening to what is there. What is the responsibility of the disciple or, at the very least, the student? Just hang out? No, our job is to surrender, listen, and obey what the Guru tells us. We need to do what the Guru tells us. If we do not, then we need not be surprised when we face the wrath of the Guru or, worse, the Guru lets us be in the darkness. It is always our choice.

How many movies have we watched where someone thought they knew better than the guide? How many times did it go well for them? Our choice.

Here is a fourchotomy on the Guru:

Heals / guides	Harms / misleads
Coddles / carries	Challenges / tests

This is how people see the Guru depending on where they are. The Guru never changes; we do.

Here is a fourchotomy on the disciple:

Surrenders / obeys	Resists / disrespects
Loses will / loses freedom	Examines / questions

We can choose to use the best guide to take us out of the darkness, or we can choose to remain in the Hell we work so hard to call something else. We look to experts for so much in our mundane life, yet we refuse the aid of the one that can walk us out of our darkness. We first have to accept we are in fact in darkness and can't get out alone; then we must search for the best Guide to show us the way into the light.

What Does the Guru Do?....

The *Shiva Sutras* say the Guru is the means (II.6). For me, my Guru, Swami Muktananda, Baba, has been and is the means. In all the years I knew, studied, and worked closely with Baba, he never let me down. He was and is always guiding me to the state of union with God.

If the Guru is the means and does everything, then what is my job, what is our job? Our job is to surrender and let the Guru do everything. We tend to want to remain in the mix. Big mistake. Right effort is having our attention on the Heart where the Self resides, where God and Guru speak to us. Our effort should not hinder the Guru; it should be in harmony with the Guru.

A great teacher like Baba is not personal. Great teachers discern and are able to give each student the teachings they need. Many times, however, the student does not want those teachings, and then the teacher will withdraw. If we are obedient to our teacher, we will gain what our teacher has gained. The teacher wants us to attain what he has attained.

When I received *shaktipat* from Baba, I had already surrendered to years of discipline and had had many experiences and breakthroughs. What I

wanted from Baba was to live in the awareness of who we are even during my mundane life. From my *shaktipat* experience, I knew Baba had what I wanted.

Having studied with so many different kinds of teachers, I knew what I needed to do with Baba. My job was to not fight him, but to surrender and be open to receive what I knew he knew and what I professed to desire. Right effort was not fighting Baba. Every time I forgot this, smack! Accepting his direction, even when I did not always understand, always brought me to a greater understanding and a lighter sense of me. It was not personal. We wanted the same goal, whatever it took.

So when a breakthrough occurs, you need to know how to use it. First, you have to learn what and where you are internally doing during a breakthrough. What did you lose? What did you break through? And the most important question you should ask is this: Why did I again pick up that which I had let go?

The answer to why breakthroughs tend to delude us is that most breakthroughs are unconscious. They happen to us; we have no control and then just go with them without any awareness. We may enjoy the moment, but usually we believe we have arrived at a new place from where we cannot return to the old. Even with *shaktipat*, Baba used to say the momentary experience is showing us a glimpse of where we want to go. But we will not remain there; our job is to practice in order to return consciously.

Shiva Sutras I.5 tells us that when we are practicing right effort, there will be an opening, an upspringing of the Truth—who we truly are. As I have said, that glimpse happens either consciously or spontaneously. When it happens consciously, I know I am practicing correctly. And what is this correct practice? Complete surrender to and complete awareness, concentration on God and Guru. Our direction, our attention, our perception is trained toward God and Guru.

When this opening occurs spontaneously, it is like magic, and we do not know how or why it came or left. We tend in this situation to find erroneous reasons for our experience. So even though we have breakthroughs, they do not aid our *sadhana*. The breakthrough is followed by a closing down. We remain unconscious and unaware of the right effort we should be applying.

The Guru is pointing us always toward God. And the Guru is both within and without. So when the true outer Guru points us in a direction, our inner Guru is pointing us to the same place. Remember, the Guru is not personal. The Guru is the Grace-bestowing power of God. The Guru works for God and brings us to God.

On this Guru Purnima, I *pranam* with great respect to my Guru, who has been my mother and father these many years. May I always obey you and honor your greatness. *Sadgurunath Maharaj Ki Jai!* Glory to Muktananda!

The Gardener....

Every tradition uses the gardener as an analogy for spiritual work. The garden is a place where everything grows within a prescribed area. We are gardens where everything grows, both beautiful and ugly things. And many times in a garden, a beautiful plant begins to be seen as a weed because it has been allowed to grow to the detriment of the whole.

The garden must be tended carefully. If we do not do this, then, as Kipling used to say, we are "letting the jungle in." When tending a garden, restraint and discipline are vital to the garden's life and longevity. If we do not exercise restraint and discipline, then the integrity and structure of the garden will be compromised. If our care is too tight, then we strangle the life from the garden; if we are too lax, we lose the garden completely.

The good gardener is like a loving parent: direct and soft, firm and caring, nurturing and critical. A good gardener or teacher is able to see the

whole picture and discern the correct path to a fulfilled life. There will be times when the plants or students do not follow the path to their own success and fulfillment. This is where the gardener moves in with a firm and clear hand, able to correct the course, able to move everything and everyone back in line.

When a gardener neglects the garden, it is left to its own devices. The plants grow anywhere and propagate in places that hurt the feel of the garden. Plants grow into each other so that there is no clarity. The garden has no discipline, and even if there are great plants, they cannot be distinguished from each other or even from weeds. Everything becomes an expression of vagueness; the message of the garden is confusion and lack of consciousness.

The teacher of spiritual practice must be a consummate gardener. The student can also be seen as the plant. Constantly aware, the teacher knows the correct tools to use with a student. The teacher, seeing the whole picture, directs the student in the right course even when the student doubts or resists. Our qualities can also be seen as plants that are either allowed to grow or clipped back. Unhealthy qualities have to be pruned and hopefully rooted out. The teacher will see the student's qualities and be able to encourage the good ones.

The teacher provides the fertile environment for growth. The student will decide whether he or she wants to grow or not. If not, the student leaves, removed from the garden because he does not contribute to the whole.

Each teacher, like every gardener, has a particular style, so that students are attracted to the environment or repulsed by it. There is a mutual vetting. A student or plant needs a certain environment in order to thrive.

This reminds me of Nathaniel Hawthorne's "Rappaccini's Daughter." Rappaccini created a garden filled with poisonous plants. He brought up his daughter, Beatrice, in this garden, exposing her to small quantities of these

plants. She was then unable to leave the environment that she appeared to thrive in. She was a prisoner in her own home. A good teacher or gardener does not imprison but frees the student or plant to be capable of thriving when transplanted outside the initial garden. The teaching or tending moves the student or plant to thrive and share the life and love of the original garden. Beatrice could have figured out how to detoxify herself, but would she? Did she have the tools? Did her father give them to her? And even with the tools, would she have used them? She was not nurtured to be alive and free.

A good teacher will share all that she has to share. The teacher wants a student to reach the goal of Absolute Freedom and pure Love.

The Business of All Businesses....

St. Bernard called this work we do here "the business of all businesses." And it is. I am in the business of going to God; going home to God. That is my business, my profession. If you are looking for winter clothes, you came to the wrong store. If you are looking for a mommy, you came to the wrong store. If you are looking for a therapist, you came to the wrong store. If you are looking for a car, you came to the wrong store. I am in the business of God, period.

Who is this God that I am making available in my shop? God is the everything, the underlying fiber of our entire existence. Out of God, everything on the physical plane manifests, including us. Therefore, there is no place that God is not. God informs all. God informs what we call good and what we call bad. There is nothing, including evil, that God does not inform. Everything is God; that is why going to God is the business of all businesses.

We may know this intellectually, but experientially not know it at all. When truth about God is just a belief, we are idealists, always thinking, believing, looking; we are not being. We are not with God. So no matter

how beautiful these ideas are, we are always separate. We are a shadow of the Truth, so there is always a dissatisfaction; always a feeling that something is missing.

Here is where this business of businesses comes in. The purpose of this business is to bring you to God. If you walk in my store, I will offer you all kinds of tools that will help you succeed in this endeavor. There will be meditation, *shaktipat*, fourchotomies, the seed tool, scripture study, tools for removing obstacles, chanting, the Guru, three levels of practice, some external practices, and internal practice. All is here at my store. If you only want to browse, then do it quickly and leave. I do not have time for window shoppers. This is a niche business, intended only for the people who know that they want what is offered here.

This business is not personal. If it were, then it would not be the business of all businesses. Using tools you can find here leads you to the universal. They are designed to remove the personal. So if you want to keep your special, unique individuality, best not come to my store. You will get very angry if you buy and use these products not knowing their real danger to the shrunken self. If you are looking for a glorified shrunken self, all pretty and up to date, definitely do not set foot in this shop. It is very hard to go back to where you were once you have used what is offered here.

The shopkeeper is someone who has used all the tools and is an expert, having been trained by a master of this business. The shopkeeper cannot just be anyone. She is there to show you how to use the tools, guide you with any difficulties, and answer your questions, all the way to the goal— the fulfillment of the store's purpose and your purpose in using what is offered at the store.

I love my store. I love my work. I love my business. The lineage of this business is long and exalted. I apprenticed under the master Swami Muktananda. I bow to Baba Muktananda, the great Guru. He gave me life, fulfillment, and love, and taught me all I know. Everything in my shop

follows and is informed by his teachings. I respect all that he taught me. I am proud to be of this lineage and dedicate this business of businesses to my Guru. For without him, I would not have gotten anywhere and would have nothing to offer.

Do come to my shop if you are looking for Love. Come if you want the Truth, God. Come if you are ready to leave behind what is dissolved when using the tools here. Come if you want what this shop offers. Well come.

The Guru's Grace....

The five-fold action of God is as follows: Create, Sustain, Destroy, Conceal, Reveal. As human beings and therefore shrunken manifestations of God, we perform these five activities in a diminished form, believing we are powerful. We obviously create, sustain, destroy, and delude/conceal. Revelation or grace is harder for us, as individuals, to see or perform. Our "grace" is the grace of the shrunken self: power and control rather than Love. This idea of grace usually means hitting "reset," pretending to wipe our slates clean. So we continue the cycle of birth and death.

God clearly creates; just look at the wonder of birth, of life itself. God sustains the continued existence of the universe. Destruction happens on the level of decay, natural disasters, and human destructiveness, in which people who, in gratifying themselves, actually serve as the instruments of God's destructive activity. God conceals by hiding the truth from us so as to maintain the game. As part of that game, we delude ourselves, insistently thinking we are honest and clear-sighted. If we only had these four activities, then we would never escape a constant misery. Create, sustain, destroy, and conceal. Create, sustain, destroy, and conceal. Over and over again. Where is the solution, the way home?

God's fifth action is Grace/revelation. God uses the Guru as the means to manifest His Grace. *Shiva Sutras* II.6 says: The Guru is the means. "The Guru who has attained Self-realization can alone help the aspirant in

acquiring it" (Singh). The Guru is the Grace-bestowing Power of God. The Guru always shines a light. If the Guru is in the room, light still shines even if those nearby are blind to it. The Guru does not judge where to shine the light; it just shines. To be in the presence of such a being is a great gift, not to be taken lightly.

Swami Muktananda was one such being. To sit in his presence was to bathe in the Bliss of the Self. Baba shined the light of God everywhere he went. It emanated from his body. The job of the people around him was to receive the grace.

Because of you, Baba, I woke up.

Because of you, Baba, I live and die.

Because of you, Baba, I know my Self.

You were beyond pleasure and pain. You were about knowledge of Truth, not just *shakti*. You taught me what surrender is and what to surrender to. You taught me that we surrender all the time, just to the wrong things, the temporal. You taught me how to surrender, how to let go as a practice that rids us of all that is not Real. You taught me that I wasn't just to sit and bask in your greatness. You taught me that I had a responsibility and an actual dharma to pursue.

We all have a part to play. We are not to be passive, but active; we are to work side by side with the *shakti* and the Guru to eliminate what keeps us from Us. We are to be a part of the cleaning crew.

God even uses false gurus—as agents of concealment and destruction who ironically help to deliver Grace. Baba used to say, "Thank God for false gurus. How else would we know the true?"

The job of the true Guru is to uncover and destroy concealed delusion. We are to participate in this destruction of darkness. The problem is that, so many times, we believe we "know" the practice. The Guru removes our delusion about our practice.

People used to say, "I practice: I chant the *Guru Gita* every day, I follow the ashram routine of chant, meditation, service." People did not understand that those activities were only scaffolding, only the external discipline. There is nothing wrong with chanting, meditation, and service, but they are not sufficient on their own; they have to be performed while practicing inwardly. The practice is internal, using the will to surrender all to God and Guru; to rest in the Heart at all times. Practicing means giving up our individuality. That is what Baba did in relation to his Guru, and I pray I am strong enough to give all up to Baba.

Baba persistently destroyed my ideas of practice. He was always stripping away my wrong understanding. We never consciously choose ignorance, so when the Guru cuts like a surgeon trying to save the patient, we may believe he is mean or cruel. If we resist, then the procedure takes much longer for us.

The Guru provides the function of grace for God. We are to surrender in order to receive this grace. We cannot receive the revelation if we are holding on to our ideas of ourselves, the Guru, and what practice is. When we surrender, our ideas disappear, and with them our ignorance.

We have to resolve this fourchotomy before we can share in the revelation. It is easy to maintain delusion; only the Guru will remove it.

Guru	Shrunken self / individual in own right
Dictator / tyrant	Disciple

The Guru is the way God delivers Grace to us. The revelation Grace brings is that in Truth we are and have always been the Self.

My Apparently Useless Gift....

When I owned my school of Tai Chi Chuan in Cambridge,

Massachusetts, I had a lot of energy. People would feel it and even I would be overwhelmed by it, yet I had no wisdom. People thought I was something more than I was because they were entranced by the energy and identified me with it. The energy knew things; I had much to learn.

Baba had tremendous energy. He gave *shaktipat* to many thousands of people at a time. But I did not go to Baba for the *shakti*. I went to Baba for his wisdom. I experienced the Truth within him, and I knew he could teach it to me. There are myriad teachers with *shakti*, but very few with wisdom, and almost none who have realized the Truth.

Being with Baba meant, for me, surrendering to his wisdom and receiving what he had to give me. He passed on to me the essence of spiritual practice—not an insight or idea, but an actual moment-to-moment practice that will lead us Home, where wisdom resides. In teaching me, Baba removed the obstacles blocking my path, and activated what was latent within me.

Everyone has a gift. Within each of us, there is some latent capacity that spiritual practice will nurture. In the course of *sadhana*, a person's gift or gifts will expand, and may take on qualities that had not appeared before. Over the last thirty years, my own gift has developed. This gift is the ability to burn up people's pain. This removal of pain is what happened for me with Baba. It is one of the many things he taught me.

Yes: people's pain is dissolved when they sit with me. I go deep within myself to the groundwater of consciousness, where I can feel their pain as if it were my own; then I dissolve it in the light of consciousness. In relative reality, of course, their pain isn't mine, but in an Absolute sense, we all share all the pain and joy in the universe. Many people have experienced me removing their pain.

When Baba was teaching me, all I had to do to facilitate his dissolving my pain was to let go. And yet very few people are willing to do this. They want to hold onto their pain. They would not know who they were if they

let it go. Their shrunken self would lose its grip. They would lose their motivation. They would lose everything if they sat and I dissolved their pain. And they certainly wouldn't want to acknowledge that they needed me to do for them something they couldn't do for themselves. The shrunken self prefers to believe that I just sit there while it dissolves its own pain. The problem is, the shrunken self cannot dissolve its own pain.

I have to say that I am naïve, as Baba once said I was. I really thought people would want to get rid of their pain. People are always saying they do, but when it comes to actually doing it, the resistance is palpable. We all have fear and resistance, but we do not have to let fear and resistance run us. I want to teach people to get to a point in their practice where they can burn up their own pain, but people refuse to give up their sense of control. They don't want to feel dependent on me as their guide. Nor do they want to be wholly independent, because that means taking full responsibility for their own pain.

So I am left with the realization that very few people want to accept what I have to offer. Many don't even want to accept that I have something to offer. Baba used to say, "I give you what you want, so that one day you will want what I have to give." Now I see every day what he meant.

Monkey See, Monkey Don't....

I feel like such an idiot. I thought that if I did my best to live an exemplary life, others would see it and want to follow that life. For many years, I have openly modeled a life informed by the *yamas* and the *niyamas*, the restraints and observances in all religious traditions that lead a person down the path to Love and God. That path may have different cultural trappings, but the Truth is the Truth. The qualities of kindness, compassion, non-attachment, non-injury, transparency, responsibility, and discernment lead us down a very different path than do passion, anger, greed, delusion, attachment, cruelty, selfishness, and lying. And yet, I have

met people who believe these two ways will take us down the same path, that they are just different approaches to the same goal of happiness. In truth, one takes us toward Love for All; the other takes us to separateness, and to indulgence for the individual.

Growing up, I always watched very carefully. My parents, my teachers, even my friends; I watched them all. There is a reason our teachers should be in the front as we watch them; it is because they are supposed to be the only experts in the room, the ones each of us should learn from. Our learning is only as good as the expert who should oversee and determine the validity of our conclusions; our peers or fellow students do not qualify. Going to good public schools allowed me to have a great variety of teachers—teachers with different styles of sharing their knowledge. And as I grew, the styles also changed. But the teacher remained the one arbiter. Whether I liked that teacher or not, at least I knew where I stood.

My sixth-grade teacher was an ex-Marine. He was young and barked orders as though we were in his platoon; he never spoke in any other tone. It was abrasive. Finally, one day I said to him, "I have had enough," walked out of class, and went to the principal's office for guidance on how to handle the situation. The teacher and I talked, and came to a place where we could work together. It was not that I did not do well in his class. He even liked me, and would tease me a bit. Many years later, I went to visit him, and he told me I had been the most independent student he had ever taught. Still later, I met a man who had been in that class; he said, "I remember you as the smartest in the class." I had never thought that of myself. I had just concentrated on learning all I could.

But teachers were never just people who passed on information about a given subject. A good teacher is a model, embodying and living what it means to be a learner, with the goal of becoming an expert.

Over my many years of dance training, I always watched my dance teachers, as they were the perfect models of what I wanted to achieve. In

Alicia Langford's classes in Boston, I was one of two girls eight years younger than the other students; we would watch the older dancers as they worked, because they embodied where we saw ourselves heading. At WashU, Annelise Mertz tore us down again and again, yet she modeled what I was looking for in a creative dancer.

I watched all my various teachers as I proceeded each step down the road, not sure of my final destination but only of where I was at any given moment. Leslie Laskey, Nelson Wu, T.R. Chung, Frank Pierce Jones, James Tin Yau So: I was always watching and learning and moving until I met Muktananda, and that is where I found my home.

Muktananda was the ultimate model through and through. He embodied the goal. Watching, feeling, sensing, thinking, and imbibing him was a gift beyond belief. I only wanted to be with him, to learn from him, because everything he said or did was informed by the Truth. I understood that in the core of my being. What Baba modeled was never about lifestyle or manners or habits; it was about his essence and how it informed every fiber of his individual manifestation. Baba did not manifest as his Guru had, and he did not want me to live as he did. He wanted for me what he wanted for everyone: to live resting in the Heart and being truly who I am.

Each of my models was an expert who wanted what was best for me. Baba was the final and Perfect expert. He embodied all the qualities needed to take us to Love, because he was Love: in him, the qualities that take us away from Love were burnt seeds no longer able to sprout. What a great model.

And yet I know people who did not see as I saw. Because I was so close to Baba for such a long time, I was clear in my assessment. So many years had been spent watching so many people and teachers; I had been determined to learn all I could from others, so by the time I got to Baba, my learning skills were honed. Blind faith was never my way. There was always conscious and unconscious testing, checking, making sure, listening,

watching. I was so lucky to see Baba relate with so many people. He taught me not only discernment in relation to others, but also in relation to him. He amazed me. He never failed. Even when his responses seemed strange, he was always right on the money in ways I would not have seen before. Why? Because Baba was motivated by Love and possessed of supreme discernment, so even when they turned people's lives upside down, his instructions always led to Love. Such a great model.

And yet we are not interested in spiritual masters or models anymore— certainly not as part of our own educations. We do not have the humility or the rigor to practice this kind of learning. Today we regard learning from these models as giving up our precious individuality. We also, if we are honest with ourselves, find it too much work.

So few are willing to do the work to Love within and then without. So we either ignore these important models, or we set them on abstract pedestals and learn nothing. We have lost the will to dig, to reflect, to truly and respectfully question. We are all now "experts." "It's my life," we think, "so I know better than anyone else how to live it."

So when I have openly shared my life as a way to model and therefore a way for my students to learn, I know some people have missed the point. If I called my mother during *satsang*, these people did not see me as instructing through modeling; instead, they always wondered why I was talking to my mother on their time.

I thank those people for modeling for me, so that I could be reminded that not everyone sees the way I do. After all, Baba did once say to me, "You are naïve. You think everyone is here for spiritual practice. People are here for hiding, business connections, to find a spouse." Thank you, Baba, yet again, for being such a great role model; for seeing things as they really are and not being angry or upset but just accepting the human condition as it is. I will work to live up to your modeling.

The Guru Manifests Personally for Us….

Not everyone wants a personal relationship with the Guru. I did. I loved Baba personally and as the Guru, and I still do. Most people want the Guru without any personal relationship. When people see a Guru in human form, instead of being excited by the wonder of this manifestation and his accessibility, they diminish the Guru. This is like Arjuna not understanding who Krishna was. For Arjuna, Krishna was a wise friend, mentor, and advisor. Krishna went along with that perception until Arjuna needed to be woken up from a delusion of great magnitude and consequence. Only then did Krishna reveal his true form.

The Guru in the physical form is so important for us as a model. He shows the intersection of the divine and the material. He aids us in learning how to function in the world and then how to transcend the material. I loved watching and being able to play with Baba on the physical plane, learning the outer and inner at the same time.

The Guru is not stingy. The Guru always gives. What does he give? Love. Love manifesting through the physical form at all times. The Guru's Love is always manifesting, no matter what the Guru's physical form is doing. He always gives Love, even in the form of anger.

People tend to have an idea of what the Guru should look like. But the Guru transcends form even as he inhabits it. Baba happened to be in the form of a monk, but he Loved the householder saints. They just lived regular lives, not separate from the lives of ordinary people. They showed us that the Guru is not a lifestyle or anything specifically material. The Guru manifests through whatever lifestyle the form has. So whether a mendicant, a charioteer, a farmer, a banker, a woman, a man, the form is not what matters—it is the Guru that matters.

I loved Baba's form. But I knew that every moment, whether he was yelling at me, calling me stupid, playing a political *lila*, or just sitting there that last day in his physical body, when he helped me up from *pranam*ing

because I was so pregnant – Baba Loved. Strange are the ways of the Great Beings. Why? Because they are always loving in the way that is appropriate for that moment. They are God manifesting through them for the betterment of all, both personally and universally.

Most people are too immature spiritually to accept a true personal Guru. Though they profess to be seeking that, they would really rather have an abstract experience, because they are not ready for the personal. These people want someone purely ethereal, with no humanness. For them, the Guru just fulfills an idea.

Other people believe they are seeking a personal Guru when they really just want a counselor. A Guru is not a therapist. The Guru is interested in your soul, not your head.

Then there are people who regard the Guru as only human, like everyone else, so they will not see or hear what the Guru has to offer. They belittle the Guru because of the Guru manifesting in the human form. They feel that in manifesting, the Guru is diminished. But in order to manifest, the Guru takes on a physical form. These people would rather just deal in ideas, never accepting that ideas derive most of their value from being applied on the physical plane. We have to manifest and test our ideas. Otherwise, we will believe that whatever we think is great, without any reality check.

The Guru is unfailingly generous of spirit; he participates in life. People who don't participate in life are stingy and afraid. They use and they take, they protect their belief systems—and they get nothing out of life. The Guru has nothing to protect.

One way to avoid the living presence of a Guru is to be a devotee of a dead Guru. This is just one more way to keep things abstract. As Baba was fond of saying, there is nothing like a dead Guru: he never yells and always agrees with your desires. The problem is, I am still with a living Guru. Swami Muktananda's form may be gone, but Baba is alive and yelling at me as he always did. Thank God.

Baba said all kinds of derogatory things about me to others. And people did get what they were supposed to get from that. It was all a play designed for all of us to learn. Whatever Baba said was appropriate for that moment. I am thankful that Baba derided me over and over again. Baba Loved, and it always came through, no matter what he said or did, at least for me. What a blessing to be yelled at by the Guru. My job was to obey and love, and it still is. After I had malaria, Baba had me eat bitter melon every day for my health. I hated bitter melon, but not once did it ever occur to me not to do as Baba instructed.

Having a personal relationship with the Guru is the rarest of opportunities. I understood that, and cherished every interaction I had with Baba. People used to say that Baba was different in his own house from how he was in public. As someone who knew him well in both places, I can testify that nothing could be further from the truth. His manifestation may have varied, but he was always the same. Baba was always Baba, and he always Loved. That last day he was in his physical body, when he helped me up from *pranam*ing, he looked at me with total, unconditional Love. This is who he is, even now.

I Am Not a Teacher….

I am not a teacher. What a relief. If people think of me as a teacher, they relate with me as stubborn and rebellious students. They think in terms of doctrine and doctrinal disputes. I do not. I am not a teacher.

I share silence, and the practice that brings silence. My Guru, Swami Muktananda, lived this and shared it with all of us. I share the practice he taught me. There is no rhetoric or concepts. You are either practicing or not.

People looking for nothing more than teachers want their sense of self to be enlightened. Their shrunken self is going to take the instruction and get all the goodies; it's going to win the grand prize. And the truth is, what's going to happen to it? In order to win the grand prize, what has to happen?

The shrunken self has to go. So everybody's going to hit that point where they either want to hold on to their shrunken self or they want the prize. You want that pot of gold? Then let go.

And now you'll understand why Baba used to tell the story about the monkey with the bottle. The monkey would put his hand in—there's a banana in the bottle—and he'd hold on to the banana because he wanted to get it out. But if he held onto the banana, he couldn't pull out his hand. The only way the monkey could be free was to let go of the banana. You can't have your banana and eat it. You can't have your cake and eat it. You can't have it.

And if you think your separate self is going to be the winner, you've missed the whole point of *sadhana*. And if no one else is making that clear, so be it. Most "teachers" will tell you that you can be a better version of you. That is not the goal, that is not the pot of gold, and that is not spiritual practice.

The one who is chasing after teaching and doctrine is not going to be there at the end. So whom is the doctrine for? For the shrunken self. The doctrine is for our narrative, to steer it in the right direction. It's a beginning stage. It's the wedge we use to drive out a wedge. And if all you want to do is keep putting in that wedge—"Let me put the wedge in again! Let me read that doctrine again! Let me study another doctrine!"—and you think you're going to accomplish something, you're crazy. That is not what doctrine is meant for.

Remember, the one who's following the doctrine is not going to be there when you actually get to the Truth. This is a joke on all of us. And we're all supposed to get it. And it isn't as though the world doesn't show us this.

Thank God I'm not a teacher. As a teacher, my commitment would be to getting through to my students, no matter how recalcitrant they might be. All that I do is share silence, and the practice that brings silence—which brings us to Love.

The Guru Is Not Your Enemy….

The Guru is not out to get you. The *shakti* is not out to crush you. There may be times when you are convinced that they are out to ruin you, but it is never true.

The Guru, *shakti*, and God want what is best for us, in every sense of the word. And when we obey the Guru and the *shakti*, lo and behold, we find ourselves moving to a better place, closer to God.

Once the *shakti* is awakened, it is moving toward Home. *Shaktipat* can be exhilarating, and we at first may be excited by this newfound experience and dimension in our lives. We feel blessed, and acknowledge the *shakti* as a beneficial and extraordinary gift. But as we proceed to practice *sadhana* and confront the reality of what must be sacrificed for the process to reach fruition, we move from excitement to dread and fear and resistance.

Though we may deny it, this is when we see the Guru as an enemy—as the antagonist against whom we must fight to preserve our sense of self, our integrity, our narrative. We see that the directives the Guru gives us go against our beliefs about ourselves, so we conclude that the Guru must be trying to crush us, and we refuse to obey. We believe that rejecting the Guru's guidance will get us out of harm's way.

In short, the shrunken self sees the Guru as a demon: risky, reckless, tyrannical, harmful, and humorless. The Guru crushes students. This is why, in tantric traditions, deities have terrifying forms such as Bhairava or Durga: God and Guru seem horrifying to the shrunken self. This is appropriate, because they will bring about the shrunken self's dissolution.

So why, then, do people who see the Guru this way stay on? Because they feel better when they see the Guru crushing someone other than them. In many cases, this feels like their family lives; watching a sibling get crushed always meant being in the clear. A more common reason people who demonize the Guru choose to stay is that while they reject the guidance of the Guru, they like the experience of the *shakti*. Being near the

Guru means being beside a source of power. They can't see that the true enemy of the Guru is ignorance. And they can't see that what the Guru wants them to have is not power, but Love.

If we trap ourselves in that kind of delusion, then, rather than heed the Guru, we will choose to listen to all our friends and people we consider knowledgeable about the world. But every time we disobey the Guru and do things the way we are sure they should be done, we will find ourselves in a greater mess. In truth, the Guru's knowledge of the spiritual realm leads to the deepest understanding of worldly affairs.

If we do not get the lesson, then the results of our actions will take us farther and farther away from God. We will become rigid, isolated, sure voices stuck in the mud of hell. But we cannot see the way out of our alienation, for we refuse to see that we had and still have choice.

If we are willing to surrender and learn, though, we will move from clue to clue in the treasure hunt of life. We will continue solving the riddle and finding our way back Home.

The spiritual path is dangerous for anyone unwilling to have a guide. Our goal is to dissolve our separateness in Love; the shrunken self's sense of direction will never get us there. As the mystical poet Al-Niffari wrote, "If a man regards himself as existing through God, that which is of God in him predominates over the phenomenal element and makes it pass away, so that he sees nothing but God. If, on the contrary, he regards himself as having an independent existence, his unreal egoism is displayed to him and the reality of God becomes hidden from him" (in Nicholson, *The Mystics of Islam*).

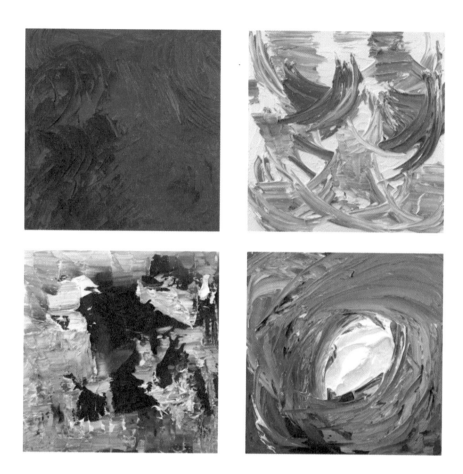

Wounded (2015)

Wounded	Cared for
Educated	Indulged

the world matters....

 o real ly
 then

put your home

 in order

matter matters

 only when
we know what

matter is

we think we are what matter
 matters but

we are all that matters

which is not
 matter

you cannot offend me only
 offend my matter which
ultimately does not matter
to
 me

 or God

erase to the finish....

 when we surrender
 to the
 erasing
of the shrunken
 self
 Love Joy Truth
 Consciousness
Bliss
 remains
 always there
 never left
 we cloak
 we forget
 until
we finally surrender
 to God
 and laugh

Rohini Ralby

refraction….

calm down
reproach

be
accepts

let go
when
ready

not to control

then
hide
box

get ready
to let go

by being
allowing
vibration

label
deny
distance
explain

think
experience
is
not

be
what is
is

209

rasa....

heavy handed heavy footed
 light touch
Ram
 the truth

only way
break the spell
to return

to light
to Self
to God

surrender
accept
relax
emerge

won't hurt
tastes
feels
looks
smells
sounds

the rasa
 of the Heart

give up

not the earth
 do we get

life
Love

eternity

know it all….

knowing what
do not
know

is
knowing
so
much

get to
be
where
we
are
not
somewhere
else
move

God
lights
the runway

white flag….

i give up
 do it
 your way

 ran from
 you coddled me
 for so long
until i was

 willing to
 do it
 your way the way
 that would
 make me
God world
 in harmony

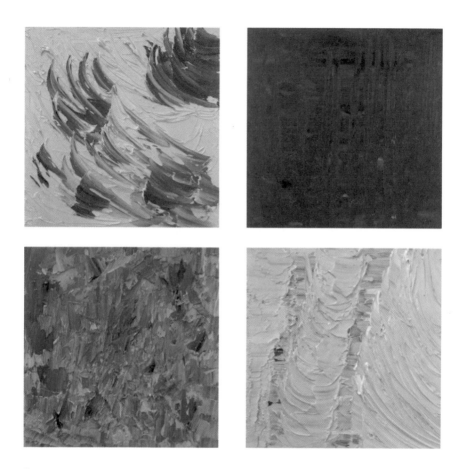

Spontaneous (2015)

Spontaneous	Rigid
Impulsive	Disciplined

HUMILITY, ACCEPTANCE, AND SURRENDER

Thank You....

Whatever God does He does for good. So say "thank you." Yes, say "thank you." When things go "wrong," say "thank you." When things go "right," say "thank you."

We are actors in a play. Stop complaining about the scene in which you are playing. First, the part was designed specifically for you; second, the lines are up to you. If you are playing the victim, that is your choice. If you are playing the bully, again that is your choice. You could change the way you relate with the scene you are in. The act and how it is playing out may be set, but at least your acting and the way you approach the scene is up to you. You can improvise; you do not have to always say the same lines. So no complaints about all the other actors, no complaints about the props or scenery. Have you noticed how we never complain about the lines we deliver? We say we have no choice. Not true.

Everything, no matter where we are, is God's play. So all is sacred, from the seemingly concrete and mundane to the most sublime, if we are relating appropriately. Everything is here to teach us to return to God. It is up to us. Even the hard and miserable times are from God. We decide how we are going to play our part, what lines we are going to say, what emotion we are going to express.

God resides in war. Yes, He does. God resides in peace. Yes, He does. He resides in everything. We can choose not to fight or to fight appropriately. We can also be inappropriate and battle it out blindly. There are groups of people that are attached to fighting, and there are people that

are attached to peace. It is their nature, we say. Can we change? Yes. Can we learn to be appropriate? Yes. Are we willing to change the lines we read? We should be. But we have to know they are just lines and not who we are before we can let go of them and find something else to say.

So our complaints and fights are lines that we may use regularly. Though we might not be bored with the lines, for all we know our friends are completely bored with them. We may keep those lines going and going and going, and if we have friends that enable us, they will just sit there and nothing will change. Our friends may change, they may change their attitude, and that can be helpful for us. Why? Because when they are truly our friends, they can tell us to stop complaining, to shut up. Then, instead of being angry with them, we should be able to say "thank you."

If we really want to change things, then we have to be able to keep our mouths shut and burn up our fight within ourselves. When we do that, we are freeing ourselves, and changing the way we approach our parts in the divine play. Repeating our lines dilutes the lesson so we cannot even see or feel it anymore. The fact is that if we keep quiet, a friction is created inside, grinding down the vibration that encourages the inappropriate lines. We no longer wish to express things the old way. This refraining from expression is a great opportunity for us to dissolve, to free ourselves from and change our lines. Our part in the play moves so that we actually are in harmony with God.

The whole purpose of this theater is to bring us home to God. Everything—and I mean everything—can be a means to that end. But we have to be willing to approach everything—and I mean everything—in that way. Once we do that, our lines, our scenes, and our acts become more interesting, and we are more willing to play.

So what is it going to be? Kicking and screaming down the path, or riding the horse in the direction it's going? You choose. We always do choose, whether we know it or not. We choose to complain. We choose to

kick and scream. We choose to go smoothly. We can choose to go to God consciously. We do have the freedom to go to God. So say "thank you."

We Have to Crack....

Whether we like it or not, in order to go to God, we have to crack. What has to crack? We do. Who is we? Not who we are, but who we think we are. Why crack? Because the only way we are going to get to who we really are is to shatter our wrong understanding.

The greatest delusion is that we all use the words *I*, *me*, and *we*, thinking we actually are that *I*, *me*, or *we*, when in Truth we are none of them. The joke is on us. We are caught in the web and don't know who is speaking. We unfortunately believe we are the thinking apparatus, which is sometimes called the psychic instrument. That instrument includes the data collector, the intellect, and the ego that identifies with the decisions of the intellect.

Not until we crack, not until we snap, not until we give up all we are not, can we have a chance to know who "I" really is. So many times in spiritual practice, we hear about peeling the onion skin; however, at some point, we get to the end of the onion, and then what?

In order to crack, we have to be strong, disciplined, and able to withstand abrupt change that does not go according to our program. We must steady and still in order to crack. To put it differently, we have to surrender to God all our wrong identification. We must be willing to no longer be who we think we are and, even though we do not know who we are, be willing to go in that direction. Then the only one who will suffer is who we are not. So if we really give up our wrong understanding, we will fall into who we are and be in Bliss. Who we are is always here; we just hide from it. Usually, instead of breaking, we suffer bitterly through the process of self-deconstruction because we are still attached, even subtly, to who we are not, to that "I" which is going to die, going to dissolve. After that false self goes, the Self, the true "I," will still be there.

Some people are sure they have already found their core, so there is no need to search; they are finished. The only problem is this core is within their shrunken self and in most cases is just the commentator, the conscience. This is idolatry. At this point, the person desperately needs to crack, to break from this wrong understanding. But unless they are able to perceive this voice as an object, they will hold on and convince themselves that their voice is Real. In truth, they have no access to the Real as long as they hold on. They believe their individuality, their shrunken self, is the universal Subject, present everywhere. As a result, if you disagree with them, they believe you are out of sync with the universe. Though they need to break, they have a great capacity to resist discomfort, *tapasya*, purgatory. They will valiantly resist the pain that can actually free them because they believe that positive, "happy" feelings is all they should have. By avoiding discomfort, they protect their own wrong understanding.

Some self-styled teachers spread erroneous ideas about spiritual practice and the path. I have heard it said that once you experience *shaktipat*, the *shakti* will simply carry you home. This is completely wrong. Once you get *shaktipat*, the work really begins; the *shakti* does not do it for you. The *shakti* will aid your right effort. Right effort is letting go of anything that keeps us from union with God. So we crack in small moments and great moments, we let go in different ways, but let go we must. We must break in order to truly exist, and Joy is there for those strong and willing enough to Be. This is the only way out of the prison of wrong understanding: wake up, and find that Love is who you have always been.

So crack.

I Can't Accept That....

Acceptance is a word used quite a bit in spiritual venues. The problem is that we are to only accept, affirm, receive, welcome, take in the "loving," the good. The loving and good are not defined universally; though we

believe we are all in agreement, these words are defined differently by each of us. To proceed down the path to God, the Self, we have to accept everything. We have to take in the truth about each of our qualities. Not just the ones we have decided we like. What then does that mean? These last few weeks, we have been pushing hard. We have dug into the painful realities of our own systems; the systems we have created and now have to dismantle.

In order to break down our systems, we have to accept the one we have. No pretending we have a pretty one that does not need cleaning. No imagining we can just jump to the Absolute. No pretending and saying that we are One; for not until we live there are we there. Accept this. Absolute Truth is there, but the truth is that we are living in relative reality. Do not put that down; accept it. We cannot pretend we are in Absolute Reality until we are. So we hear "Be in the present," "Be here now." True. Then be here with all the reality of now. Acceptance is being able to own both our good qualities and our flaws, and to know our character. Then we can actually do something about these things. Accepting our sins is what purgatory is about. Purification cannot occur if we are pretending to be enlightened, finished, One with God, the Self, etc. This realization is not bad or negative; it is the truth, reality. Accept it and you will actually free yourself from what you have run from.

We cannot just say "I have this," "I do that." We have to own and accept without any rancor that we have these and all qualities. When we practice with a fourchotomy and our seeds, our vibrations help us to accept and experience our qualities so that we can eventually still them. The process is to own, master, and then transcend all our qualities, all our vibrations.

We cannot get rid of something we have not owned. This entails really experiencing what we do and the impact we have on ourselves and others. Accepting the truth is not an intellectual exercise only. We have to dig in to

the deepest part of our awareness and accept from there. This does hurt; it can wrench, and hopefully we will feel remorse. But the process of accepting the truth and then working to master and transcend our attachments leaves us with Love. We accept as the beginning of cleaning away the dirt that covers our love. We have to see the dirt as ourselves, and then gradually know it as ours, and then finally go beyond it. This first act of acceptance of these qualities, then, is the real beginning of loving ourselves. This is taking the first step out of Hell. When we resist this, we find ourselves remaining stuck in the mess of Hell. "I can't accept that I am bad" puts us right where we do not want to be. How ironic it is that if we could just accept our flaws, we would be heading in the right direction. How sad we are. And we think we are holding on to the good when we are running from the truth. We are in a strong repulsion relationship with our own qualities.

The only way to Paradise is through acceptance of Reality. This is simple and clear. If we were already there, we would not fight the Truth. And yet we all have some form of resistance, something that we refuse to face, something we deny instead of accept. Accept your whole self, and then you have the choice to be free from your whole self. When we are free from our whole self, we emerge to be the Self, which is Love. Can you accept that?

We Are Not as Good as We Think....

We cannot go forward without first bringing down our shrunken self. What is the shrunken self? Simply, it is who we think we are. It is not who we are. The shrunken self is just a set of ideas, but we then believe those ideas are who we are. Our true Self actually enlivens these ideas, but our shrunken selves forget the Self and decide those ideas are alive and who we are. Who we think we are and how we act may have no similarity; for when we are deluded, imagination runs us. Reality may not even come close. One

of the first steps in spiritual practice is to bring into harmony our actions and our ideas. Then, when we shine the light of consciousness, we call our actions, ideas, attitudes, and motivations what they are, not what we would like to call them.

We must own that we are sinners. That we do not do only good. That we are not innocent. Isn't that what Christ was modeling? Jesus had to die as a criminal in order to have Christ rise in glory. The Passover narrative also does not depict everyone as either good or bad. Pharaoh wanted to let the Hebrews go, "but God hardened his heart." Life is a play in which each character has to know the part he is playing and the lines that go with it. It is a play in which we are all the characters, both the victims and the bullies, and we must embrace this fact if we are to own our connection to God. Who we really are is all; we are all as God is All. It is losing our subject in the object of the shrunken self, the individual, that causes us to be blinkered and miss the Truth.

Yes, there is relative reality, and each of us sees the world through a different individual's eyes. However, there is also Absolute Reality, where the Truth is the Truth. If we are looking from the standpoint of Absolute Reality, we have the same Truth. The Self is the same for All. God is God. Do you believe that evil is in fact separate from God? There is no place that God is not. From the standpoint of Absolute Reality, evil is a part of God. In relative reality, we distinguish between God and evil, which in itself limits God. This limited view comes from our being identified with the shrunken self. We believe we are the sun when in fact our shrunken self could not survive or shine without God, the Self. We are the moon, not self-illuminating but illuminated by the Self, but we will not face that Truth.

If we can accept that our shrunken self as an independent entity has nothing to be proud of, then we can begin the work of disentangling and turning inward to the sun, the true Self.

Surrendering to Growth....

I am in the middle of a change. Change is never pleasant, no matter how positive it is. Throughout my life, there have been times when I was heading in a particular direction, only to find I was being guided to a place I had never thought about. So periodically I reach a place where I say I want to quit, I give up. From there, I then see that I have no idea where I am going. Here I am, in the midst of a change. Surrendering, accepting, going down the road to the next way station, with no idea what it will look like.

Clues? Only what I know I have to leave behind. I know I have to let something go; it has to happen. I do not know where I am going, but I trust it will be better than what I am leaving, no matter how good it may be. Having been through this so many times, I know the steps and know that the outcome will be good. I just have to be willing to go down the path set out not by me but by God and Guru.

Have any of you ever been coached? Been on a team or somewhere where you have had to surrender to authority? By the time I got to Baba, I had been coached by so many people. They helped me see my good qualities and flaws, and they gave me tools for discerning these traits and correcting them where necessary. My teachers and coaches have been straight, sharp, kind, direct, and for the most part available. Baba had those traits, heightened to a supreme degree. I did not always like the way they spoke to me, but I hung in there and found they were almost always right. So one thing I learned was not to jump to the conclusion that I was good and they were wrong. With Baba, he never missed. He was always there, loving me enough to scold me instead of coddling me. He continued to give me what I had asked for: the Truth.

I was not always so surrendered; it took me a while to learn to discern good authority. I stood up in my sixth grade class, told my teacher, a former Marine, that I had had enough, and walked out, going straight to the principal's office. Years later, this teacher said I was the most independent

student he had ever taught. So I was not a pushover who obeyed everyone given a position of authority. I learned to respond and to relate with authority figures, and seek out the most competent in the field I was entering. If we want to function at a high level, we must not relate with authority as if we were two years old.

My job was and is to receive whatever is given and to learn. My early coaches and teachers shined a light on my shrunken self; they did that so "I" would not get in the way of the activity we were pursuing. I wanted to be successful, so eventually I gave in and won. This prepared me for mundane life and, more importantly, readied me so that when I got to Baba, he could do more advanced surgery. Each of my coaches and teachers yelled and berated. Each of them helped me get a little more distance. They did so in order that I not think that my shrunken self was so special and worthy of being adored. I learned to laugh at my shrunken self, to have a sense of humor about the character I am playing in this lifetime and not be so attached. If I was identified with my shrunken self and having "good self-esteem," then everything was personal and humorless. Not much fun.

Humor, then, was and is so important. Baba was great that way; he would laugh. We laugh at all kinds of things; why can't we laugh at ourselves? Without this kind of humor that is able to put some distance between us and the shrunken self, we get nowhere. Baba would laugh, and hopefully we could join in. If we refuse to laugh, then we are uncoachable.

I am still Rohini the meanie, a phrase I coined in a talk I gave in Miami while with Baba in 1980. I was sharing how I had gotten to where I was at that point. I was and am direct and straight. My "part" was formed in Boston, where flinty is normal. I do not coddle or stroke; I respect you too much. But that means if you have no distance, you will see me as harsh and judgmental. In reality, I am harsh and judgmental when it comes to your shrunken self. So you are correct in calling me those things if you are identified with your shrunken self. I can be harsh when I see a refusal to

learn. Trash the authority if you must, but first look at why the authority is so mean. Look at your actions. Ask questions; reflect on your choices first. Then see whether the tools I've used are the only ones that will cut through the resistance and the only way you might listen. Without Baba's uncompromising directness, I know I would not be where I am today.

Whether I accept it or go kicking and screaming, the change will come, because I want it. My *sadhana* is not abstract; it is alive in everything I do. God is not isolated to corners of my day; I know God informs all of my day to a greater or lesser degree depending on my veils.

I will continue to do my work, focusing on God and Guru. Both will guide me through this change to a manifestation I do not know. But I trust my authority figures to wake me up, berate me, laugh at and with me, and guide me to the goal of Love, which is where they come from.

Acceptance....

We have to face the ugly truth and accept it before we can get to the beautiful truth. We have to surrender to the way it is, not the way we want it or imagine it to be. Then, through acceptance, we and everything around us changes. No, it does not end up being the way we wanted it to be; it is the way it is, and we are okay.

We need to stop running away from the truth. Just accept it and then you can move on. Do not accept it and you are stuck forever. We stay in the same frame of a movie, the same scene in a play, and it never changes. Why do we run, avoid? We run from pain.

If we would just turn and face the pain, it would dissolve, and we would then be free. But we are attached to pleasure, so we will not go in the direction of the pain. We are looking outside, away from the solution and from life, for pleasure. We are running from the one direction that will give us joy and love. Looking for pleasure rather than love will take us far away from happiness and bring us to separateness. We end up with misery and

hate, and believe we are entitled to whatever we desire.

Stop the fight. Do you want to be alive or dead? When we surrender and accept life as it is, we no longer hurt. If not, then we are lost in a play where we numb away the days.

So: what hurts?

Love hurts. NO. Love does not hurt. Hurt hurts. Love loves.

Care hurts. NO. Care does not hurt. Getting lost in others hurts. Losing ourselves is not caring, and losing ourselves does hurt.

Accepting reality hurts. NO. Expectations hurt.

Life hurts. NO. Choosing death hurts.

So how do we turn around? Desire is actually our will. What we desire, we then will to happen. That is why we feel surrender is the wrong direction. We believe that if we surrender, we lose. We do not ask the question to what or whom we are surrendering. Purifying the will purifies our desire. We will then find ourselves surrendering to going deeper and deeper inward toward the Heart. We are moving to where we live before pain manifests, before our love has twisted to pain. As we will ourselves deeper, all becomes more subtle; our vibrations are more subtle until they are still, at which point we find ourselves at peace, free, and resting in Love, our true nature.

Baba used to say, "I give you what you want so that someday you will want what I have to give you." For so many years I have pondered that phrase. My understanding now is that Baba saw reality and did not fight. I realize I have been fighting, not accepting that not everyone wants what I have to offer. So now I see I could not train them. I am thankful, because they have trained me. I get it. They did not learn anything from me, but I learned so much. They chose to turn from Love. I surrendered and accepted, which allowed me to still and not be distracted by a fight I could not win. I gave them what they wanted so that someday they might want

what I have to give them. I understand. Baba saw so clearly; he was extremely patient.

By accepting and surrendering, then, I have been a good student. I have learned to be a good supporting actress for their play, and am in fact free. These people will move on because they do not want what I have to offer. For me, that is totally acceptable. I want Love. Fighting people to get them to receive what I have to offer is hurtful. I then am causing pain, not helping cast out their pain.

This goes back to Ganesh as the remover of obstacles. Ganesh now has developed inner restraint so that obstacles can remain where they are. Not everyone wants love. Not everyone wants joy. We have different goals. That is okay. I surrender. Do you?

Whom Do You Serve?....

This question is a difficult one because we tend not to be completely forthright with our answer. God, we will say. And yet the truth is we are idolizing our egos, our sense of self. We are in fact committed to serving the ego in everything we do and are not aware of this.

If it serves my ego to do it, then I do it. Are you egoing? Do you know what that looks like? Here is a clue; if you take everything personally, then you are serving your ego. All is about you.

Once we assume, we are cutting off reality. Our ego, our sense of self, is telling us how to see the world, and our read *is* the truth. No matter what is being said by anyone else, we know better because our assumption is as good as, if not better than, any other read.

The problem is, it never gets easy for the ego. Struggles, fights, fortifications, rationalizations, justifications are all we get, and our poor ego never wins. There may be a momentary, apparent victory, only for us to watch it get crushed in a flash. Encounter after encounter and we never

win; we only struggle and fight. The elation of the apparent win drives us further down into the depths of despair. We call this the ups and downs of life.

Acceptance means we do not assume; we accept whatever is. No matter how ugly, if it is in front of us, we need to accept that it is ours. We then surrender, which is actually accepting life.

Refusing to accept does not bring us to independence. Refusing to accept reality brings us to separateness and an internal death.

When we accept life as it is, we are alive; we connect, and are a part of everyone and everything.

When we avoid life and pretend that life really is our assumptions, our projections, we remain distant and are apart from everyone and everything.

What we each have to learn is that acceptance is what causes us to move forward to resolve. If we serve our ego, then the only way forward is to accept it. Do not fight it. Surrender to the reality of where you are and accept. Then the knots will begin to loosen. We can choose resolution for ourselves. We actually can choose to change no matter where we are.

Every level of nature is based on *tamas, rajas,* and *sattva.* In nature, inertia, activity, and calm are present in different combinations. Our level of discernment and ability to see what is and accept is based on whether we are *tamasic* (inert), *rajasic* (active), or *sattvic* (calm). As we become more *sattvic,* we are less personal and not so dense.

For the person committed to their ego, *tamasic* is the highest level. They do not see their actions, and they feel they deserve the most. These people do not see that they contribute to any of their problems. Inertia reminds us of Dante walking through Hell. No one knows why they are in Hell.

Rajas brings us to a state similar to Dante's Purgatory. People are aware of their sins and are facing the consequences. The difference, however, is that *rajasic* people tend to oscillate between unaware action and conscious

action. They are reflective some of the time and lost some of the time. This depends on whether they are closer to *tamas* or *sattva*. They are unsteady.

Sattva is likened to Paradise, but in the case of spiritual practice, even this must be transcended. *Sattva* as a quality brings us clarity and peace, brightness and calm.

We live amid combinations of these qualities permeating all of nature, both within and without. Our job is to learn to discern on every level. So if we learn clarity on the mundane level, we are then ready to go deeper. We can and will move on to deeper and deeper levels and arenas. The tools we learn at the beginning of practice are the tools we use all the way through. *Yoga Sutras* 1.14 tells us: "Practice becomes grounded and fully integrated when it is done for a long time without interruption and with great reverence and devotion."

This practice is simple, yet not easy. To be who we truly are, our job in life is to move from serving the ego to serving and completely surrendering to God.

Spiritual Practice Ruins Your Life....

Approaching spiritual practice, most people get excited and jump into the process that is sure to bring them to enlightenment. If they have stumbled into actual practice, however, it will not take long before they realize their life is ruined. If their life is not ruined, then they have not begun to practice.

My whole life was turned upside down after my first month with Baba. I had had a successful Tai Chi Chuan school with a hundred students on Mt. Auburn Street in Cambridge, Massachusetts. Everything needed for a successful life was in place: a great space, great students, my teacher in California. In addition to my other education, I had a degree in acupuncture I had earned with Dr. James Tin Yau So in his inaugural class in the US, and had studied Chinese language. I taught, traveled, and was well known. I had

even demonstrated Tai Chi for the Taiwanese consulate. Even though I had continued to search for someone who could answer my deeper questions, I had a successful life.

On my return to Cambridge from that first month with Baba, I was not sure what I was going to do. Baba had revealed Truth, and I knew I had to go study with him, be with him. I had no idea how I was going to do that, especially since I had such a successful life. As soon as I went to my school, my landlord told me that a Rockefeller wanted to buy out my lease. I said yes, not knowing how I was going to make my living or how I was going to be able to be with Baba. My whole life turned upside down. I had never liked Indian trappings, and now I was going to be with an Indian Guru. I knew none of the outward lifestyle. I have a terrible singing voice, and of course they chanted every day. So much of my discipline was about physical movement, and now people just sat there. My life was ruined. Why?

Our lives have to be ruined in order to go Home, because if we are really practicing, we are realigned internally, and that will change our outward manifestation. Our lives and all our decisions are based on our "love machine." When we give up the machine, our motivations will change. If we just take on board new concepts and external rituals, we will not change our lives. We will just have intellectual pablum. And that is sad.

So my life was ruined—and I am so glad for that. As I practice, whatever has not been ruined needs to be. Slowly, though I am always me, my life is being transformed. By anchoring into the Self and God, we remain true; our whole being is realigned with God.

If we do not surrender, whatever we are holding onto will only get bigger until we cannot hold on anymore.

In the fourteenth century, the great Dominican mystic Henry Suso began as a committed—and proud—renunciate, withstanding all manner of privations, and rejecting rather than being nonattached. He was annoyed by most human contact. God ruined his seemingly perfect spiritual life.

Scandal engulfed Suso when a woman accused him of fathering her child. At first, he could not understand how God could do such a thing to him. But when a local came to him offering to do away with the baby, he insisted that he see it. On meeting the infant, Suso realized that his task was to accept the child as a gift from God and take responsibility for it. His world, and his idea of himself, had been completely dismantled. Only at this point did he surrender—by surrendering his idea of surrender.

Our task is to surrender to God completely on all levels, and have only God left as the doer.

Accept, Let Go, and Redirect....

We have to accept what we bring to the table in our lives. We have to accept that we love the vibrations we perpetuate. We have to accept that we mis-direct our attention. We have to accept that we remain addicted to the vibrations that make up our idea of love and hold on to them for dear life.

Attention is the fuel. We maintain our addiction with our attention, our will. But attention is also the cure—if our attention is in the Heart. Depending on where it is, our attention will feed the addiction or starve it. Boring into the Heart burns away our attachment to twisted Love.

The mind is not self-illuminative. Sometimes it is a subject and sometimes it is an object. When the mind is a subject, when the voices within our mind appear to be who we are, our attention fuels our love machine. The vibration we are attached to at any given moment is our addiction; we believe it is who we are, and even life itself. This wrong understanding leads us to cling for dear life to a false identity.

When the mind is an object, we are able to see our vibrations for what they are, accept them, and work to give them no attention. We then can disentangle from them and redirect our attention back toward and into the Heart. We are actually withdrawing our attention back Home. Once we have accomplished this, our attention is in the Heart and from the Heart. Our

will is directed by the Heart. We are then realigned, and we function from the Heart.

Whatsoever makes the wavering and unsteady mind wander away let him restrain and bring it back to the control of the Self alone. (Bhagavadgita VI.26, transl. Radhakrishnan)

This alternative is in short the direction of the thoughts and energies of the mind towards God. Direction, rather than repression, is the method… for achieving self-control. (Swami Prabhavananda, *The Spiritual Heritage of India*)

People ask, "When did things go wrong?" The answer is, "When they were going right." When things are "fine" is when we lose our vigilance, forget, and turn our attention back to our shrunken self.

We have to keep letting go of our wrong focus and redirect our attention into the Heart. When we are attached to our vibration, we cannot redirect our attention, and in truth do not want to redirect our attention, though we know we should. Here is how we can do just that.

Cease all outside action. Stop reacting to whatever is going on outside. When the outside no longer supports your reaction, you will not be able to make your vibration "reasonable."

Strap yourself in a chair and go for the ride. In other words, find a place where you will have no distractions. At the very least, allow yourself no distractions.

Now be with whatever vibration you have and do not waver in your attention. Sit with this internal experience; give yourself permission and have the courage to be with it. Let yourself have what you have always wanted and resisted. Hear your story; do not be in your story.

Accept that your life, like everyone's, is based on wrong understanding. Practice is not the annihilation of the shrunken self; it is the annihilation of our wrong understanding. Listen to all the rationalizations and know them for what they are. "I can't accept I did this." "I am not a bad person." "I am

a good person." Accept what you have. Then stop listening, let go, and redirect into the Heart.

Still the vibration not with words, because words will not still your vibrations. Words only mask our vibrations. *Will* stills our vibrations. Attention is how we shine our will. When we focus our attention on our vibrations themselves, the light of our consciousness burns up the vibrations. We have faced our addiction with the only weapon that works—our will.

Stop holding onto the world, either by grabbing it or by rejecting it. Renunciation is not rejection. Rejection is repulsion, which is a form of attachment. By rejecting all that we say we want to get rid of, we hold on to it. If you do not let go, the vibration and its expression only get worse. You are then attached to suffering. You have to know what you are surrendering; it is suffering and misery. True renunciation is letting go of what is not Real and surrendering to the Real.

We must not let the shrunken self regain control after we have let it go. In order to regain that control, we will have to trash the person who loves and helps us. Practice ruins our miserable lives. We are then no longer separate or special; instead, we become human.

So give up now before your misery gets bigger. We have to be really strong to let go of our ego. Discipline on all levels strengthens on all levels. We have to face what we do not want to face and accept it. Let it go. Then, using your will, redirect your attention to the Heart and to God.

Once we change, we have to reap what we have previously sown; then we can and will find ourselves saying "I'm sorry" a million times. We see what we did, learn from our past, and are able to accept, let go, and redirect our attention to now.

We change the future by being conscious in the present. As Kalidasa wrote in the *Kumārasambhava*, "They whose minds are not disturbed when

the sources of disturbance are present, are truly brave" (1.59, translation Radhakrishnan).

Give up Good....

I'm a good person. I mean it. I'm a good person.

That's the problem.

The Fall was the creation of the shrunken self. The fruit that brings knowledge of good and evil signifies the ignorance from which we must liberate ourselves. The shrunken self is not a good person. If you are a good person, then you are also a bad person. Stop projecting the bad onto others. You want to be equal? Then be equal by surrendering to God and letting go of your individuality.

People work to maintain their individuality. They keep secrets in order to prevent people from knowing and understanding them. All people committed to their dark secrets assume everyone has a dark secret. They try to make everyone equal by making everyone deviant, just like them. That way they believe they can still call themselves good. Rather than raising themselves up, they try to pull everybody down—especially those they see as morally and spiritually superior. Their real deviance is their attachment to their deviance.

Believing we will die if we surrender is the delusion of death. That "death" is actually life. What people call "going and living my life" is actually death. The life of the shrunken self means the death of the true Self in our lives. It's total delusion.

The delusion is that we can be happy locked in our individuality. A happy shrunken self is impossible.

And yet we are encouraging the shrunken self to think of itself as a good person; that is good self-esteem. We cannot accept that we do anything wrong—we only have accidents—so we end up projecting

wrongness on others. We are innocent and others are bad. We define bullying down: if someone says something about us that we do not like, then instead of learning from the situation, we say we are being bullied and feel justified acting out with knives or guns or tongues. We are the victims, and the one who says those mean words is a bully who should be punished. The problem with this worldview is that those mean people are as innately good as we are. Our read of reality is a double standard; it does not make any sense.

So we force people into the shrunken self's idea of unconditional love, which is the acceptance of anything we do, no matter what. We are good people. In the meantime, we are acting inappropriately. Love means putting up with my dysfunction and supporting the delusional idea I have of myself. NO.

This is where the Abrahamic traditions have it right; we have to accept our innate badness. The Fall is true. We need to get over ourselves both as good and as bad. The shrunken self is not innately good or bad; it is a made-up construct; it is not who we truly are. We need to return to ourselves, and we cannot do that unless we return to God.

The Enlightenment brought us to think of ourselves as something more important than we are. But we are not the center of the universe. We are not special. We exist. It is only in returning to God that we are who we are, that we are Alive. When we return to God, we will see that the self we thought was so important did not even exist.

Because we have taken God out of the equation, the "I" that is perfect is the "me" I think I am. We are confusing Absolute Reality with relative reality. We do not realize that what is truly good is something we have to surrender to. It is not just who we are now. If that were the case, there would be no evil, no cruelty. We do in fact have to develop character and practice good; it does not come innately.

The psychological, corporate, and pharmaceutical complex has

removed God from life. God is just an idea within the framework of the shrunken self. We are who we think we are. So we believe whatever we do is true and good if our intention, our thought, is good. We live in a world of excuses against the rest of the world.

A self-righteous man once asked the great Sufi saint Rabia what more he needed to do to be holy. She replied, "You haven't dealt at all with your greatest sin—the fact that you exist." As long as we want to be separate and special, we are committed to the shrunken self. We must give up the delusion that our attachment to goodness will bring us closer to God.

Mirror, Mirror....

When my two sons were born, I felt that one of the most important jobs I had was to be a mirror for them. As I looked into their eyes, I would also be looking into my Heart. There was a strong feeling of connecting with them, and this was not about me; this was about us in the greater sense. My job was to help them become fully human and give them the tools to function appropriately. This was about Love; it was not personal. God was to guide our actions.

The point was not to make them the center of attention. It was to help them cognize that they existed within themselves, so that if they were left alone or not given attention, they had a sense of being. There would be an awareness of self.

If no one is looking at you, do you still exist? This is a good question for many people today who are looking to be gazed upon. They might prefer to be adored, but they will take any form of attention available. Because they did not establish a sense of self when they were young, they are still looking for the mirror so they know they exist. This is a form of *asmita*—losing subject in object. When I would look into my sons' eyes, I would not lose myself, and I was encouraging them to be themselves. "I see you in there. Hello."

How ironic: the culture that proclaims that we are to be free and independent is the culture that creates bondage and dependence. We neglect and abandon, and call it helping people be themselves.

The resulting belief is that if we are not the center of attention, we have no value. Spiritual practice redirects attention from the individual to the Real Self. A good teacher does not want to be the center of attention; neither should you want to be the center of theirs. God should be the center of everyone's attention.

But in the culture we have created, the highest state for the individual is to be the center of attention. In contemporary America, we strive to be the center of attention. We all want to be celebrities. A celebrity rates higher than the President, because celebrity is about personality, while the Presidency is about public service.

Our pursuit of attention is humorless, even when we try to get attention by being clowns. We are seriously committed to this goal, because we believe it will maintain our existence. And we see as rivals the people who tell us to give up striving for attention. Of course they are telling us that; if we are the center of attention, then eyes are off them.

We manage to think of ourselves as the center of attention even when we are passively watching something. Sitting and listening, or looking at a screen, is in fact being the center of attention. If you are looking at a screen, it exists for your entertainment, and you can change the channel at any time. So you are both inert and the center of attention.

A good leader is not the center of attention in his eyes. He is with everyone else, but he has given up his individuality to fulfill the position. A good team member will do the same. And if we all did this, so much more would get done clearly and efficiently. A poor leader won't delegate until he is so weakened that he has no choice. Some leaders, like some parents, belittle their authority in order to be loved. Still, celebrity is the goal: to have the individual exalted rather than the task or the ability or the expertise. We

are looking to be the center of attention for everyone else without having anything to offer.

This fourchotomy will help us dismantle our attachment to celebrity.

Center of attention	Nonentity
Vilified / disgraced publicly	Allowed to live / left alone / granted privacy

Once we are nonattached, we can align ourselves appropriately in the world. If we are in the Heart, we are no longer the center of attention; everything is the center of attention. Which is to say that God is the center of attention.

Skipping the First Step....

Everything and everyone is perfect. If we are to use this belief as fact—which is what is implied by the people out there saying, "You are perfect just the way you are"—then we need to be consistent. The murderer is perfect. The cruel person is perfect. It is all perfect. Everything is perfect.

But usually these shouters of truisms will be the judges of where and when everything is perfect. They are perfect, and anything they deem perfect is perfect. The Truly Perfect, the Self of All—which, to them, has nothing to do with their identities or pronouncements—doesn't factor into their judgments. When these people are tested by the Truly Perfect, they tend to decide that the "wrong," hurtful, and mean are not perfect. The Absolute, God, is then "perfect" everywhere and in every way—except where and when they decide.

We cannot have it both ways. We can try every mental move possible, but we will not be able to be happy or in harmony. Frustration with life's refusal to conform to our "good and perfect" plans will always be coloring our perfect perfection.

So in order to be true to the Self, we have to first be true to our shrunken self. We have to start where we are, just as we are. The shrunken self is not who we really are; it is the vehicle through which we manifest. We use it; it is not us. We defend it when we identify with it or, at the very least, are attached to it. So relax and look at it clearly; there is no need to defend it. The shrunken self is not you.

But when we do something wrong…then what? If we do something bad, then we are bad. We cannot accept that. "I cannot accept that I did something bad because then I will be bad." In order to maintain our idea of perfection, we have to blame the outside. We have to blame others. We are good; it was not our fault. So are the others not as perfect as you? If you are perfect, then so is everyone else. You made a mistake. You did something wrong. Admit it, learn from it, and move on.

Everyone wants to skip this first step and move on to being Perfect Bliss.

If you are perfect just the way you are, then you are perfect being bad, wrong, mean, cruel, good, right, kind, and any other adjective. Stop filtering, denying, and not accepting things the way they are. We cannot move until we assess and accept where we are with no judgment, just fact.

People who say that they cannot accept that they are bad or stupid or whatever are missing out on tremendous joy and relief. The freedom that comes from this acceptance is amazing. We are then able to choose our actions and not delude ourselves. No person who has accepted all of themselves has not also had this experience of relief and usually great laughter. Our attachment to our ideas is what makes this acceptance so difficult, and not the fun it actually is.

So if you want to move in your *sadhana*, you have to stop skipping the first step. We cannot move until we first accept where we are. That means we have to assess clearly and not pretend to be somewhere we are not. So what? We are all stupid. We are all smart. We are all learners. We are all know-it-alls.

Get over your shrunken self. We are playing God, and we all think our creation is the best. It is perfect. We look at each others' shrunken selves and see so clearly what someone else is doing. We need to accept what we do and where we are.

Stop skipping the first step: "Be with your experience whatever it is." The way we skip is by judging our experience and then working to ignore or erase it. We tell ourselves a story.

When we allow ourselves to be with our experience whatever it is, let whatever comes up come up, and function appropriately on the physical plane, then we can begin to laugh at our ridiculousness. We can see our delusion, and the light begins to shine. We then can all share in the joy and love of who we really are. We can disentangle from who we are not and we can shine forth.

We are all. ALL.

Surrender....

According to Indian philosophy, the world is made up of the three *gunas* or constituent principles. They are different vibrations. These three principles are *tamas*, *rajas*, and *sattva*. They combine in infinite permutations to form the manifested universe. When we put these three in complete balance and still them, we are said to have completed our *sadhana*. Combinations of the *gunas* make up our vehicles as well as the world outside our bodies. Our minds, therefore, are made up of the three *gunas*.

Tamas (inertia) is the cause of ignorance. When *tamas* predominates, we as people will be dull, lazy, and stupid. We will read life from this viewpoint and respond to the world with "heedless indifference."

Rajas (activity) is the cause of pain. When *rajas* predominates, we will be agitated, anxious, and impulsive. We will approach life as a fight. We will live life in battle with the world.

Sattva (calm) is the cause of peace and happiness. When *sattva* predominates, we will be calm, bright, light, and peaceful. We will approach life discerning its truth and be able to accept how it is. We will love life and act appropriately.

Each of us is a combination of the above three. Our task is to move from *tamas* to *rajas* to *sattva* and overcome the expressions of each. We are to own, master, and transcend the *gunas*. Ultimately, we are to transcend even *sattva*, so that the *gunas* cease to control or be part of us. We then will find ourselves resting in the Heart, being the Self, and knowing we are All. At that point, the *gunas* will cease to attach to us because we no longer are in the Play.

Surrender serves an important part in this journey. Depending on where we are at any given moment, our definition of "surrender" will change and we will be approaching surrender to God, to the world, and to surrender itself in very different ways.

So, depending on which *guna* is running your life at the moment, you will "surrender" very differently. When we are *tamasic*, surrender is losing, passive, and dark. We will find ourselves "putting up with" something rather than facing it. We will be fatalistic, saying that our situation is just the way it is and there is nothing we can do. We are actually miserable and stuck, believing we have surrendered. We have lost and have nowhere to go. We are sitting in the muck, determined that this is the only option. We may think we are doing *sadhana*, but we are attached to where we are. There is no way out.

When we are *rajasic*, surrender is active. It means surrender to impulse. We will surrender to an urge, an idea, a food, an activity, or a person. We will think we are free and giving ourselves to the event, thing, or person. We will lose ourselves in the other and believe it is a good choice.

Finally, we come to *sattva*. In the place of *sattva*, surrender will be letting go of what is actually appropriate to let go of, and having equanimity and acceptance. Our action will then be right action.

When my son Aaron was six, he had not developed his ability to lose graciously. His belief was simple: if you win then you are a winner, and if you lose, then you are a loser. Not a surprising view for someone his age. But if he was going to grow to enjoy games, and eventually life, whether he won or lost, he would need an education in surrender. Surrender for him was synonymous with losing, and losing meant life was miserable. Winners got to enjoy life triumphantly. We all tend to start with this understanding.

For Aaron's sake and mine, I knew it was time to move him through the process of surrender. Checkers was the venue. We set up the board and began the play. I knew the part I had to play if my son was to be free and actually win. So I destroyed him. At first, he took it with a tense and unhappy expression. I remained as light and free as I could possibly be. "That was a great game. Don't you agree? Let's play again." And so we played again, and again and again. Each time I destroyed him. Each time I related how good it was to play together. The game itself was fun. It did not matter who won or lost.

Tears of frustration streamed down Aaron's face. I did not stop, and neither did he. He could not win the game, and he was lost in trying. We played on.

And then it happened. Aaron gave up. He surrendered. What did he surrender? He surrendered his attachment to his idea of winning. He saw that it was not making him happy, and that winning and losing were off the point. He accepted and played and enjoyed. Though he never actually defeated his checkers opponent that day, he WON.

Game over.

So Thankful Practice Is Easy....

This spiritual practice is not easy. Going the most direct way up a steep mountain is not easy. How could it be that easy? We are returning Home to who we truly are. I have come far enough to know that there is nowhere

else I want to be. With each painful and then liberating dissolution of attachment, I become more thankful:

Thankful for all the "farmers"—the occasions that show me what obscures my Love.

Thankful for all the *lilas* (dances) that show me how to be appropriate and make me learn.

Thankful for all my vibrations, which give me something to do—still.

Thankful for all my students who want God and do not resist Love.

Thankful for the *shakti* that keeps kicking me to God.

Thankful for Baba, who continues to guide me on this path, which is not as easy as advertised.

Thankful for those among my *Gurubai* (Guru brothers and sisters) who continue to practice and love Baba; you know who you are.

Thankful for everyone who continues to support me as my attachments to body, mind, and Rohini dissolve.

Thankful for my vehicles, which are holding up to the pressure of *sadhana*.

Thankful for the obstacles placed in my path to teach me one way or another.

Thankful for the Grace that illumines the lessons, so I can learn from them.

Why did anyone ever call this an easy path? Marketing. This path is anything but easy. This path is not easy for the shrunken self. This path is not easy for the body. This path is not easy for anything that resists the Truth.

For whom is it easy, then? For the Truth. For God. How? The Guru's Grace illumines the path so that we know where to go. That is what makes it easier for us. Before Grace, we are stumbling in the dark, imagining we are somewhere we are not. After the awakening, there is a light guiding us.

If we are willing to go only on the path that is illumined, then it is an easy path. If we still want to live and act according to the character of the shrunken self, then we have a problem. The path won't be easy at all.

When we are willing to do it God's way and it is easy, what does this easiness look like? Ease means no resistance, no obstruction. That means when we have surrendered and let go of every thing that gets in the way of resting in the Heart, all is easy. As long as we give up any attachment to who we are not, all is easy. The easy path is easy only because the path is clear and we choose to walk it. If we are still committed to having a "normal" life, whatever that is, then the path is difficult.

So are we to change our clothes and act weird in order to walk on the path? No. We may end up not changing any of our outward life. People around us may not even know we are walking the path. What we surrender is the misguided notion that our outward life in and of itself is the answer. It is not. Our shell can change many times. Each of us has a unique expression given specifically to aid us in learning and moving toward God. All we have to do is let go of the belief that our lifestyle, qualities, personality, talents, obstacles, etc. are in fact who we are.

Even free of attachment, we still get to use all these vehicles. So what is the problem? We do not have to throw them away. We just have to no longer identify with them.

To awaken to this, we have to know somewhere who we really are, which is where Grace comes in. When we have known and experienced who we really are, it is easier to acknowledge and let go of something we are not.

This is when we become truly grateful for the Guru's Grace. This is when we say "thank you" for making it easier than it normally would be. The Guru does not take away your destiny. He does not take away your life. He does not make you into a zombie. The Guru shines the light on the Truth. We get to then experience the Truth and grow clear in our direction.

We will still live out our past actions, either in meditation or actually on the physical plane. But we will be thankful for the Guru guiding us to who we really are—Love. Though we will wear our normal clothes and speak normally and even work normally, we will experience Love. Then the spiritual path is easy, and we are thankful.

Accepting Surrender....

Surrender is not throwing away or giving up and losing. Surrender is giving up the fruits of the outcome. It is acting complete in every minute without expectation of winning or losing. Outcome is off the point. The question is, "Did I play with integrity and authenticity, and without thinking? Did I give my all without seeking any reward?"

In his introduction to *Mastering The Art of War*, Thomas Cleary speaks of the dangers of success: "[E]ven in success they are in danger, for success itself becomes an object of contention that continues to animate the aggressive tendencies of all people on this level." The truth is, unless we are careful, success will feed aggression. Then both the success and the successful will be crushed. As the *I Ching* states, "Honor will be taken away from you three times before the day is out."

According to Liu Ji, "When you have won, be as if you had not" (Cleary). This is not about pretending you did not win. This is about surrendering the results, the fruits of your efforts. When we operate from this place, we do not have any pride or personal ego investment. The shrunken self does not and cannot take credit, because it was not the doer and therefore not involved at all. At this point, we no longer have excessive celebration; we are nonattached, so we act with equanimity. We no longer care in the conventional sense, nor do we have apathy. In developing our *sadhana*, we learn that neither the one who turns inward nor the one who acts outwardly is who we truly are.

Care	Not care
Enmeshed	Nonattached

"Care" and "not care" are still on the same playing field; they are two sides of a coin. If we have the quality of care, then we also have the quality of apathy. When we are surrendered and nonattached, we are the blissful spectator. That is why it is so enjoyable.

This is not about tricking the shrunken self to go to the other side, the side of not caring. It does not take place in the faculty that thinks; we are letting go of the ideas of caring and not caring and relocating to a completely different playing field, the Heart. Here the one you have always called "I" is no longer the invested player and the receiver of the rewards.

Elsewhere in the introduction to *Mastering The Art of War*, Cleary cites the commentator Cheng Yi: "'Even if the army acts in the right way, the leaders must be mature to obtain good results. After all, there are those who are lucky but also faulty, and there are those who are faultless but still not lucky. To be lucky and also faultless is as mature as people can get. Mature people are stern and worthy of respect.'" The mature person or leader sees the whole and proceeds appropriately. He is not swayed by expectations or ideas. He accepts what is, takes that in, and then clearly discerns how to proceed. The mature person actually is not lucky; rather, he sees the whole spectrum and can choose how to proceed to an outcome that can be both lucky and faultless.

In spiritual practice, we are uncovering the layers. We have to work inward from outward manifestation to subtle vibration. The vibration gives rise to words, which we must be able and willing to articulate clearly. But the answer is never just words. It is what is underneath, internal to all we do, that changes everything. Acceptance of the deeper vibration allows us to let go of the more superficial manifestation. Proceeding in this way continuously, we find ourselves as our Self.

Once we have let go of a deeper vibration, though, we have to resist the temptation to re-establish it. For example, a person says he wants to get rid of emotional pain. I say, "Let's do it." We then do the practice together and get rid of it. The practice calms wave after wave of vibration. Now there are no excuses, because we are doing the practice and it works. But then the person actively pursues the return of his vibration of emotional pain. He does it by going into his head and looking for resistance so he can recharge the vibration by thinking about it. He had dropped his ragged old doll, and then went looking for it. He had surrendered and let go, and then he turned back to look for what he had lost instead of being glad he had lost it.

These seekers usually say the practice does not work. The reason it doesn't work is that they are committed to doing it wrong; therefore, they aren't doing the practice at all. Whatever it is they are actually doing will not work, and the shrunken self is thrilled about that. So these seekers need to stop calling what they are doing practice, because it is not practice.

What every shrunken self really wants is to be off the hook. Until you know who you really are, you are just whining to get off the hook. But if you really wanted to be off the hook, you would complete your *sadhana* and find that God is the only doer. God is responsible for it all. An intellectual understanding of this Reality won't get you anywhere. Intellectual knowledge is shrunken knowledge; it doesn't give your voice authenticity.

In order to strip away all the layers of your inauthenticity, you must first accept them. You can't get rid of something until you accept it and take it in; only then can you let it go. We become what we fight against.

Accepting / taking in / receiving	Rejecting / denying / dismissing
Impressionable / weak / dependent	Independent / powerful / self-contained

We Are Always Choosing....

We are always choosing. And by thinking that we are not choosing, we are in fact choosing—choosing God or not, Love or not. By our very distractedness, we are choosing. And if we occasionally think we choose God, we are fooling ourselves, just as when we exercise for ten minutes very intensely once a week, we can fool ourselves that we exercise enough. Somewhere in there, we do know better.

By choosing God, I do not mean intellectually. Though the intellect is needed in the process of going to God, God is not a concept. Neither do I mean choosing emotionally, though the emotions are an important vehicle to be mastered and used. Nor do I mean physically, though our actions do aid us in the journey to God. In choosing, every vehicle has to be surrendered to God's will, into God's service, at all times. So we then choose to use our will to God's purpose. We do this by resting in the Heart and letting God use us. We are then no longer the doer. God is the doer.

Our greatest sense of agency arises from choosing to surrender to God and letting God act through us. That is ultimate free will. But we have to be willing to let go of our identification with our "amazing" shrunken self. We are letting everything that is temporary be where it is, no big deal, with no attachment. When the shrunken self stops thinking and choosing for itself, that is when there is a chance for God to take charge.

The belief that, in order to make it in the world, we cannot make it with God, and that in order to make it with God we can't make it in the world, sets up a false dichotomy. There is no place where God is not. Therefore, God is everywhere, on every level, no matter how deep or superficial. Whether we are aware of it or not, God is there in every moment and provides a lesson that when learned will bring us closer to Home. We have a choice whether to learn the lesson or not. We choose.

If we are committed to being "good," we cannot accept the misguided choices we have made. I hate mistakes, but am always thankful for them

later, when I have learned so much from them. There is grace even in our errors and our crimes. We can't let go of "righteousness" and become human until we recognize and accept our mistakes and learn our lessons. If we want grace, we have to own our past choices—not as an intellectual recognition, but as an experience.

Radhakrishnan, commenting on verse II.4.4 of *Bāhadaranyaka Upanishad*, makes the difference clear: "It is said that some people are clever only at expounding, while others have the ability to practice what they learn. The hand carries the food to the mouth but only the tongue knows the flavors."

When people preach the Truth as a concept only, it can be interpreted as positive affirmations instead of choosing the Truth. The problem with "positive thinking" is that we are not just "thinking positive," but actively trying to avoid something we perceive in ourselves to be "negative." As a result of that choice, we end up manifesting the very thing we wish to reject. What we run from, we run into.

Choose wisely. Because whether we realize it or not, we are making a choice at every moment.

Living Humility....

Everyone agrees that humility is a virtue. But no one really wants it. We all either redefine and belittle it as a kind of lightweight modesty, or deride it as belonging to losers. True humility, though, requires great courage, because it consists of completely surrendering our separateness to God.

In your life, if God is the doer, then you are world class. Everyone wants to think of themselves and to be seen as a big deal one way or another. The shrunken individual is so determined to be bigger than it truly is. It wants to shrink everyone smaller than its size.

Baba used to tell a story of the mathematician Ram Tirtha. One day,

Tirtha drew a horizontal line on the chalkboard and said to his students, "How do you make this line shorter without touching it?" When no one could answer, he drew a longer line underneath the first and said, "Instead of erasing another's line, we should make our own line longer."

The only true way to make your own line longer is to realign yourself with God. Then, and only then, can the shrunken self be put in its place. I don't care if a person is a "nobody," or not "world class" in some generally accepted way. Anyone's line is world class when they allow God to draw it. Think of the Desert Fathers: their lives were stripped to utter simplicity, and yet truly world class. They were humble and harmonious because the Desert Fathers were working to surrender to God.

Yet precious few people genuinely want to commit and contribute in this way. People remain selfish and prideful; their real priority is holding onto their idea of their lives. Baba used to say, "What are you so proud of?" When we are so prideful, there is no real care for others—no one else exists for us except to support our narrative.

When we pridefully hold onto our identification with the shrunken self, we cannot empathize. Empathy is actually feeling what others feel—not imagining it or resonating with it, but genuinely feeling it. If we resonate with someone's feelings, we are only feeling our own vibration, not theirs. To empathize, we turn inward and humbly let go of our individuality. We are willingly empty so as to literally feel what others feel. It has nothing to do with our individuality, so there is nothing to be proud of. When we are in the groundwater instead of isolated in our separateness, we empathize and contribute to the greater good of the world, from the small to the large, from the simple to the grand.

What we bring to the table of life reveals where we are in relation to God. God is everywhere—not just in some places, not just in some activities. God should always be the doer, and we should not interfere, believing we are of equal status. Our job is to practice, listen, and then

implement appropriately. We have to let our vehicles operate literally the way God wants them to.

The sages of all traditions tell us this:

In brief, do everything as though in the presence of God and so, in whatever you do, you need never allow your conscience to wound and denounce you, for not having done your work well.

(*Philokalia*, transl. Kadloubovsky and Palmer)

When the Son of Heaven is enthroned
And the Three Ministries installed,
Presenting jade discs
And four-horse chariots
Cannot compare to sitting still
And offering the Tao.
(*Tao Te Ching*, transl. Addiss and Lombardo)

If we were able to forget our own existence, we would find Him who is the source of our existence and at the same time we would see that we do not exist at all.
(*Letters from a Sufi Master*, transl. Burckhardt)

Achieving true humility is hard work. But when we are humble, our action is then accomplished and informed by Love. We empathize, listen for right direction, and then proceed, all the while having given up the fruits of our labor. Service and non-action are one and the same when we surrender to God. We are then always acting and serving from a place of non-attachment, where there is no separateness, no individuality.

It isn't as though I live a spectacular life. I live a simple life, but God is here. I am not asking you to change what you do, whether privately or professionally. I am asking you to let God be the one running your life. Don't change your life; just humbly change who runs your life.

The Wrong Surrender....

Today, the message being conveyed in all kinds of relationships is this: "You are perfect just the way you are. You do not have to do anything differently. If you follow my ideas, all will be okay. If you bring your view of the world in line with mine, all will be okay." The paradox is that there actually is something you have to do: agree with them, and do as they say. Then everyone will know you are being true to yourself and that you have the right voice. Is there any internal awareness or questioning? No need. They are the deciders.

This sort of relationship is sustainable—up to a point. And that one point is disagreement: dissent is considered treason. Arrive at that point, and you will be rejected, because they have the right vision. You have no right to question them, and you should not have your own voice. That would take you off track. Your voice should simply echo theirs. "Just follow my voice, and I'll like you. And when I like you, all will be okay."

These people say they care for you, but who's the "you" that they care for? They support your narrative, because they resonate with your shrunken self. How do they show their love? By wanting what is best for you, they say. But what they really want is for you to surrender to their narrative.

The actual word "surrender" is never used, but surrender is implied. The delusion is that these misguided people are not asking you to surrender to them but wanting you just to be yourself. How do you get to be yourself according to them? You already are, as long as you're in agreement with them. That's harmony. In harmony, there's nothing to do.

The true teacher, however, is unsafe for any narrative—especially this one. According to the above narrative, the true teacher is asking you to go in the wrong direction. From this perspective, the true teacher does not want you to be "successful"; the true teacher makes you feel bad about yourself. In reality, the true teacher challenges you to turn to the true Self and hear your real voice.

Unlike the true teacher, the misguided person does not turn your world upside down. The misguided person lets you keep everything—but there can be no growth, no change, nothing. That is all that your shrunken self wants, and the misguided person reinforces the delusion that that is all there is.

The true teacher wants you to turn inward, listen to the Self, and find your true dharma or path, which will bring you into harmony with God. The true teacher wants you to have and be Love. The true teacher leaves room for you to test the teaching. The true teacher wants you to surrender, and says as much—but you are to surrender not to the teacher, but to God.

But if you have already bought a misguided person's teaching, then you will see the true teacher as not true, not right—too harsh, too much work. You will believe the true teacher doesn't really love you, that the misguided person loves you and cares for and about you.

So the true teacher is seen as the scam, and the misguided people are seen as telling you the truth. It's a comfortable truth, an easy truth. And it is nowhere near the Truth.

How is someone to get past this delusion? What makes that move so difficult is that the true teacher can do nothing to facilitate it, because the true teacher has been labeled as the false. The only way out is for the trapped person to wake up to their delusion. How do they do that? Too often, only by following their delusion to the bitter end, and finding that the people to whom they surrendered never really cared about them. Once the scales fall from their eyes, they may be able to hear the true teacher, and then heal themselves.

Stand Firm by Surrendering….

Practice requires us to actually practice. And because this practice is internal, there is no place where practice is not appropriate. And yet, we decide when and where and how to practice. More insidious than this

willfulness is our tendency to misunderstand what practice is.

From the standpoint of the three *gunas*, our understanding of *sadhana* is determined by which quality is dominant at a given time. If we are *tamasic*, we resist facing the truth and see surrender as losing. People wedded to hate never surrender. If we are *rajasic*, we will say we are working, but our work will always entail fighting and struggling, and surrendering will still look like losing. When *sattva* is the dominant quality, clarity and discernment rule our *sadhana*, and we understand that surrender is truly freeing.

Without understanding the *gunas*, we fail to see what shapes our *sadhana*, and fail to see the crucial difference between questioning and wrestling on the one hand, and struggling and fighting on the other. Whatever we are facing, we begin by questioning it and ourselves, and then proceed to wrestle with what we find. Too often, though, we then turn to resistance. At first we may feel sure of what we are doing, but we are deluding ourselves that we are practicing, because all we are doing is being in our heads, struggling and fighting with no resolution and no desire for resolution. By doing this, we perpetuate the shrunken self.

We do not ask whom or what we are fighting. The answer is so simple: no one. We have merely created a dialogue between our shrunken self and our shrunken self. As I have said before, if you really listen, you will hear that the competing voices in your mental dialogues are really only one voice chiding itself. So how do we get out of this? We have to stop struggling. True wrestling—the kind that advances us down the path—comes only through asking questions that will reveal our wrong understanding for what it actually is: just a combination of thought constructs that will never be us.

If we believe our wrong understanding is correct, then whether we are challenged outwardly or inwardly, we will resist letting any new knowledge seep in. Our resistance can take the form of silence, which we believe gives us the moral high ground. This may mean lying low—remaining invisible until whatever we are resisting blows over. That is one way not to learn the

lesson. We might also tell ourselves, "It is not safe to open my mouth." But the reality is that we are protecting our shrunken identity from any blows that may in fact reveal the truth about it.

So the question we must continually ask ourselves is this: What do I want to accomplish? What is my motivation?

If my motivation is informed by hate, then whether I shut my mouth or open it, I will be cruel. When I speak, I will be cruel. When I don't speak, I will be cruel. When I question, I will be fighting, but call it wrestling. In these circumstances, we are not clear at all, but believe we are totally realistic and reasonable.

When we believe we have something to protect, we will become fearful. In *sadhana*, our wrong understanding leads us to protect exactly the thing we want to let go of. This next fourchotomy shows the confusion that results.

Fearful	Love
Directed / certain / clearsighted	Abandoning reason / reckless

Questioning and willingly listening to the answer is not fighting. Always ask the next question. Be honest in facing your experience. Are you afraid that, if you tell yourself the truth about your experience, you're going to get in trouble with you?

If we believe that complaining and fighting is what caring looks like, then once we have resolution, we will believe we won't be connected or have caring relationships anymore. We will not be invested in resolution; we will work to avoid resolution. We then believe that we are doing people a favor by resisting.

Oppositional (unteachable / no need to listen)	Agreeable
Autonomous / independent	Dependent

We are capable of seeing the truth and accepting that truth without a fight. But we tend to believe that in order to remain autonomous, we have to fight and resist. So we never move forward. According to the shrunken self, tools to resolve are tools to end it all. And because we hold onto this belief, we have a difficult time, which only perpetuates our fighting against life and the very people who could free us.

Fighting	Accepting
Wrestling / questioning	Gullible / impressionable

Wrestling is different from fighting. When we wrestle, we have *shraddha*—faith that is questioning. What are we questioning? We should be questioning what the lesson is for us, where our attachments are, what our resistance to growing is. Student and teacher should be on the same team. The student should not be fighting the teacher. Only in this way can the student get clear about where she is and what she has to let go of.

When we are non-attached, we are able to surrender and win rather than fight and lose. In *sadhana*, surrender means accepting truth and removing our wrong understanding. We are then working with our teacher. Surrendering is a critical part of practice. We stand firm by surrendering.

Surrender	Resist
Lose	Stand firm

Baba explained, over and over again, the real meaning of surrender and where surrender leads:

"[Y]ou should also surrender yourself totally, completely, to the Lord, giving up the pride of your own effort. You should offer yourself entirely to Him. Then the Lord will become yours in his fullness. This is the essence of all teachings and the answer of all answers" (*Satsang with Baba III*).

What We Are Willing to Sacrifice….

We all live by rules, assumed rules. We live by unconscious rules that are so embedded in us that we believe they are universal. But when we reflect, we see that these rules are not only not universal but in many cases harmful and counter to Love. These rules have been developed in environments that promoted the shrunken self, and therefore encouraged selfishness in the name of "family," "normal," and even "good" and "right."

In many families, there is a strong sense of hierarchy. Though words like "love" and "care" are used, underneath there is no sense of real Love and care. If we scratch the surface, we will see that at any given moment, there are only two choices: either we sacrifice ourselves, or we sacrifice everyone else to our desires. There is no third option.

In this kind of inhuman environment, it is sacrifice or be sacrificed. Someone has to be immolated in every interaction. There is never a situation in which all family members win. Love is win/win. Here, there is no Love. Because what we have is familiar, we call it normal, and normal is more important than Love.

Many years ago, I asked a person I was with, "Why can't we both be powerful, good cooks, artistic, smart, spiritual?" His answer was "No. Only one of us can be that." His response revealed that in his mind, he was clearly the only one allowed to have those skills. There was no win/win. I was left to quietly accept the situation. There was no compromise that would have allowed us each to move in from an absolute position and share. In order to keep the peace, sacrifice was what was called for, and sacrifice is not compromise. It's giving in and discarding one's self.

What we are to learn from that story is that people sacrifice others to maintain their idea of themselves. It is about power and control. If we want power and control, we will not sacrifice ourselves; we will sacrifice others to the demands of our system, and expect those others to be willing and happy to be sacrificed.

The one who sacrifices herself to another's demands deludes herself, calling it "doing the right thing." In this delusion, if we are willing to be sacrificed, we are "good." If we are not willing to be sacrificed, we are "bad." People who aren't willing to be sacrificed are bad because they make the demanding person's life more difficult.

Until we ourselves are willing to be sacrificed, we will only sacrifice others to our demands. We will expect them to go along, and we will be baffled and angry when others aren't happy to be sacrificed this way.

When we willingly sacrifice ourselves rather than others, we have started on the path towards humility; if we continue in that direction, it will bring us to humanity. We are, however, to sacrifice neither others nor ourselves. In Truth, we as ourselves are others—family in the best sense of the word.

In a real family, there is human-to-human interaction. Everyone feels supported and there truly is a win/win outcome. Everyone is encouraged to be themselves and work to the best of their ability. There is no sacrificing of our or others' authentic voices or actions. There is only one real rule, and it is to Love.

The One True Sacrifice....

The last lesson established how "sacrifice" can be a destructive force. From this point of view, sacrifice is a negation; it implies scapegoating, discarding, abandoning. It is not sacrifice, though, that is the problem. It is what we sacrifice, and to whom, that determine whether our offering leads to good or ill.

Sacrifice	Hoard / grasp
Scapegoat / abandon / discard	Cherish / keep

Sacrifice yourself	Preserve yourself
Serve the situation	Impose yourself on others

I have heard people actually say, "If you were spiritual, you wouldn't mind being the scapegoat." No. We are not to abandon or discard ourselves; our work is to sacrifice all that separates us from God.

The Passion is such an example. People tend to misread Christ's sacrifice. They want to see it as a scapegoating in which Christ suffered for our sins and was murdered as a threat to the so-called purity and order of the time. They speak of how much He suffered. In doing this, they belittle who Christ was and what He accomplished. They miss the purpose of retelling the story.

The truth is that we suffer only because we cling to our shrunken selves. This clinging is the essence of sin, because it is our effort to displace God and be the center of the world—it is what separates us from God.

Christ didn't allow Himself to be scapegoated; He gave up His separate will. At Gethsemane, He sacrificed everything no one should want. The rest was just the completion of the rite. He modeled the correct sacrifice by saying, "Not my will, but Thine be done."

Because He had sacrificed His separate will, Christ was never reactive. Unfortunately, the rest of us, with our at best partially surrendered wills, are highly reactive: we blame others, or circumstances, when we are the agents of our own behavior. Christ did not trade in blame; He always knew what was going to happen and what was needful.

Patanjali explains this in *Yoga Sutras* 4.3: "Causes do not put the nature in motion, only the removal of obstacles takes place through them. This is like a farmer breaking down the barrier to let the water flow (the hindrances being removed by the causes, the nature impenetrates by itself)." (transl. Swami Hariharananda Aranya)

In *Walking Home with Baba*, I explain the sutra in this way: "An incidental cause does not create a change in nature; it merely creates an opening for an existing tendency to express itself, just as a farmer irrigates a field by moving obstacles out of the water's way. We assume that what happens to us or around us causes us to act in certain ways, when in truth those incidental causes merely provide an opportunity for us to manifest an inner tendency. Because we don't always respond in the same way to similar situations, we know that the situations aren't really causing our reactions."

It is never the farmer; it is our tendency to irrigate the field that is the problem. The farmer may appear to be the cause, but when we dig deeper, we find that the real cause is always our willingness to irrigate the field when the opportunity arises. That is what we bring to the table. People wait for an opportunity to irrigate. When the environment is perfect, we "can't help ourselves."

The truth is that we *can* help ourselves, by sacrificing our shrunken selves to God rather than sacrificing ourselves and others to whatever farmer comes along. When we discard ourselves that way, we throw away our lives. When we understand that it is we who willingly sacrifice ourselves to someone else's wishes, we realize that we always had choice. Our practice is to work so as not to irrigate as we have always done. We do not sacrifice others, and we sacrifice ourselves only to God.

We all are then willing to sacrifice what should be sacrificed: that which does not encourage Love.

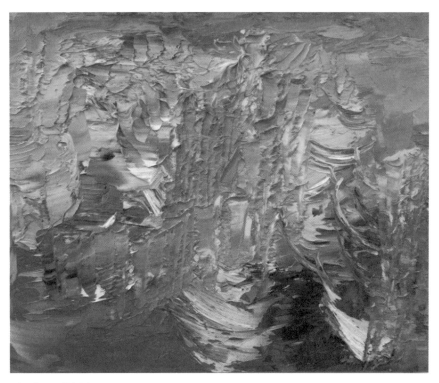

Anabasis (2017)

see to see....

we must

 get

 under the

 see

to see

 the real

the waves

 of vibrations

 wash

 over

the truth

 churning

 spinning

until we drown

 in our

 own vision

 dive under

 and

finally we

 breathe

 see the light

 of God

performance….

pain individualizes
 us
 separates us
Love removes
 all separateness

pain becomes the
 addiction
individual
 sustaining itself

Love dissolves
 created boundaries
individual
 losing its identity
reaching for pain once
 more to know
 itself

Love seen
 as delusion
ruins every
 thing
pain called
 Reality
not reality

Love called
 pleasure
not Bliss

individual so
 smart
God uses it to
 maintain His
 play
and yet
 His play is
always Love
 and follows
 those rules
 no matter
what the scene
 the act
 the drama

always a comedy
always one troupe
always one actor
always one theme

surrender your pain
 the essence
 of individuality

surrender to Love
 lose your part
 becoming whole

de-spelling poisons....

poison food
 expelled
 violently

poison ingested
 through air
 coughed
watered
 out

poison of hurt
 hate wounds
 heart
 so deep

 crying
 tears
 of toxins
 leaving

expelling
 poison
 takes Grace

 to incinerate toxins
 into Love

Rohini Ralby

i doctor....

if you see it
 everywhere it
 is
 in you

it is
 inclusive

we judge
 and so
 join the club
 it includes
 all
 differences

it is
 in all
 of us

 remove
 by
 acceptance
 stop
 looking
 at
 others

look
 within
 accept
 and
 clean
 no
 longer
 part of
 that club

All
 Love
 All
 One

265

variations on a theme....

love to
 hate
hate to
 love
way of
 the
 world

return
 to
 Love
God's
 Love

give up
 power
 surrender
 weakness

strength
 comes
surrender
 to
 God

 Love
will win
 even when
 optics
say
 loss
 hate
surrenders God

hate distracts
 us
to focus on
 this
 and
 that
 and
 i

Love does
 not
 distract

includes all
 focused all ways

love / hate
hate / love
 chooses
 sides
 and misses

 the
 mark

discern
 surrender

to what
 to
 Real

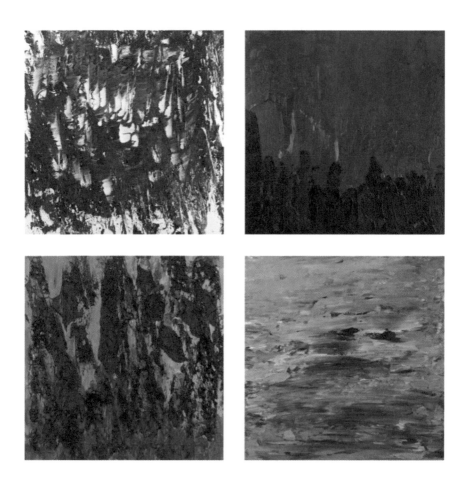

Love of Life (2017)

Love of life	Despair
Too out there	Self-contained

CHAPTER SEVEN

LOVE: GETTING TO LOVE

The Risk of Love....

If you do not love, then you are not alive. If you do love, you will be killed.
–Herbert McCabe

Love is everyone's goal whether they know it or not. Love comes with a
risk, because until we actively choose this goal, we will be moving only
toward twisted Love, which is always tainted with hate. The people who
Love are willing to Love no matter what.

So who are these people who embody Love? Swami Muktananda is one
of these people. He Loved, and everything that manifested out of him was
Love. There were no twists and turns. Just Love coming through and
manifesting as Love. Wild, uncanny, spontaneous, and always clean.

This is what I witnessed. Some people may say I was, and am, blind; I
am okay with being called blind. In all my years, Baba never let me down.
Even today, I feel his guidance, through the mundane and the sublime. Life
around a Great Being does not always make sense. Reason was so off the
point. I went to Baba as a well-educated person, a person trained and
disciplined. I went to Baba for the internal practice. I was not looking for
another external structure. He gave me everything I asked. I am so grateful.

Love is not reasonable; it is True. Love fulfills everything, so the person
who embodies Love is always fulfilling every moment, every event, every
situation. We in our ignorance only see the superficial and miss the
underlying purpose. Love is always moving to resolution, to
harmony, to God.

Baba was always moving us to being resolved within ourselves by being

our Self. That meant that events and actions had to occur that were not nice in order to illuminate what was in each of us. Baba, because of who he was, was always willing to play and orchestrate the *lila* that would shine that light on our delusion, so even we could see it and then choose to go with Baba and let go of the obstacle to Love.

Baba left his body in October 1982. He has never left me. The Guru Loves his disciples, and the bond is strong. The disciple may leave, but if he were to turn around the Guru would be there. Baba wanted what was best for each of us. There were people who did not always agree with him. They wanted their individuality to shine. For them, Baba was power, not Love. From the head, "love" is power.

If you Love—if you have Love—people who don't want Love will see you as possessing some kind of power, and they will want to take it from you. When they realize they can't take it, they will try to crush or humiliate you to restore their sense of their own power.

The shrunken self is always looking to recruit allies in its war against Love. If someone doesn't buy its con, the shrunken self will only see that person as having been suckered by some other con. In other words, people will see me as weak, and conned by Baba. But there is a problem with that line of reasoning: Baba Loved. People say, "But Baba told different people different things." That was how Baba expressed Love for each person, to bring to light what each person needed to see. What was in each of us that would cause us not to see his Love? Hate.

Baba was always moving us toward resolution; his Love used whatever device was needed. And depending on where the person was, Baba was subtle or really blunt. Hate and twisted Love inform each of us until they are resolved back to God. Baba was and is always shining the light on our separateness, so that we see it for what it is: selfish individuality. Then he is there with us, encouraging us to choose life instead of death, to surrender to Love instead of hate.

Who Doesn't Want Love....

"Who doesn't want Love?" I ask that question a lot. Can someone answer that question for me? When people say yes, they want Love, I then tell them how to get it: be with your experience, let whatever comes up from your experience come up, and function appropriately on the physical plane. That is where everything breaks down. No one wants to do it.

Everyone says they want Love, but they don't want to accept that real Love comes from stillness. If we want real Love, we have to do the rigorous work of knowing our vibrations and stilling all of them; then Love, which is underneath it all, can emerge undistorted. This Love is not at the mercy of anything outside of us. "Outside of us" includes our bodies, senses, minds, emotions, intellects, narratives, habit energies—any vehicles or vibrations. This Love arises out of the Heart.

The practice is nothing new. The *Yoga Sutras* say that Yoga is the stilling of all vibrations. In the Bible, Psalm 46 says, "Be still, and know that I am God." The Desert Fathers say for us to guard the Heart and all will be quiet—their word *hesychia* is Greek for "rest." Kashmir Shaivism instructs us to rest in the Heart by a mere orientation of the will. A great Sufi Sheikh once wrote, "When your heart is emptied of beings it becomes filled with Being and from that moment love is born between you and other beings" (*Letters from a Sufi Master*, transl. Burckhardt).

We have the free will to choose Love or not. We recognize Love when we experience it because it is our nature; we have just covered it up and then forgotten it. But once it arises, there is immediate knowledge. We have to have at least a trickle of Love within us to feel love from others. Therefore, I have to love myself in order to feel someone else loving me.

This is so seldom the case. Everyone has their moments when they're likable, because at those moments they tend to have stilled even a little, so Love is flowing less obstructed within them. We have to be practicing to have those moments all the time. Strangely, we usually don't like those

moments in ourselves; we don't feel we're being ourselves. When you come into the meditation room and sit, you might not like you. And that's a big problem. Who is it that doesn't like you? The one that doesn't like the moment is not you. The meditation room is the laboratory where, hopefully, we continually choose Love.

To get to the place where we continually choose Love, we must have a guide, and that guide must encourage real rigor in our practice. People like the concept of a tough, no-nonsense teacher. They just don't want to sit in the same room with a tough teacher. They only want the concept, which allows for the idea without the rigor. You don't have to do the work; you do the concept of the work.

But if you are doing the concept of the work, you are doing the concept of Love. If you want Love, you have to go to the stillness that is beyond all conception.

Caring....

We all talk about being caring. And we usually refer to being caring to others. But if we haven't learned how to truly care for ourselves, we will not be able to effectively care for others.

The problem is, we may well have learned what care is from people who didn't know how to care for themselves, and so did not appropriately care for us. In my case, it was only from Baba that I learned what care truly is, and how to express it fully. I had to dismantle my understanding of care, which I had been carrying around with me up to that point.

What I learned is that care is paying attention to a person and wanting what is best for them and facilitating that—and this includes yourself. Care is manifesting Love. It is not a decision you make on the basis of your ideas. Care is not a zero-sum game, in which care given to one person means a withdrawal of care from someone else. Care is a bulb shining in all directions, not a spotlight. Everyone benefits.

One way to work with our understanding of care is to use a three-dimensional fourchotomy.

The first fourchotomy is just the quality of caring itself:

Caring	Indifferent / neglecting / abandoning
Lost in / codependent	Non-attached

The second fourchotomy is how we care for ourselves:

Am I caring for myself	Am I indifferent to myself / neglecting
Am I lost in myself / self-absorbed	Am I nonattached to my self

The third fourchotomy is how we care for others:

Am I caring for others	Am I indifferent to others
Am I lost in/codependent with others	Am I non-attached with/to others

Finally, the last fourchotomy is how others care for us:

Are others caring to me	Are others indifferent with/to me
Are others codependent with/ lost in me	Are others non-attached with/to me

When we relate with people socially or professionally and we care both for ourselves and others, our interactions should be engaging, respectful, enjoyable, interesting, comfortable, voluntary, relaxed, and full of care.

Caring in action should look like this: listening, being honest, respecting others' agency, and giving ourselves and others appropriate space. If we are resonating, forsaking ourselves, letting ourselves be receptacles for others' outbursts, getting emotionally enmeshed, putting up with inappropriate things, or wanting to be fixers, then we are no longer caring but rather losing ourselves, which is no help to anyone.

When we are indifferent to others, we don't listen, we don't participate, we put up walls, we belittle, we fail to value, we allow ourselves to be distracted, and we remain rigid. When we are truly nonattached, however, we will be present, conscious, disentangled, listening, clear, non-reactive, at ease, receptive, agile, and responsive.

If we actually take appropriate care of ourselves, then we can take appropriate care of everyone and everything around us. If we do not know how to take care of ourselves, we will not be able to discern real care in others, much less know how to care for them.

Depending on where we are internally, we relate with other people according to a spectrum of possibilities:

Isolation

Resonating

Sympathy

Caring

Empathy

Compassion

Love

When we are isolated, we do not relate on any level; we remain separate even in a crowd. Resonating is an immature form of care: instead of remaining grounded within ourselves, we vibrate like tuning forks with the vibrations of those around us. This fools us into thinking we are connecting with others, when in fact we are losing ourselves and being selfish at the same time, because we are really indulging in our own vibration.

Sympathy is seeing outside ourselves without selfishness. We feel for someone else's situation. This makes caring possible, because we are focused unselfishly on someone else while remaining grounded inwardly. When we are completely nonattached and feel someone else's vibration

while knowing it is not ours, then we are truly empathetic, and can grasp and understand someone else's experience. Only with nonattachment can we show pure compassion, which will then bring us to Love.

From Despair to Love….

During the Christmas season we tend to put aside our differences and come together to celebrate the Joy of Life. We celebrate the triumph of God over the shrunken, alienated self. We celebrate the birth of a Great Being, the Incarnation of God. We feel God's compassion and Love for all of us. We recall the triumph of Good over Evil in the story of Judah Maccabee. We are all God's, and in Truth there is nothing but God.

Love of life	Despair
Too out there / lost in externals	Self-contained

But despite all the celebration, we have forgotten our true nature. We foolishly think we are steering the ship; instead, we are drowning, yet completely unaware. This is what Kierkegaard meant when he wrote in *The Sickness unto Death* that the specific characteristic of most despair is that it is unaware of being despair.

True self-containment requires awareness; when we despair, we work not to feel, and mistakenly call that self-containment. When we become aware, we move from despair to feeling, which will mean feeling the pain of our self-abandonment. It can show up as anxiety, upset, grief, anger, or weariness—but only by facing it can we move past it. Getting past the pain moves us to Love. To be proud in our despair is to choose to live in alienation.

We tend to distract ourselves with the world around us and believe this is loving life. But we are really "too out there"; we lose our subject in the

object of the world. We abandon ourselves, and are therefore cut off from the source of life. Love comes from within; we cannot Love if we are outward-turned. In order to Love the world, we have to rest in the Heart and look out at the world simultaneously.

God will never forsake us. We forsake God. And we forsake ourselves, believing that we should please the outer world. We then fool ourselves into thinking we are giving when in truth we are abandoning ourselves, and that we are selfish when we are truly taking care of ourselves and others.

Forsaking self	Self-fulfilling
Giving	Selfish

When we have abandoned ourselves this way, we then hide, believing we are being careful and protecting ourselves. We hold everything close to the chest, even our Hearts, believing we are smart and that those who are generous are foolish.

Hiding	Open
Careful	Exposed

Stingy with their heart	Generous with their heart
Savvy / smart	Naïve / foolish

Clamping down, choking off, or shutting off feelings then seems to us to be exercising appropriate restraint. But it is really a form of stinginess. People who are stingy do not Love. For the stingy person, being in the Heart is losing.

Willing to play	No fun
Frivolous	Serious

Just let Heart sing	Stifle
No restraint	Restraint

Generous	Stingy
Too open	Measured

Generous of spirit	Mean-spirited
Extravagant	Contained

Nasruddin was a tax collector. One day he fell into an open pit of sewage. People would come along and try to help him out, saying, "Sir, give me your hand." He would be rude and either insult or ignore them. This went on for hours. Nasruddin was stuck in the sewer and could not get out. Finally, someone who knew him came by. Seeing Nasruddin, the man understood just what to do. "Nasruddin, take my hand," he said. And of course, Nasruddin did.

When we are stingy, we call ourselves measured, restrained, careful. But in truth we are takers and will not give. Our stinginess reveals our despair.

We despair only when we are wrongly identified, and miss God's play, and see ourselves as important. When we are full of ideas about ourselves, whether positive or negative, we cut ourselves off from Love. Love is our true nature, and we are to be our Self. To fully manifest our nature is to Love life. When we truly Love life, we will never be "too out there." That would be like saying, "There is too much Love, too much God."

Despair is ephemeral, no matter how hard we cling to it. We are all destined to Love for all eternity. And we should celebrate accepting that destiny.

The Harvest (2011)

rituals....

performing rituals
consciously
pranam
light incense
meditate
kneel
chant
study
live
consciously
with Love
surrender
care
give
serve
live
consciously
with Love
make food
wash dishes
brush teeth
live
consciously
with Love
dress
walk
work
sleep
live
consciously
with Love
be with experience
let whatever
come up
function appropriately
one ritual
consciously
with Love

dining in….

Love is God's
 nature
we
 twist
 and
 shout
to make it
 better

 over
 under
 cooked
never
 tastes
 as good
 as
 just
 God

the joke….

at least
 Baba is
 laughing
 humor humors
 bubbles up
 the joy to
 play
with life God
 play
 All the time
 erase the story
that is no fun
 Baba laughs and
 laughs
 Loves

happy holy days....

spanda grace spirit
 manifests into
 word
 manifests into
 wor(l)d

 manifests each of us

 as we play on the playground
 of wor(l)d

 God's choice
 manifests us

 as
Love
 or fight
 and challenges the wor(l)d play

 through past effort

 we earn our side
right effort at all costs

 brings forth Love

Rohini Ralby

all and nothing....

now
 is
past
present
future
 right
 now

a moment
 a blink

 to nothing
 for All

 close eyes
 All gone

where when
 waking
 dreaming
deep sleep

now
 misses
 nothing

encompasses
 nothing
 and
 All

 relative
 Absolute

live it
 All

 right
 now

wellness....

physically separated but

 connectedinwardly wemeetinthe Heart

where God resides

crampedtogetherphysically with no inward reflection

hollow empty nothingness brutal

 loneliness

in one second we meet within with

joy Love our choice

physical alone or Love

have it all from going within and never miss each other

there is no other

Joyous (2015)

Joyous	Despairing
Intoxicated	Grounded

LOVE:
WHAT LOVE IS

The Light That Enlivens....

The light that enlivens the subtle creative process is the same light that enlivens the shrunken, ignorant, delusive shrunken self. We have to choose—and we can choose—what we enliven. Will and discernment are so important.

Love enlivens everything, but because it passes through different vehicles until it reaches full manifestation, it is twisted Love by the time it manifests fully. We then have a narrative that we live out, and we believe there is no other way to see things. Each of us, though our expression is different, believes our way of seeing is the real way, the Way. Though we are the moon and not the sun, we believe we are self-illuminative and sure.

Once we begin *sadhana*, we learn that our view of the world is diminished and not universal. Our enlivening is not as pure and clean as we previously thought. We now turn around and look at our vehicles, which are covered with the dust and dirt that distort our light into a narrow and deluded vision and expression. We become reflective and grow aware of our impurities and faulty thinking. We are in the process of cleansing ourselves, so we can be who we really are rather than the shrunken self with whom we have wrongly identified. We are cleansing our will and discernment. In this phase, as we cleanse ourselves deeper and deeper, we see the world with a wider vision, and we understand in new and clearer ways.

At this point, we need to be extremely careful, because we can believe we are somewhere we are not. The fact that we can see from a greater perspective does not mean we are fully realized, or that we are better than others who have not attained our exalted position. *Sadhana* is about the removal of the wrong understanding that we created and enlivened in the first place. What are we so proud of? We made the mess we are now cleaning up. We are retracing our steps back to the beginning and cleaning as we go.

Finally, once we reach home in the Heart, where there is only Love, we then will turn again and manifest what remains: pure Love. There will be nothing to cloud the Truth. We will truly be who we are, with no distortion or diminishment. Pure Love expressing itself as Pure Love. When we each reach this place, we still look different because our vehicles, even our pure vehicles, will express Love differently.

We will then manifest for the good of All, and no other reason.

What Love Is....

Love is our nature. There is no object for this Love. We live in Love when we *know* that all is us and we experience no difference from anything. We are no longer separate: all is perfect, all is one, and we perform all actions.

Everything comes from Love and is Love. Once we lose our wrong understanding, we know that all is Love. Our wrong understanding is that we do not know who we are. We believe we are what we think and feel, but that is not who we are. We cannot know who we are until we *are* who we are. We do this by giving up our individuality; then we know all is perfect because there is nothing that is not Love. We are first the *con* of consciousness, and then we become the *sciousness*. We move from individual with wrong understanding to Shakti to Shiva—from character to lover to Love itself.

Does God Love creation? Absolutely. So God creates both loving and objects to love. We then turn around and re-enact this by trying to love God. But we cannot fully love God until we become God. We have to sacrifice ourselves in the fire of purgation, which is the fire of Love, to then emerge as Love. God always Loves; that is God's nature. All is the same, all is Love.

So we have to give up our limited identity, to which we are so devoted, in order to return to who we really are. This is what God asked of Jesus in Gethsemane and of every other Great Being, and what God continues to ask of each of us. Yet our shrunken selves refuse, and remain devoted to our wrong understanding.

Our first step is right listening. If we will not obey our outer teachers, we will not have a chance with our inner teacher, the Guru. If we think, then we are not listening. If we emote, then we are not listening. Go inward, beyond the mind, to where God and Guru speak. Then you will begin to recognize our true nature—Love.

Twisted Love....

Twisted Love is still Love. So everything is Love in one form or another. The problem is, God is having to push through our ignorance. Manifestation is Love; just twisted Love; twisted because of us. If we give up our wrong understanding and let God be the doer, and we no longer believe we are the center of attention, then God will shine through each of us as pure Love.

The question is: Is the manifested world pure Love, and are we just not able to see it? Or is it also twisted Love, as we are because of wrong understanding? Are we just as wrongly entangled in nature as we are in our lives? If we disentangle and non-attach, nature and all our vehicles will become clear and still and allow God to express through all of us and the material world as Love.

Are you not bored with your vehicles? Are you not sick of your narrative?

Are you not bored with your five senses? Living life at first level is going to be relating through your five senses only unless you move on. Relating with your life using the five senses, even with discipline, is functioning at first level. We are in a beginner's ritual. This way of relating with life is no different than performing rote rituals. Whether you are doing rituals like washing statues, singing hymns, or reciting prayers in different ancient languages, you are still practicing first level. There is nothing wrong with that focus as long as we realize we are not going to get to the final perfection if we only follow this practice.

So if you are approaching your life as an empty ritual without anything deeper, then it does not matter where you are. Whether you are in a monastery, an ashram, a city, or a suburb, your life and all your actions will remain without the richness of God. Do you report your life or live and share your life? Why are you so attached to just going through the motions? You do not realize it; you believe you are contributing to world peace, but you are really contributing to world inertia.

We should not be attached to our rituals or our lives. They come from the same place, and our job is to transcend both. God should be our focus, and we should not be distracted by life, whether in the form of mundane or sublime activity. If we see either kind of activity as the pinnacle, then we have missed the point.

We may begin to ponder, question, and study; this is better, but still only second level. Not until we are practicing the third level can richness be consistently infused into our rituals and mundane life. Being still, resting in the Heart, and functioning in the world is how we live life to the fullest. We then live our lives and perform our rituals, but our focus is on God in our Hearts always.

Do you want to have and allow God to play or are you still so attached to being in control? The purpose of life is to have God play, and we so want to be involved and make decisions instead of God. We have forgotten our place. Someone—one of us or all of us—has to let God in on the game. As long as we are all involved in our lives, God is on the bench. And at the same time, no one is willing to step up to the plate and give it their all. We live as if our separate lives had ultimate importance. If we were to give up our attachment to the part we are playing, we would actually have a chance to express the Love of God in everything we do. Now that would truly be magnificent.

If I am trying to change the outside, then that effort is still just twisted Love. If I let God be the doer, then He can actually change the outside. We have to get out of the way to let God play. Let us work to untwist the love we share by having God share God's Love through us.

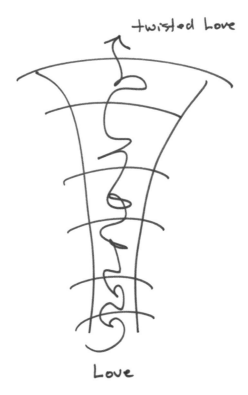

Be Not the Moon....

We say the moon is so bright tonight. We should be saying the sun reflects beautifully off the moon tonight. The sun is the source of the moon's light. Please tell the moon this, because it thinks it shines on its own.

We as individuals think we shine on our own. And in our present predicament, the individual has shrunk so much that it is just the brain. So if we drug the brain, we change our selves. But the brain is not the source; it is only a vehicle. And the brain cannot love. Through drugs, the brain can produce pleasure; if that is the final goal, we are not looking at the shadows on the wall of Plato's cave; we are the shadows.

I have written elsewhere about lovers and the righteous: "We are to give up even survival over Love. So much of the fight these days is because we believe we will not survive if we do not kill the other. Even this idea of survival has to go so that Love of God shines here." We need to ask, "Who wants to survive?" The answer is that the individual wants to survive, at all costs. And survival for the individual means having a certain level of safety. Hence this fourchotomy:

Safe	At risk
Closed off / isolated	Engaged with the world

But are we safe when we isolate ourselves? Not necessarily. And are we at risk when we engage? Also not necessarily. We are in fact isolated when we operate as if the individual is the sole entity and the soul's true identity. In order to be an "individual," we have to isolate ourselves from the sun, the Self, God, which guides us and keeps us truly safe.

The individual believes "kill or be killed." In the *Yoga Sutras*, clinging to life is the last of the five afflictions. From ignorance of who we really are, we fight to keep our shrunken self, our character in our narrative, alive. In

spiritual practice, this shrunken self, the moon, has to be put in its proper place. We have to cease to identify with it and instead use the shrunken self merely as a foot soldier for the true Self.

To be Lovers, we can no longer identify with our individuality. This is not an easy task; it is not asked lightly. As someone who once loved to fight, I know what I am asking. Hate and fight feel so much more "alive" than Love and peace. Are they? For whom are they more alive? The haters? The fighters? They imagine it as vital and a great rush, but even *The Art of War* by Sun Tzu says differently:

Therefore those who win every battle are not really skillful—those who render others' armies helpless without fighting are the best of all. (transl. Cleary)

Killing does not help us survive; it is a shrunken-self solution designed to keep us in ignorance. Love is the only way to live, but to Love we have to acknowledge the Heart as the sun it is. The Heart informs everything.

This Love is not the opposite of hate. This Love informs even hate. Hate is a mere emotion, while Love is the source of all. Hate is just twisted Love. It comes from our wrong understanding of ourselves and of life itself.

Self-loathing / doormat / enabler	Self-assured / leader / tough love
Humble / of service / fosters growth	Arrogant / tyrant / crusher

Mean / hateful / selfish	Kind / loving / selfless
Honest / straightforward / self-contained	Doormat / enabler / self-loathing

The attachments in these fourchotomies foster inequality. We must give up our desire to be unequal. In order to be equal, we must give up the survival of the shrunken self. We all must own all these qualities to free ourselves from the above fourchotomies. When we do this, we will Love with all our Heart, mind, soul, and strength—and even body and brain.

Even *The Art of War* says the greatest warrior wins without fighting, and definitely without killing. We can discern without hating. We have to give up even hating those who hate. Loving is living.

Love Is off the Grid....

Until we have experienced our true Self and indisputably know we are not our shrunken self, we do not have an opportunity to embody real Love. Even then, we have to be vigilant not to "forget" and return to our "normal" life. Knowing the difference between who we are and the shrunken self allows us to choose; we can choose Love rather than just fleetingly glimpse it, believing that is all there can be. Love is off the grid. It is beyond the dichotomies, beyond the fourchotomies which make up the grid. Love emanates from the playing field of the Heart. If we are clear and conscious, Love will inform all we do. Love will be the expression of who we are.

Until we are committed to Love, power and pleasure will be directing us in all we do. We won't think this to be true because we will use the word "love" many times to describe feelings and actions that in fact have different signifiers. Love is reserved for the experience that is beyond signification, beyond thought and emotion; Love is Universal Subjective Being. With Love, we experience the Unity in the diversity of the world. With Love, there is All for All. With Love, there are no weapons; it requires us to give up our weapons. With Love, relating would have qualities such as these:

Willingness to lose	Agency	Appropriate care
Resolution	Wholeness	Stillness
Transparency	Safety	Generosity
Respect	Joy	Unity in diversity
Empathy	Independence	Harmony
Nonattachment	Compassion	Wanting best for all

What the shrunken self calls "love" is really only power and pleasure. In ordinary relationships, power and pleasure will be present in different proportions. A certain relationship could be comprised of 70 percent power and 30 percent pleasure. Depending on the people involved, this will or will not be sustainable. From what we have observed we will say "they have a great relationship," only to find out a short time later they have split up. We will need to examine what we believed was at the core of that relationship, what was actually there, and what qualities were being used to express that core.

The love that people generally settle for is the emotion that is the opposite of hate. Remember, real Love is completely off the grid. Power / pleasure is on the grid. Our shrunken self, the grid, has to lose if we want the opportunity to Love.

At the beginning of a relationship, often it will be as if a portal has opened to a new dimension and Love is everywhere. Because we are not conscious, we are unable to maintain it. Either gradually or abruptly, the access is shut, and what had appeared as universal and all-pervasive has now shrunk and is stuffed into the constricted life of the shrunken self. We do not know how to open it again. We are left with memories that we cling to, and we accept the realities of life. The survival skills and qualities that we have developed are again operational, and an old life we had thought was over resurfaces yet again.

We are on the grid. We will take care of ourselves using anything to gain or maintain power and pleasure, hoping those around us will support our choices. Every action—even the slightest—will be infused with power if that is what motivates us. The shrunken self calls power and pleasure love. Real Love will be seen as superficial and lacking because it is not invested in power.

The qualities of power will unconsciously answer these questions: what weapon do I use, and how do I leverage using it?

Below are some obvious components of power:

Judging	Superficializing	Withholding
Crushing	Wearing down	Putting down
Fuming	Playing the victim	Acting superior
Healer/enabler	Guilt tripping	"Conering"*
Controlling	Cornering	Dismissive
Flattering/ingratiating	No agency	Controlling info
No responsibility	Blaming	Being blameless
Being needed	Needy	Being ill
Overcompensating	Self-marketing	Isolating / protecting
Standoffishness	Colonizing space	Withdrawal
"Sneakretive"*	Wounded/wounding	Winning
Obtuseness	Seducing	Undermining
Keeping secrets	Lying / deceiving	Diverting
Being annoying		

*Coinages of mine. "Sneakretive" means "sneaky and secretive," while "conering" means "isolating and cornering someone so as to con them."

The qualities of pleasure—which complements power—will unconsciously answer one question: How can I feel good?

Indulging	Numbing	Gluttony	Lust
Greed	Chasing beauty	Vanity	Appetites
Coddling	Mmmmmmmm…	Fulfill sense desires	Lost in others
Self-pitying	Guilt tripping	Wallowing	Worrying
Processing	Sleeping	Exercising	Shopping
Complaining	Commiserating		

Unlike power and pleasure, Love does not go under any disguises. If our eyes are open, it is always apparent. But we will only see it clearly and live it fully if we choose to surrender to who we truly are.

Love Is Nondual....

The more we move toward nonduality, the more Love we will have; the more diverse we are, the less Love, compassion, and empathy. When we live in our notion of diversity, we may believe in our uniqueness and not feel our unity with others.

I have written elsewhere about unidualism vs nonduality. "All is good" or "all is bad" is unidualism. Unidualists believe they see the truth and the big picture. They are really only taking a very superficial view of the world, and not even the whole world. They compare themselves with people whom they see as narrow in their vision; then they can believe they are broad-minded.

Sees big picture	Tunnel vision
Cloudy / vague / abstract / missing details / noncommittal	Detail-oriented / grounded / earthy / handles day-to-day reality

But these kinds of comparisons miss the truth entirely. On the one hand, people—individuals—think they matter in the world. But the truth is, they don't even consider where we truly matter, and how. Most people live in their own narratives; if they are even conscious of their vibrations, which undergird their narrative, they think those vibrations don't matter. But our vibrations impact everyone.

Our manifested activity happens because of our vibrations. All spiritual traditions teach that we must still our vibrations so that Love can and will shine forth. Our vibrations obscure the truth of who we are. So in order to truly be in harmony, we must be willing to practice, and to still our vibrations. Then Love will be clear at all times, and the reality of nondualism will be apparent. This understanding is the way to embrace the world.

The only way to fit in is to Love. Love is nondual. It really is as simple as that. But in our narratives, we believe we are clever, and know how the world really works. And our idea of how the world really works doesn't make any real sense at all. We conflate all sorts of things. To take one example, we may not know the difference between being savvy and being deceitful.

Savvy / smart / independent	Stupid
Deceitful	Transparent

In 1979, Baba gave me a powerful experience of the void. But it wasn't empty; it was completely full. It was darkness that was completely light, and brightness that was completely dark. That is what I experienced—the universe as illuminated darkness, or dark illumination. It was everywhere. It was everything. There wasn't and there isn't any "Oh well, over here we have something else." No, it's *all*. And that's why the experience I had was in the waking state. Eyes open. It wasn't a vision in my meditation.

That is the understanding of unity in diversity: the understanding and the experience of what underlies everything. So it's a both/and simultaneously. There's unity, there's unity in diversity, there's diversity. *Bheda, bhedabheda, abheda.* We're heading toward nondualism; that's where we are ultimately going. And that's what Love is. The more we Love, the more nondual we are. If we are committed to diversity, we can't Love.

If we are committed to diversity, we spend our time being separate, and separating everyone else into categories. We don't have real Love, nor do we have real empathy. So the more we move toward nondualism, the first thing that's going to happen is we're going to hurt more. That's just the way it is. If we're not strong enough to feel that hurt, and if we're not strong enough to face the hate within all of us, then we can't practice.

That is why this is not a "friendly" practice.

From the standpoint of nonduality, we can never attain; we can only realize and re-cognize. With nondualism, there is no subject and object. All just is.

If we go back to the *Yoga Sutras*, the fourth section talks about how the mind is sometimes a subject and sometimes an object. And it can't be subject and object at the same time. You're sometimes a subject and sometimes an object. And therefore the mind cannot be you. And the more we practice, the more that sutra makes sense. When we think we're an individual subject, we're just a stew of thoughts using the word "I." It's just a notion called subject.

So be with your experience, whatever it is. Let whatever comes up from your experience come up. And function appropriately on the physical plane. This is to be done all the time, without interruption. We will then be guarding the Heart and will still all our vibrations. We will rest in the Heart. Love will then be unobscured.

Love is not a notion. Love is off the grid. There is no opposite to Love. Love is the only way to truly fit in. Truly fitting in is living nonduality. The Lover and the Beloved are the same.

What Makes Us Human?....

What makes us human is a level of consciousness that goes beyond the five senses and a basic striving, a basic will to live.

What makes us human is a degree of consciousness that allows us to perceive, to desire, to will, and to be transformed into Love on a universal level.

What makes us human is Love—Love in the greater sense rather than the lower levels of attachment, which are merely will and desire.

Animals possess will; they desire to live, whatever that means for

them. The will to live is encoded in all of us; it is the most basic form of Love. A true human being transcends personal will, transcends personal desire, to and for the greater Love of All.

If the will to live is the most basic expression of Love, then if I feel my life is being threatened in any way, I will actively destroy what is preventing me from living. We see that all around us now. Isn't that what we all do individually—defend our idea of living?

The Love that a human being is capable of, that full consciousness, is for all—not just for a selfish individual. So if I am truly human, then I want the right to live, and to Love, for all.

We therefore need to choose consciousness if we want to be human, to Love, to transform our desire by disciplining our wills to turn to the Heart. Only then can we begin to Love as God Loves us.

But if we are clouded, if we are numb, we will not Love—we cannot Love. We are selfish. Our humanity is gone. We are not conscious. People who plant bombs in public spaces think they are conscious, think they are sure, think they know what they are doing and that it is the right thing to wreak destruction. Somewhere they feel their lives are being threatened, because their beliefs on how to live are being threatened. They see themselves as making a sacrifice for a greater good when all they are doing is destroying themselves and others.

How many times do we blame and destroy because we are so sure we know what is going on, what life is, and what it means? And we reject Love because our lower form of desire, which is will, is devoted purely to our shrunken self's narrative, a misguided understanding of who we are. Our lives are not threatened; our narratives are. And that is enough for us to do terrible things to ourselves and to others.

Asmita is the loss of subject in object. This is not the same as *avidya*, or ignorance. In Sanskrit, *vidya* is knowledge; *avidya* is not the lack of knowledge but a different kind of knowledge—in this case, a shrunken,

limited knowledge in which we take the non-Self to be the Self, the unReal to be Real, the impermanent to be permanent. *Asmita* is a consequence of *avidya*: we lose sight of our true nature as the Self of All, as Love, and instead locate our subjectivity in our intellect, which is to the Self as the moon is to the sun—only a mirror.

So, for us, the intellect—the mirror—is now "me." I look in the mirror; it's me. That's I-ness, I am-ness, I am—but it isn't the Self, our true identity. From this place of identifying with the intellect, we lose ourselves even further, in a panoply of wrong identifications. So once we get to "being" our bodies, our jobs, our cars, our anything, we are involuted completely into the material world. And we now cling for dear life to that shrunken existence. That is affliction.

Mired in this limited condition, we look for bliss, and maybe even for truth, but we avoid consciousness. Everyone wants *Sat* and *Ananda*, hold the *Chit*. We do not want to be conscious and therefore responsible. So we choose to be less than human. And we make this choice to be less than human while convincing ourselves we are completely aware and fully human.

Baba used to say that you have to have a strong mind to get rid of your mind. We have to have agency to be able to give over our agency to God. Our wills have to be redirected to God, away from maintaining our wrong identification. And if we are strong enough to understand what we must do, we will surrender that shrunken self to uncover who we truly are: fully human, universal Love.

The wills of the people who choose to set explosives in public places are completely separate, sure, and honed in on their commitment to wrong understanding. They could not be more involuted away from God.

In our *asmita*, we appear to limit *Sat-Chit-Ananda*—Absolute Truth, Absolute Consciousness, and Absolute Bliss—to the small pleasures and indulgences of the shrunken self. We insist on seeing everything as it

relates to us and our desires. We choose unconsciousness, when our humanity comes from our being conscious.

Through all this, the Self remains the Self. Our true nature abides beyond all ignorance and attachment. We will all eventually make the choice to return there. That is our destiny, and also our task. *Sadhana* is therefore not selfish; every step we take toward the Self is contributing a step toward Love for the whole world.

Cinder (2017)

your move....

how sad we are
how sad
we choose

my way
i know
my way
i go my way

the right
move

i think
and thought takes
me down the
path
of my way
which is always
the wrong way

how sad we are
we think
it guides us
to a voice
our voice
we crave that voice

that takes us down a
path where always
we lose
and yet we think
keep listening
listening
listening to
what we think
to our
voice

if thinking ceases
failure ceases
Heart emerges

checkmates
the unreal

there are no
losers in the Real

stasis....

normal has no
 ground
only quicksand

sinkingly settling
 self
 deludes
with thoughts

in an hourglass
 thoughts
tell the time
 and
we are done
 before
we know
 anything

the desert filled
 with empty thoughts
 has
no nourishment
 to sustain
 life

arid wind blows
 our thoughts
 globally
inflicts all
 on all

thought storms leave
 us blinded
no where to travel
 grains irritating our
 senses

cover ourselves in lies
 no where to go
sink into
 narrative
 lost

no love....

no love
does not
 save us
 no
 Love
 saves us

monster emotes
 feeling
with no love
 fooled by
 show
with no love

monster sacrificed
 humanity
 for ideal

Love within
love awakened
 remorse
frees us
expels the monster
 within us
outside playing
 destruction

amoral
ill moral
moral

of
the cautionary tale
Love
breaks through
amorality

God is
everything
seed
we know this
monster denies
living in an
abstract
where God has
no teeth

God is
always waiting
always witnessing
always
in all ways

God seeds
in every pore
monster's dissolution

patience

secret agency....

no voice

 really

is

 questioned

 terrible words

terrible actions

 are

 agency

 choice agency

 pretend powerless

really

 really full

 of voice

 fury

 no love

 lots of voice

 no discernment

really

 choose poorly

 but voice

 it

 is

dim wit....

i am tired of the dim light
my sin is boredom
it connects us

yet it is a lie
we are so far apart

as we sit together
i cry
judge judged
you laugh
i laugh

blinded by truth
my glasses fail
we miss each other
and yet we sit side

by side
i choose
no more one small place
one only

the dim light remains
we sit remains
i no longer care

such a fragment of
the way it is

exile....

delusion denies
 divine

concrete clocks
 clouded concepts
 cover

 pleasure pleases senses
 Love then lingers

 languishes far away

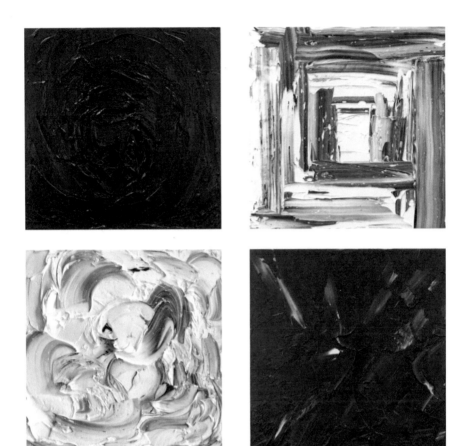

Hoard (2015)

Hoard	Minimalize
Preserve	Abandon

CHAPTER NINE

LOVE:
WHAT LOVE ISN'T

Love and Worship....

Love and worship—people so confuse the two. I love you, I worship you: very different. Many people are looking for someone who will worship them. That means they are looking for someone to objectify them. Love is not based on subject and object; worship is. In worship—and by worship I mean idealizing an object, not practicing sacred ritual—there is always the Other. With Love, we are moving to union. Our motive and action are selfless. Very different. Worship tends to deal in contracts: "If I love you, you must fulfill my wishes."

In some ways, worship is an immature form of Love; it is beginners' Love. When I adore someone, what am I adoring? My idea of the person. I am not really seeing and loving them. So I objectify, project, and love/worship; this puts me in the realm of knowing not you, but my idea of you. I decided about you; I do not know you. And my decision is better than you. This is selfish and not in any way in relation with the person other than as a screen onto which I can project. Whether it is a person or God, worshipping can fall into the category of "all about me."

When we really Love, the goal is union within. Can I experience who I really am in your presence? If I have to overcome all kinds of obstacles to do that, then we have a problem. At the beginning of a romance, it is all about love, this all-powerful feeling, and that is all that matters. Both parties feel it. Then that feeling begins to disappear and we return to normal. The love is gone and all is as it had been. We then look for ways to get the feeling back. The only way is to do what we were doing inside ourselves, an

internal activity of which we were unaware. It has to do with selfless surrender—letting go. Out of the head, into the Heart. The Heart moved us.

In some ways, *shaktipat* has a similar process. The Guru transmits the *shakti* into the disciple, and the disciple begins to have a very different experience. It will recede, and then the disciple will want it back. What were we doing internally? That is the practice that brings us to Love, not just to worship.

The Love Machine, Part One....

It's all about recreating our childhood vibration, which we call love. We call it love (or safety, comfort, normalcy, etc.) because it is how the shrunken self gets attention, and therefore power. For the shrunken self, power is the surrogate for Love. Intellectually, we hate the vibration and look for "solutions," but emotionally we crave it and keep looking to maintain it, and we find other "solutions" to help us do that. We go to people and situations that will support the vibration, yet we say we want out. In Truth, we do want out, and are out.

The love machine does not create love. Actually, it is a system for twisting Love. When we realize that, we try to change it from within the machine itself. But the one who fights the "good" fight against the system is not only a part of the system, but is the one who feeds the system.

How we set up the love machine:

We set up the love machine initially when we were very young, and all we knew of love was the caregiving environment we inhabited. Whatever experience we had, we called it love. The most powerful person in our world became the exemplar of love. By imbibing this experience without any discernment, we became attached to it, and began seeking to maintain it.

How we can uncover our love machine:

First, we have to feel the vibration we aspire to have. We may intellectually know that this vibration is not love, but emotionally we believe it is.

Next, we have to recognize how this "love" is nurtured. Who, what, when, where, why, how does this happen? What kind of person or situation encourages us to experience this vibration? What qualities must this person or situation have in order for us to feel our vibration of "love"? What kind of experience and mental chatter do we have around them?

Finally, I need to know my "solution." My "solution" is what I do when I recognize intellectually that the experience I'm having is not real love, and I try to "solve" the vibration. For instance, if my "love" vibration is in truth anger, I may use numbing as my solution. Or if dread is my vibration, I may see accommodation as my solution. The truth is, I do not want to leave my system, so my solution is in fact part of my system, and keeps me inside my system.

Take the example of a person whose childhood experience of love was one of deep insecurity, despondency, and fear of abandonment. That vibration will be what he calls "love," and he will spend his life trying to nurture and maintain it. He will gravitate toward people and situations that make him feel insecure, despondent, and fearful, and avoid people and situations that actually offer him security and acceptance.

First, he must recognize his "love" vibration for what it is, not what he calls it. This means being willing to face a delusion that has shaped his life. Not easy, but necessary. We must have courage to do this.

Then, he must come to grips with how he nurtures his "love" vibration. What sort of people, situations, and thoughts encourage him to indulge it?

Finally, he needs to identify his "solution." It may be to reject outright, or to take what he calls "the high road" and put up with things he shouldn't

tolerate, or to obsessively analyze and then discard. Each time the "solution" is applied, it hits a reset button, and the machine starts humming again. Often, people will deflect an opportunity to recognize their system in order to hit reset.

The Love Machine, Part Two....

How we resolve the love machine:

The love machine only keeps running because we fuel and maintain it. We even make sure to fix it when it breaks down. Any time the machine breaks down, we are given an opening, a wonderful opportunity—but we don't take advantage of it; we don't recognize the experience of actual Love, and we reject it. Instead, we see ourselves as having lost, or gone weak, when in fact we have a chance to be equal with everyone else. Rather than expand the opening and go into the Heart, we desperately work to fix the machine.

One of the most important ways we keep the machine running is by fighting it. It's normal to believe that if we don't fight the system, it will take over, but it totally takes over if we fight it, because then we are one-pointed on it. We hold on to something by fighting it; the one who fights is the one that feeds it. That voice is part of the system. If you want to be free of the system, you have to stop fighting it. You cannot move forward until you do this.

Remember, though, that not fighting does not mean letting the vibration take over and swimming in it. Neither does it mean thinking the shrunken self is bad—who is thinking that, anyway? The shrunken self is a vehicle we need to function in the world; not the shrunken self, but our wrong identification with the shrunken self, is the problem. And you can't just decide you're not your shrunken self anymore, because the one making that decision is the shrunken self. Though the shrunken self can be a

subject, we are sometimes aware that it is also an object, a vehicle. We have to do the work of consciously disentangling from the vehicle. The true Self is never an object; it is pure Subject.

Once you've stopped fighting, you can recognize the "love" vibration for what it actually is, and call it by its real name. When we face our delusions, we shine a light on them that allows us to see them clearly.

Next, accept the feeling and know that you work to feel it all the time. This first acceptance is really just intellectual. Emotionally, you still believe love and all relations and relationships are based on your "love" vibration. Let yourself have the "love" you have always aspired for.

Everyone wants the fast train to resolution. Forget that, unless you are willing to completely surrender, and stay surrendered. Otherwise, just accept that you can't and won't accept. What can you do to move? *Accept that you do not want to accept.* "I can't, I won't, and you can't make me" is the litany of the shrunken self. By accepting, we stop punishing our own Heart.

Then, be with the experience, for however long it takes to get to a place of total acceptance. Once you have fully been with it and accepted it as what you want, you can begin to let it go. You have to be willing to give up your "love," without knowing what will happen. The belief is, "If I give up my 'love' vibration, no one will ever love me or want to be with me ever again." We believe that if we don't maintain the system, we will die. Though this is a complete delusion, you will find that you are committed to it. You have to be willing to have nothing rather than your system. Until we fully accept this, we will at best only oscillate between moments of acceptance and eons of maintaining the system.

It is not that there are no more situations encouraging your vibration and that you no longer feel it. It is that you are not looking to create or maintain those situations so you can feel your vibration "makes sense."

Only then can you still your "love" vibration, and uncover that true

Love was always there, hidden beneath the distortions. We now rest in our true Self, in the Heart, where love is Love.

The Lovers and the Righteous....

We all want peace. We all say that, and yet our actions show a different desire. Vengeance, retaliation, revenge—what a great dance. The dance of hate. I have more in common with my brothers and sisters of the Muslim faith who Love than I do with my brothers and sisters of the Jewish, Christian, Hindu, or Buddhist faiths who hate. How can I stand by my Buddhist family that kills Muslims? How can I stand by my Hindu family that kills Muslims? How can I stand by my Christian family that kills Jews and Muslims? How can I stand with my Muslim family that kills Jews, Hindus, and Christians? How can I stand with any of my family who rapes women, abuses children, attacks, and kills?

Where is my family? My family is scattered across the earth, hiding. We are a family of Lovers no longer identified with our religions or nationalities or ethnicities. We must now rise up and Love. We must still any hatred and anger that remain within us. Our task is to Love, just Love. If enough of us actually allow Love to shine freely, without the cloak of hate that tends to lurk within us, then we have a chance. We are to give up even survival over Love. So much of the fight these days is because we believe we will not survive if we do not kill the other. Even this idea of survival has to go so that Love of God shines.

Swami Muktananda was of the family of Lovers. The scriptures I read and share are the scriptures of Love. And yet the family of hate will use some of these scriptures to justify their hatred. We are all saying we worship God. But there is a difference: we are either the Lovers of God or the righteous of God.

When we Love God with all our Heart, mind, soul, and strength, we are a family that brings joy and sees that there is one God for all of us, though

we praise and worship God in different ways. We are not attached to our way or our ethnicity because God is our focus.

When we are righteous, God takes a back seat to our individuality. We insist that we worship the only correct way. The belief is that the only true God is ours, and everyone else's God is a false idol. We know our language and expression and rules are the only principles to live by. Convinced that we are right(eous), we forsake God.

The more we forsake God, the more involuted we become. We are now lost in our righteousness. We attract others who are also lost in their righteousness, and now we can dance our dance of hate. That is our greatest form of worship: to hate and kill the "other." Fundamentalism and rigid righteousness from all religions, ethnicities, and nationalities bring us all into battle. To come to the Love of God, we must give up our righteousness. That is true for all of us.

The funny thing is, there is no "other." We are only looking in a mirror. We are seeing ourselves across those lines. We are seeing our own reflection.

I have been told that, had I been in Germany during the Nazi era, this "other" would have killed me. I have been told that this "other" will come for me in America. I know this "other" is me. I am here. I am looking in the mirror. My task is to remain nonattached, discern the appropriate course of action from moment to moment, and follow it. If it is appropriate to fight, I will—but without righteousness or hate. If my fate is to die by the hand of the Self in the guise of an "other," then it is God's will. So be it. I will go Loving God, not losing myself in the "other," no matter who or what that apparent "other" is.

Love: The True and the False....

Baba used to say "Thank God for false gurus." Why? Because they serve as foils by which we can recognize the true. I never questioned this.

Baba had me take care of the false gurus that came to see him. He taught me to discern the difference between these false guides and Baba. These people had trappings, disciples, protocols, rituals, all of which meant little or nothing. Most of them also had *shakti* that emanated from their bodies. People get swayed by the energy they feel coming from a guru. Clearly, since all these people had *shakti*, the energy does not make the teacher real. Of course, Baba had and has tremendous *shakti*, but he taught me that *shakti* does not make a Guru.

What made the difference between these people and Baba was Love. They all had power but lacked Love. There was never a sense that they wanted what was best for their followers. So, what is really clear to me now is that false gurus are the counterfeits that show us what is truly real—if we have the discernment and discrimination to see. We have to know the difference between what is false and what is real.

Ignorance is what causes us not to be able to tell the difference between the true and the false. Ignorance, according to Patanjali's *Yoga Sutras*, is taking the unreal to be Real, the temporary to be permanent, the impure to be pure, the non-self to be the Self. Once we are ignorant, we then lose our subject in the object we have mistaken to be real. From there, we are attracted to actions and lifestyles based on our false self. We are repulsed by all that does not agree with who we think we are. And finally we cling to this false life and fear we will die if we lose it.

There is a difference between what people say and where they are internally. When we try to forgive someone for having wronged us before we have reached a place where we are truly able to forgive, we actually prevent resolution. We perpetuate disharmony between people. Denial or resignation is not love of ourselves or others. If our actions do not head toward resolution, we are not going toward Love.

Power is not Love; however, Love is the most powerful force there is. Ultimately, Love will prevail. Pleasure is not Love; however, Love is bliss.

We have to wake up and discern the difference between Love and hate, between the real and the false, between resolution and destruction.

If we do not discern clearly, we will be blindsided. Unfortunately, most people's idea of *sadhana* is to be blissfully unconscious. Blissful ignorance will bring destruction and will be repelled by real Love. Love is uncomfortable for people who are attached to hate. They will misread the situation.

Because Love goes to resolution and dissolves hate, it can be seen as destructive by those who hate. In Charleston, South Carolina in the United States, a young man went into a church and sat in on their Bible study. In the midst of Love, this young man felt hate. Hate moves to destruction. The young man then opened fire and killed nine people.

Love always goes to resolution, but we have to discern what true resolution is. Enabling does not resolve; it is not Love. Enabling encourages destruction.

Baba said: "If someone asks me, why did man take birth? Then I will say, only for the sake of love … Supreme Bliss pervades everywhere, but man is not aware of this, and that is why instead of having love he has the opposite of love, and that is agitation and anxiety. Instead of experiencing love, he experiences sadness. But he experiences sadness only because he doesn't recognize the true love inside himself" (*Darshan Magazine*). Love brings us to real security. Outer security can be taken away easily, but inner security is always there to bring solace.

What Baba is really pointing out is that Love is our true nature. In verse 2.4.5 of the *Brihad-aranyaka Upanishad*, Yajnavalkya explains to his wife Maitreyi the reality of the Self. "Verily, not for the sake of all is all dear but all is dear for the sake of the Self. Verily, Maitreyi, it is the Self that should be seen, heard of, reflected on and meditated upon. Verily, by the seeing of, by the hearing of, by the thinking of, by the understanding of the Self, all this is known" (transl. Radhakrishnan). True resolution ultimately brings us to the Self of All.

In our daily life, resolution is working so that everyone is in harmony, loved, and headed toward what is truly best for each person. If we are not working from and for Love, then the outcome is hurt, alienation, agitation, separateness, emptiness, irritation, shallowness, superficiality, anger, and hate. These will be the true goal, though we may say our intention was love. We are then not willing to see the true from the false. We have to want to Love so that we can resolve ourselves. We resolve ourselves through Love.

If we want to love, we first must be opened to Love by a moment of Grace. Then we have to confess—to own and accept—that we actually do not love, and do not know what Love is, because our "normal" has nothing to do with real Love. We have to discern the true from the false. Whatever we have called "love," we must call what it truly is. Then we must reap the past and earn the present, so that we can Love.

Love and Independence....

The Guru brings us independence from the tyranny of the shrunken self. Independence means that we know who we are and know we are not the shrunken self. We are freed from the constructs that have kept us locked into the smallness of an idea. We are now free to act and relate with the world without being identified with any of it. The Guru opens our eyes to the truth of our wrong understanding. The Guru shines a light so that we can move forward toward God. To receive what the Guru has for us, we must be willing to accept and own what we have chosen. We have to accept that though we thought we had chosen Love, we had not.

In the Absolute, all is Love, no matter what. In relative reality, Love gets twisted. Hate is Love in a twisted form. Hate is not and cannot be its own thing.

To get to know Love, we must first be able to distinguish all the gradations of love. We must know the whole spectrum of love. From there, we must clearly choose Love and not twisted Love.

Most people can't discern between power and Love. They confuse the two because they live in their heads and therefore cannot discern. Adoration, which comes from the same motivation as power, is mistaken for Love. But indulging the shrunken self is not Love. Because we are trained not to listen to our real experience, we can be manipulated and not notice it. We will call someone or some action "loving," when it is actually "loving" the ego only.

When we are "loving," our action is based on:

Enabling the other's ego

Indulging the other's ego

Deceiving the other's ego

Our reasoning will then be based on:

Blindness

Denial

Mitigation

Having power as our motivation skews everything away from Love. We adjust our labels to accommodate our behavior. Then everything is "in harmony" and "makes total sense," so nothing needs to change. Our self-indulgent behavior is a constant that controls our lives and prevents us from experiencing the freedom within. We persuade ourselves that our ego's ability to adapt everything to its purposes is the virtue of mental flexibility.

Love is then seen as just about power. Everyone does for themselves and steps on others. It is about ego management:

How we relate with others:

Police others' egos and motives. Don't feed someone else's ego or power. No swelled heads here. Make sure no one is too big for their britches. Then we think, "If this is what the Guru does and this is what I do, then I am a guru."

How we relate with ourselves:

Take care of yourself. Take what you need and look after yourself (take care of yourself and don't feed someone else's ego). Indulge yourself.

How others are to relate with us:

Gratification. Adoration. Niceness. Enabling. Propping up your ego. Your ego should be propped up.

Indulging the shrunken self is not Love. The shrunken self will not indulge others at the expense of its own care. If I give you what you ask for, I am supporting and validating your ego. If you give the other person what they actually ask for, you will be indulging their ego. So if you are to be "loving," and because you believe you are "loving," you will do everything not to fulfill a person's sincere request.

If I operate according to this system, then I know that the only way I get my needs met is if I sneak. I also expect others to fulfill my needs; they have to "know" what I need. And then I get angry when they don't know, and then don't meet my needs.

To love yourself is to seek what is truly best for yourself. But a "good" fake guru encourages you to side against yourself in favor of them. Everyone sides against themselves in favor of the other person. That's called "surrender," but it's actually enslavement. This is one way we get to maintain our shrunken self.

For people who think power is Love, spiritual practice is punishment.

Instead of practicing, these people want the Guru to bail them out, to fix them, and to make their problems go away. But they know better than to feed the Guru's ego. They do not realize the Guru does not need ego strokes. Giving and showing appreciation to the teacher is for the student's benefit. It is an opportunity to express real Love. The lover learns how to Love by having someone to love.

When power is the mistaken goal, the one who initiates is the loser. So the disciple who goes to the Guru and appreciates the Guru is a loser. The Guru has to go to the people, if the Guru is to be seen as "loving." The Guru Loves, and so sees through this game and does not play it.

The true Lover is beyond power, beyond winning and losing. Everyone has to be willing to be a loser in order to win.

The Delusion of Ownership as Love....

Ownership is called love.

Therefore, objectifying is love.

Therefore, love is essentially pornographic.

Therefore, power is love.

Love is therefore the pleasure of possession and control.

To own and feel the pleasure of ownership is to love.

To be owned is to be loved.

Therefore, the beloved's obligation is a constant willingness to be an object, to have no say, to be compliant, so as to be always loved.

The owner/lover's responsibility is to make all the decisions and keep the beloved object safe.

If that is true, then I am perfectly happy not to be loved.

Owned (possessed and controlled)	Free (able to be and express yourself)
Cared for (supported and respected)	Unloved (unacknowledged and unsupported for who and how you are)

Many people do not even consider what "cared for" and "free" look like. People tend to conflate "cared for" with "owned," and "free" with "unloved." So if we are owned, then we will be cared for. And if we are

free, we will be unloved. Within this system, the only way to be "loved" is to be owned and never free.

The shrunken self is made up of dichotomies, and therefore it is made up of dialectic. One voice in our mind says "I own you," and another says "I am owned." We delude ourselves into thinking that one of the voices in this particular dialectic is who we are; we don't question who the other voice is. We believe they are two different speakers, but really there is only one. Confined within this dialogue, we selfishly sleepwalk through life.

The shrunken self, which is a vastly diminished manifestation of God, has all the qualities and activities of God, but in a shrunken form. In truth, God possesses all through Love; the shrunken self owns and calls that ownership care. God liberates us through grace; the shrunken self thinks it liberates us through individuation and spurs us to individuate—which separates us further from who we truly are. We become small and petty, thinking we are free when in fact we are unloved in the world and unloved by ourselves. False identity individuates us. To recover our true nature, we have to give up our identification with that individuality.

God Loves, we own. God liberates, we abandon.

| Owns | Liberates |
| Loves | Abandons |

We are to live our little lives knowing that God is everywhere in them. It is not our lives that are great; it is God enlivening our lives that makes them and us great. Our mission is that Love is to inform everything we are and do. Then, and only then, will our lives be genuinely full and vital.

Love or Its Counterfeit....

Love is so much better than power. When we Love, we are at the Source, expressing the Source. Nothing is watered down, nothing is

minimized, everything *is*. Real Love is the essential nature of everything; it is the untainted manifestation of God. Power is shrunken and twisted Love. When we pursue power, we believe we have strength with authority. We believe we are in control. But the problem is, we are not even in control of the tiny fiefdom of our own minds. We are manipulated by the very system that we believe we control. We are deluded by the very voice that tells us we are in charge. We have neither power nor Love when we are identified with our shrunken self.

The shrunken self "knows" exactly how to get what it calls love (power), how to get attention, and how to get its will and desires fulfilled. All shrunken selves will do what they have always done to get attention.

The question is, how does my shrunken self get to be "loved"? "Adored"? "Focused on"? What do I have to do? When we do whatever that is, we are totally unsafe for ourselves and others. We will forsake our Heart, our dharma, our true path, in order to receive that affirmation from the outside. Because we have lost our subject in object, the outside has been given the role of the valid assessor. To us, internal reflection looks like heading in the wrong direction.

Our shrunken selves are always either the receivers or the givers of attention. Neither one gets Love, only various kinds of power. For instance, in order to get "love," we may believe we have to give others the power in our relationships. We give up our power, and the other person gets all the attention and has their desires fulfilled. We then get "loved" by being of use and being allowed to be in their presence. For the receivers, the benefits are obvious: they just happily deserve and therefore take willingly what the other gives. The receiver gets gratification wholly on their terms. But the receiver isn't getting Love, either; they are only getting projected on, just as the giver is. And just as the receiver gets to feel powerful, the giver also gets the feeling of power—by being useful, needed, good, empowering, nurturing, and supportive. These relationships work only as long as each

shrunken self is consistently and completely identified with the part they play.

In this world of power rather than Love, this world without inner reflection, the only way to assess our progress is whether the other is happy with us or not. How many times have we been so sure we loved the other person because they were so happy with us? Mutual enthusiasm is such a deluder.

Real Love is not based on the shrunken self's getting its desires fulfilled by others or, more importantly, by its own self-obsession. Real Love happens only when the shrunken self is not involved at all. The shrunken self is not the one that Loves, and it is never the Beloved.

Love from the Heart has nothing to do with the shrunken self, which is nothing more than a narrative. Love *is* and shines forth. It is not dependent on anything. It is a state of being.

In this state of being, the Lover and the Beloved are you and everyone else. When a person is no longer identified with the shrunken self, there is nothing that keeps that person from the state of Love, no matter whose presence they are in. This is what each of us should have, live, and *be*, all the time: Love.

Love Is Not Goodness....

I am disheartened these days watching the world steam ahead toward hate. And though we may acknowledge the character traits of reflection, honesty, care, and discernment, which come from purity and clarity, there seems to be ever-increasing inertia—heedless indifference—along with the painful traits of agitation, violence, fear, and turning further away from the Heart.

In the face of this upheaval, too many people seek refuge in a dangerous idea of "goodness." Unconsciously confusing Absolute Reality

and relative reality, they convince themselves that if they clearly discern and acknowledge the disorder and destructiveness within the world, then they are not "good" in the way everyone else is. For them, seeing clearly and honestly is being negative. We are supposed to be blind to anything that doesn't affirm human goodness.

The mistaken belief is that we are all innately good; the truth is that we are innately Love. But in identifying Love with an abstract ideal of goodness, we twist Love. This sentimental notion of innate goodness is then seen as so sacrosanct that we refuse to deny it even when the facts are staring right at us.

| Saintly / seen as good | Demonic / corrupt |
| Doormat / sucker / used | Savvy / handles the world |

We are confronted with a failing logic when we bring into our scheme of innate human goodness names like Hitler, Stalin, Pol Pot, and Pinochet. People committed to seeing humanity as innately good will downplay crimes and abuses in order to justify that belief. So "good" people project their idea of a unifying goodness everywhere they look. In a single moment of apparent goodness, these people will deny the real suffering in the world, which is to deny a large portion of the world's experience.

Yes, from the standpoint of Absolute Reality there is no suffering in the world. We all know that. In the non-dual systems, there is no real suffering. But until we live in that Love and come from Love without distortion or obstruction, there will be suffering in the world we inhabit. There will be cruelty and terror and pain. Have you ever noticed how often the very people who insist on universal goodness and tell others in pain to "let it go" demand attention and sympathy when they happen to be the ones suffering?

In truth, there is just us, but we have to live that truth not just when it is convenient, not merely when we have the time and the inclination. Others' suffering is our suffering. Others' joy is our joy. When we are willing to acknowledge our part in the world, we then share in the play. We do not deny the suffering, but develop compassion. We develop dispassion. We develop Love. We share in community.

Shared human community	Isolation
No voice / lost personhood	Independence / voice

When we share in community, we do not lose our voices. We each have a voice, and we share. When we are isolated, we may think we are independent, but in truth we have no voice.

When we insist on what we call innate human goodness and refuse to face human destructiveness and suffering, we are hiding from Love. When we hide from Love by cloaking ourselves in "goodness," we will avoid anything that might give us true human community. And in our pridefulness, we blame others for not affirming our gauzy view, when they in fact shouldn't. Remember, if we swim in this kind of "good" life, we will not feel the hate that surrounds us. We will instead resonate with hate and feel connected with others who share that vibration. This is the most destructive form of false community. Love requires surrender, but we instead defy Love in the name of our righteousness.

Surrender	Defiance
Placate / appease	Steadfastness

If we want to stop hiding from Love, we must give up our pride in our own "goodness." We must surrender over and over again, day in and day out. Love is off the grid. There is no opposite to Love.

Misreading Power as Love....

Baba used to say that Christ was the incarnation of Love. Christ showed us what Love is. He Loved without qualification; there was no arbitrariness in His Love for all. Even on Calvary, He Loved.

For me, Baba modeled that same Love, always. In every moment, he taught me what Love is.

We all tend to think we know what love is; the problem is, we only know what we have been taught, and what we have concluded on the basis of our very limited experience. We do not willingly put our ideas of love to the test. If we did, their limitations and distortions would be exposed.

For many, what they call love is really about power. Whether they realize it or not, they see life in terms of the exercise of power. Accordingly, they see everything in light of hierarchies and roles, and love is just a function of how people use what power they have. This usually translates into a resentment of people whom they see as outranking them; whoever is an authority figure is automatically perceived as a loveless oppressor. Love, then, is being in a position to oppress and choosing not to. It is the benevolent exercise of power.

| Benevolent | Undiscriminating |
| Condescending | Equal |

As the fourchotomy reveals, this wrong understanding of Love means that we relate to others only in terms of their apparent position relative to us in a perceived hierarchy. What we call love only happens from higher to lower. When we see others getting along well with people above them in a hierarchy, we cannot see this as a good thing, as the recognition of an underlying equality; we can only see it as flattery or politicking on one side and favoritism on the other. We can only "love" those beneath us in some way. And if the only people we can "love" are beneath us, the truth is we are not loving—we are powering.

Great Beings Love equally. Love precedes whatever hierarchies we inhabit in relative reality; to Love, we must come from a place of Unity and equality, and only then operate appropriately within the hierarchies of relative reality.

When we confuse Love with the exercise of power, we also think in a very limited way about safety and security. If we see life in terms of power relations, we will only "love" when we do not feel threatened in any way. This means either that we have to have power over those we "love" or that they agree completely with our conception of love and are willing to take the subordinate role. We only feel safe in a relationship when the other person submits to us.

Another way in which we conflate Love and the exercise of power is through woundedness. Many of us as children only received what we knew as "love" when we were wounded or unhealthy or miserable. This encouraged in us the habit of identifying with the wounds we see ourselves as having received—and of seeing "love" as inseparable from woundedness. The fourchotomy that results from this thinking reveals how delusional it is.

| Wounded | Unloving |
| In pain | Resilient |

We then equate love with a vibration of woundedness and want to share it with others. If others reject our wounded vibration, they are rejecting our "love" and therefore have no "love." In our minds, we work to get others to "love" by being magnificently wounded or wounding them. At its extreme, this delusion may even lead us to mortally wound ourselves so as to wound everyone else into loving us.

People misinterpret Christ as wounded. He is seen as the suffering servant, and we are to share solidarity in suffering. That is not Love. That is not what Christ wanted for us. That is not what God wants for us. Love has

nothing to do with power or woundedness. Love always leads to resolution for everyone, at all times, in all places. And that resolution is our birthright. Love leads us to Love.

Love Is Not Pain....

Love is the bottom line of life. But we are capable of twisting Love into pain. Why do we do this? We do it through ignorance of what Love really is. In order to get to pain, we have to twist Love so much. Love grounds and encompasses everything; pain is so paltry in comparison. Love is Self-illuminating; pain cannot sustain itself. And yet, we manage to confuse the two.

We all like to think we know the difference between care and cruelty. The truth is, most of us have been fooled at some point in our lives.

If we are going to conflate Love with pain, care with cruelty, then cruelty has to have something within it that can fool us. What it has is attention. If attention is all you are looking for, then the difference between care and cruelty will not even occur to you. Attention is not dependent on feeling; without feeling, you can easily confuse cruelty and care. Someone is seeing you, talking to you, spending time with you. The focus is on you. You will see the attention, but not feel the intention.

Another component to confusing care and cruelty is that you have to lose yourself in the other person. This is something that can happen instantly, even in a casual encounter; it has to do with how you relate with others. Resonating—responding like a tuning fork when a vibration within you matches one within someone else—is one way of losing yourself. So, ironically, the quality of your attention to the other person allows them to be cruel to you.

Here is a fourchotomy that illustrates how we confuse cruelty with care and allow others to be cruel to us:

Willing hostage	Fighter for freedom
Understanding / adaptable / accommodating	Pointless rebel

It is so easy for some of us to think of ourselves as adaptable, understanding, and accommodating, when in truth we allow ourselves to be held hostage by someone who is injuring us. We might also see ourselves as fighting for our freedom when we are pointlessly rebelling against people who are truly caring.

In order to free ourselves and see clearly, we have to get off the grid completely. If we call ourselves "loving" and "caring" without deep reflection, we fool ourselves. We are then cruel to ourselves and others. We have to be off the grid in order to really Love. Love is not on any grid.

To remain on the grid, we have to not love ourselves. There has to be a level of not loving ourselves in order to allow ourselves to be treated cruelly. Once we accept that, we can then change.

If Love is the bottom line and we don't love ourselves, we are totally uprooted. There is no care, no feeling. We are lost in our idea of the other person and ourselves—lost in a series of ideas that calls whatever is occurring something it isn't. If we don't allow ourselves to feel the emptiness, the hurt, and the sadness of this situation, then we will continue to call it care and love. When "love" is an idea, there is no Love. It is impossible to perpetuate Love if we don't want to be in the Heart.

If we summon the courage to face the vibrations we have always had and feel them fully, we then will be able to discern the difference between cruelty and care. We will be headed toward the Heart, and therefore toward Love.

revelation....

two sided

 mirror

 facilitates

 a

 c

 u

 l

 t

 i

 e

 s

 two p l a y

 o l

 a

 p l a y

two manifested

 e c

 s w o r l d

 s e e

 a n d

 n o

 w e

 v

 o

 l

 v

 a c l e a n

 g

 a

 m i r r o r over again

 n

GLOSSARY

Abheda: the state of nondualism, in which all separateness has dissolved in the Absolute and there is only Unity

Absolute Reality: God, Love, the Ground of All by which All exists and which cannot not exist

Ananda: the Bliss that is, and emanates from, the Self

Ananda samadhi: the stage of *samadhi* in which the one-pointed consciousness experiences Bliss

Anava mala: in Kashmir Shaivism, the primal ignorance that allows shrunken Consciousness to believe it has a separate, limited existence apart from Shiva

Anavopaya: in Kashmir Shaivism, the term for the first level of spiritual practice, using the senses and sense objects as means of worship

Asmita: absorption; in the negative sense, it is the loss of Subject in object and one of the five miseries (*kleshas*) of the *Yoga Sutras*; in the positive sense, it is loss of all separateness and total absorption in the Divine

Asmita samadhi: the stage of *samadhi* in which the one-pointed consciousness is totally absorbed in the Self

Avidya: "different knowledge"; in the *Yoga Sutras*, the first and foundational misery (*klesha*), which is the primal ignorance of our true nature as the Self

Bheda: difference; the world experienced as a multiplicity of separate things, with no underlying unity

Bhedabheda: "Unity in difference"; the world experienced as Unity giving rise to a multiplicity of manifested beings

Buktimukti: "pleasure and liberation"; the tantric doctrine that, understood appropriately, pleasure and liberation are not mutually exclusive

Causal body: the vehicle of the Self that carries karma from life to life

Darshan: "seeing"; the Grace of being able to look upon the Guru; also, the word for the six dominant orthodox schools of Indic philosophy

Dharma: right action; what one is meant to do, or what is appropriate to do

Dualism: any worldview that posits a gap between the Being of God, the Self, Absolute Reality, and the existence of created beings, where the universe may be seen as illusory or created *ex nihilo*

Ego: the function of the mind that identifies with decisions

Ganesh: the elephant-headed son of Shiva and Parvati, who is both a gatekeeper and the remover of obstacles

Ganeshpuri: the location in Maharashtra, India, of Swami Muktananda's first ashram and the site of his tomb

Grace: the power by which God draws us back to Unity

Gunas: in Indic philosophies, the three fundamental constituents of the manifested universe: *tamas*, or inertia and darkness; *rajas*, or activity and agitation; and *sattva*, or calm, brightness, and clarity; the gunas combine much like the primary colors to create infinite things and states

Guru: both the Grace-bestowing power of God and the person through whom that Grace is passed to disciples

Guru Purnima: the Guru's moon; the full moon in June or July, which is dedicated to celebration of and devotion to the Guru

Heart: the innermost ground of a person's being, where the relative existence of the individual meets the Absolute Reality of the Self

Intellect: the faculty of knowing; the subtlest vehicle, which tends to confuse its own activity with the true Subject, the Self

Ishvara pranidhana: as referred to in the *Yoga Sutras*, total surrender of one's entire existence to God

Jiva: the individuated self or embodied soul; in Kashmir Shaivism, the shrunken self

Jivanmukta: someone who has achieved complete liberation while still in a human body

Kaivalya: in the *Yoga Sutras*, "aloneness," or the point at which the Witness, the Self, has realized its own nature and is liberated from having to engage with *prakṛti*, or the manifested universe

Kanchukas: in Kashmir Shaivism, the five coverings by which Shiva conceals Himself in bodying forth the manifested universe; they are *kāla* (time), *vidyā* (shrunken knowledge), *rāga* (desire), *niyati* (cause and effect), and *kalā* (limited agency)

Karma mala: in Kashmir Shaivism, the form of ignorance that makes the individual appear to be the doer of good and bad deeds when, in Truth, only God is the Doer

Kashmir Shaivism: the conventional term for a closely knitted set of nondualist tantric traditions rooted in Kashmir, in which Absolute Reality is represented by the god Shiva, and his consort Shakti is the power by which he bodies forth the universe

Kundalini: the form of shakti that rests dormant in each human being until *shaktipat* ("the descent of power," or spiritual awakening and initiation), at which point it spurs the individual toward liberation; it is often represented by a snake coiled three and a half times around the base of the spine

Lila: "play" or "sport"; generally, the world as the play of Consciousness, and more specifically any game or dance played out on the stage of the world

Lokananda samadhi sukham: "the bliss of the world is the bliss of *samadhi*"; the nondualist truth that the entire manifested universe is pervaded with the Bliss of God, and that one can move through the world filled with that Bliss

Mahasamadhi: the great *samadhi*; the final dissolution of all separateness when a Great Being, a *jivanmukta*, leaves his or her body

Matrika shakti: "the power of the un-understood Mother"; in Kashmir Shaivism, the power of letters to constrict Consciousness, both shaping the manifested universe and binding the shrunken self to its limited existence

Maya: in Kashmir Shaivism, the power of Shiva to conceal himself in creation

Mayiya mala: in Kashmir Shaivism, the form of ignorance that leads us to believe we are imperfect rather than the perfection of Shiva, the Self of All

Nirbija samadhi: *samadhi* without seed; the advanced form of *samadhi* in which attention becomes absorbed in complete Subjectivity, without any need for an object on which to focus

Nirvikalpa samadhi: *samadhi* without any thought-forms

Niyamas: observances; in the *Yoga Sutras*, the practice of doing the right things, observing the right outward activities, as a foundational way to discipline the will and encourage stillness

Pashu: "a beast for sacrifice"; in tantric traditions, the word for any person who is lost in ignorance of his or her true nature as Shiva

Pati: "a lord"; in tantric traditions, a person who has advanced on the spiritual path and become established in the knowledge that he or she is truly Shiva, the Self of All

Physical body: the coarsest of the vehicles in which the Self operates in the world

Prakrti : in the *Yoga Sutras*, the term for all that is not the *purusha* (the Witness, the Self)

Pranam: an act of devotion in which one drops to one's knees and bows to the Guru or prostrates oneself completely

Psychic instrument: another term for the mind, with its components of *manas* (the data collector), *buddhi* (the intellect, which makes decisions), and *ahamkara* (the ego, which identifies with those decisions)

Puja: the altar where God and/or Guru is worshipped, and also the act of ritual worship

Purusha: in the *Yoga Sutras*, our true nature as the pure Subject, the Witness, the Self; in Kashmir Shaivism, the separate, shrunken individual self

Rāga: desire

Rajas: the *guna* of agitation, activity, desire

Sadgurunath Maharaj Ki Jay: "praise to the True Guru"; a saying used as a prayer or blessing, often at the beginning or end of an activity

Sadhana: spiritual practice, usually in the context of tantra; in some limited contexts, it can mean the pursuit through spiritual practice of powers rather than liberation

Sahaj samadhi: "walking bliss"; resting in the Bliss of the Heart while functioning appropriately in the world

Samadhi: absorption; the state of sustained, completely one-pointed attention

Sat-chit-ananda: Absolute Truth (or Existence)-Absolute Consciousness-Absolute Bliss, the classic Vedantic formulation of the nature of the Self

Satguru: a True Guru, as opposed to a lesser teacher or false guru

Sattva: the *guna* of calm, brightness, and clarity

Self of All: our true nature, God, pure Subject without an object, *sat-chit-ananda*

Seva: service; work done in the spirit of devotion to God and Guru

Shakti: the Power by which Shiva, the Absolute Reality, becomes dynamic and issues forth the manifested universe; the Goddess

Shaktipat: "the descent of Power"; the awakening of the *kundalini* by a transfer of spiritual energy, normally from Guru to disciple

Shaktopaya: in Kashmir Shaivism, the term for the second level of spiritual practice, in which we use the mind to draw closer to God

Shambhavopaya: "the way of Shambhava (Shiva)"; in Kashmir Shaivism, the term for the third and deepest level of spiritual practice, in which one rests constantly in the Heart by a mere orientation of the will

Shiva: the Hindu god who destroys the universe at its appointed end; in Kashmir Shaivism, Shiva represents God, Absolute Reality, the Self of All

Shraddha: faith; the commitment to God and Guru necessary for realization

Shrunken self: the contracted consciousness and sense of self we have when we are not yet fully realized; the normal human self

Shunya: the void; that which exists beyond all difference, without any support (necessary), and therefore Absolute Reality

Spanda: in Kashmir Shaivism, the pulse or impulse of Bliss in the Absolute that brings the universe into existence, sustains it, and makes things happen within it

Subtle body: the vehicle of the Self that contains the mind and within which the *kundalini shakti* functions

Supracausal body: the Heart, the subtlest inner juncture between the relative and the Absolute, where the Self abides in each of us

Tamas: the *guna* of inertia, darkness, and ignorance

Tandra: the visionary state of consciousness on the threshold between waking and sleep

Tantra: roughly "weaving"; a term covering a wide range of spiritual traditions that operate outside and, by their own account, above and more efficaciously than the more conventional traditions of Hinduism (or Buddhism)

Tapasya: "cooking"; the use of ascetic or highly disciplined practices to grind down the ego and remove ignorance

Turiya: "the fourth"; the Divine Consciousness that underlies the three ordinary states of waking, dreaming, and deep sleep

Unmesha: "unveiling"; Shiva opening his eyes; the revelation from within of our true nature

Vedanta: "the end of the Vedas"; one of the six classical darshans; also, closely related schools of spiritual practice; the most famed is the *advaita* (nondualist) school, but there are also schools of dualism and modified nondualism

Vehicles: a term for the manifested and layered forms used by the Self to operate in the world, from the intellect to the gross physical body

Vidyā: "knowledge"; in Kashmir Shaivism, limited knowledge, ignorant of the Self, and therefore the source of bondage

Vitarka samadhi: a *samadhi* in which one enters a sustained one-pointed concentration on a physical object or activity

Witness: in the *Yoga Sutras*, the *purusha*, the Self, our true nature as a completely free, nonattached Subject

Yamas: prohibitions; the practice of avoiding things and activities that agitate consciousness and create or deepen attachments

ABOUT THE
AUTHOR

From an early age, Rohini Ralby was committed to finding the best teachers in every field she pursued. Originally from the Boston area, she completed her undergraduate studies at Washington University in St. Louis and earned a graduate degree at Mills College.

While at Mills, she began intensive study of Tai Chi Chuan, and subsequently ran her own school in Cambridge, Massachusetts while also earning a degree in acupuncture and studying Chinese calligraphy and Alexander Technique. In 1974, she met Swami Muktananda Paramahamsa, and remained a close disciple until his *mahasamadhi* in 1982. During that time, she studied spiritual practice with him one-on-one.

In the four decades since Muktananda, affectionately known as Baba, left his body, she has continued to devotedly live that practice. Since 1990, she has shared it with students all over the world.

In 2012, with Bancroft Press, Rohini published *Walking Home with Baba: The Heart of Spiritual Practice*, a guide to the inner practice she learned from Muktananda and continues to share. *Living the Practice: The Way of Love* is the first of two books that collect Rohini's shorter writings in both prose and verse as well as some of her paintings, organized thematically so readers can locate, read, revisit, and contemplate her teachings and reflections.